Jeff Wignall's
Digital Photography Crash Course

Jeff Wignall's
Digital Photography Crash Course

2 Minute Tips for Better Pictures

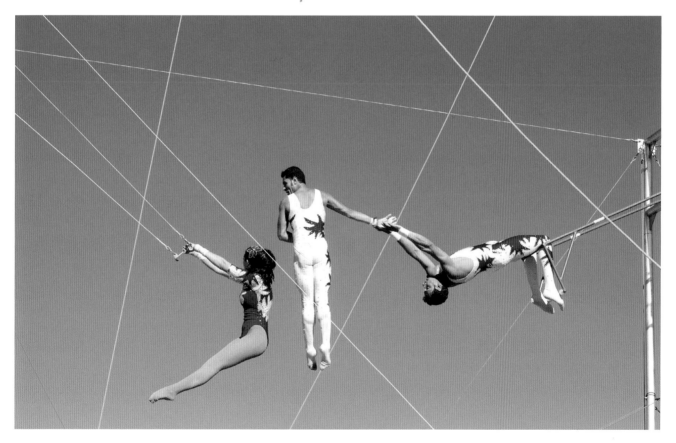

LARK
PHOTOGRAPHY
BOOKS

A Division of Sterling Publishing Co., Inc.
New York / London

Editor: Matt Paden
Book Design: Ginger Graziano
Cover Design: Thom Gaines

Library of Congress Cataloging-in-Publication Data

Wignall, Jeff.
Jeff Wignall's Digital Photography Crash Course/ Jeff Wignall. -- 1st ed.
 p. cm.
 Includes index.
 ISBN 978-1-60059-634-6
 1. Photography--Miscellanea. I. Title. II. Title: Jeff Wignall's Digital Photography Crash Course. III. Title: Two hundred top photo tips.
 TR150.W54 2010
 771--dc22

 2009053711

10 9 8 7 6 5 4 3 2 1
First Edition

Published by Lark Books, A Division of
Sterling Publishing Co., Inc.
387 Park Avenue South, New York, N.Y. 10016

Text © 2010 Jeff Wignall
Photography © 2010 Jeff Wignall
Illustration page 136 © 2010 istock.com

Distributed in Canada by Sterling Publishing,
c/o Canadian Manda Group, 165 Dufferin Street
Toronto, Ontario, Canada M6K 3H6

Distributed in the United Kingdom by GMC Distribution Services,
Castle Place, 166 High Street, Lewes, East Sussex, England BN7 1XU

Distributed in Australia by Capricorn Link (Australia) Pty Ltd.,
P.O. Box 704, Windsor, NSW 2756 Australia

If you have questions or comments about this book, please contact:
Lark Books
67 Broadway
Asheville, NC 28801
(828) 253-0467

Manufactured in China

ISBN-13: 978-1-60059-634-6

For information about custom editions, special sales, premium and corporate purchases, please contact Sterling Special Sales Department at 800-805-5489 or specialsales@sterlingpub.com. For information about desk and examination copies available to college and university professors, requests must be submitted to academic@larkbooks.com. Our complete policy can be found at www.larkbooks.com.

TABLE OF CONTENTS

TABLE OF CONTENTS

Dedicated to Tino Wallenda,
whose example is courage, faith, and grace, above all else.

Acknowledgements

Thanks to:

Matt Paden, my editor, for doing a superb job and for making the project absolutely enjoyable.

Ginger Graziano for designing such a handsome book.

Marti Saltzman and Lark Books for (once again) giving me the opportunity to turn an idea into a book.

Professor Louie & the Crowmatix for the great music and always welcoming my cameras. And thanks to John "Johnny Be Good" Corvino for his help modeling .

Special thanks also to Tino Wallenda and the Flying Cortes for graciously allowing me to photograph them.

My grateful appreciation to NIK Software, FJ Westcott Lighting, and Software Cinema for their continual help on this and other projects.

Lastly, thanks as always to Lynne for navigating the many shooting trips—GPS has nothing on a great map reader.

This book began as most creative projects do—as an innocent idea. I thought, "Why not publish a blog with a short tip every day and share some fun and useful photography tidbits?" After all, my head is well overfilled with photography notes of all sorts. Thus began my Photo Tip of the Day blog.

Somehow that idea turned into an obsession, as many ideas do. Many of my "tidbits" turned into full-fledged ramblings and soon I was putting aside my "real" work to take pictures and write tips for a rapidly growing audience. Then, irrationally probably, I decided that I wanted to turn the blog into a book and I actually believed for a short while that I might be the first person to do that. And then I saw the movie *Julie & Julia* and found out that at least one writer (probably one among many), Julie Powell, had beat me to it by turning her interesting blog into a great book that became, of course, the movie.

Without giving away much of the plot, Powell's story is about her attempt to cook every recipe in Child's *Mastering the Art of French Cooking* and then blog each day about her successes and failures. Since there were more than 500 recipes in Child's book, it meant that she had to cook more than one recipe a day for a full year. The idea of Powell cooking a new recipe (or more) every day got me thinking about how important it is to push your creative photographic boundaries by forcing yourself to take new pictures each day. The incredible thing about having a goal like that, and having the discipline to see it through, is that you never know where it will lead. Powell could hardly have dreamed that one day her personal blog would not only turn into a major motion picture, but that it would forever bind her life to Julia Child's.

Where will reading this book lead you? My hope is that it will lead you to new destinations, both creatively and physically. Moreover, by reading the tips in this book, perhaps you'll feel inspired to try something new with your camera every day. And maybe you'll want to start a photo-a-day

blog, too. There are lots of them out there from many photographers who see the value of constantly challenging their creativity and technique.

And in the end, that's what *Digital Photography Crash Course* is all about.

This book is what I would call an *idea* flipbook. It is written in no particular order and with no particular goal other than to provide you with an interesting and fun crash course in the subject of digital photography. You can read it front to back, back to front, or just let the cat climb into it and pick a page for you. You'll find tips ranging from the very basic (how to meet and greet your new camera) to somewhat obscure (how to take pictures at the fair or take photos by black light). Hopefully as you flip through the book you'll find ideas that will give you information and inspiration and feed the obsession that is digital photography.

Jeff Wignall
Stratford, CT
www.phototipoftheday.blogspot.com

TECHNICAL NOTE: The focal lengths of lenses in this book are given in actual sizes, while shooting focal lengths are expressed as 35mm equivalents. This latter focal length is determined by multiplying the actual focal length at which the image was shot by the sensor's magnification factor, which is generally 1.5x to 2x, depending on the sensor size. All this sounds complicated, but it's a way to express shooting focal lengths in a universal format (35mm terms) regardless of the various sensor sizes used. For example in tip 10, the sunset image was shot at 235mm on that lens, but with a 1.6x magnification factor applied for that particular sensor, we can express the focal length in 35mm terms as 375mm.

Keep a Spray Bottle Handy for Flower Close-ups

You probably don't think of a gardener's spray bottle as a standard photo accessory when you're photographing flowers, but I always have one nearby—especially on bright, sunny days. Nothing in the garden is as pretty as a mist-covered rose in bloom; the problem is that when the sun comes out, natural mist burns off quickly. And since I'm not much of a morning person and rarely see the morning dew on anything, this tip is a great cheat.

The solution is simple: when you plan on shooting flowers, carry a small misting bottle that you can buy in any garden center. After you compose your shot and have your exposure set, give the flower a few quick sprays and you'll get a realistic-looking, mist-covered blossom. Most bottles have an adjustable spray setting that creates different sized beads of water, so experiment with the spray nozzle or even different bottles. Also, if you build up the droplets by spraying several times, the water tends to bead up in larger drops, which can look interesting as well.

You'll also find mist on flowers and plants if you shoot after a gentle rain, of course, but often the skies are still gray and the lighting, while more gentle and even than direct sunlight, can sometimes be kind of bland. Hard rains also tend to damage delicate flowers,

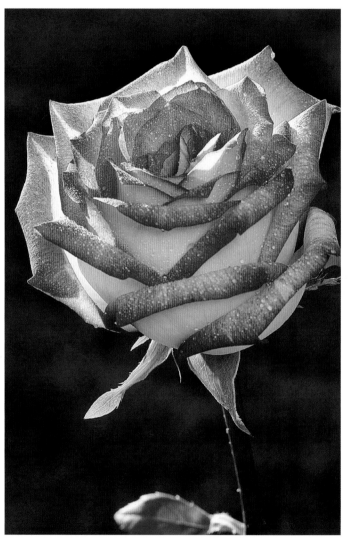

and if you wait until they pop back into shape, the droplets may have vanished. For an actual rainy day look, have a friend sprinkle your subject with a gentle (and emphasize the word "gentle" to your helper) spray while you shoot. (You might also want to note the expensive nature of your camera in case they decide to get playful with the water.)

By the way, if the roses (or other flowers) in your garden are looking kind of tattered and you still want to do some close-up work, consider visiting your local florist. I bought this rose (along with several others) to shoot for an ad assignment because the roses in my garden were all past their prime. Long-stemmed roses are only a few dollars each and if you're careful buying them, you'll find perfect specimens in all different colors, shapes, and patterns. Then just pop them into a vase with some bloom extender and they'll last for days. When you're done shooting them, give them to your sweetie and she (or he) will look much more kindly on all that time you spent taking those pictures of flowers.

TECH SPECS: LENS: 105mm f/2.8 / FOCAL LENGTH: 157mm* / EXPOSURE SETTING: 1/80 @ f/14
EXPOSURE MODE: Aperture Priority
WHITE BALANCE: Auto / FILE FORMAT: RAW / ISO: 200
*Focal lengths in this book are referred to in 35mm terms

Silhouette Shapes in Nature

Nature creates some pretty wild and interesting shapes, and if you can isolate and focus on those shapes in some clever way, they make great photos. Perhaps the most powerful way to reveal shape is to reduce subjects to a pure silhouette. By eliminating form, volume, texture and even color, silhouettes often reveal nuances and intricacies of shape that are overpowered by other visual elements and often go unseen at a casual glance.

Creating silhouettes is easy, all that it requires is contrasting your subject against a very bright background and then exposing for the background. Most of us think of creating silhouettes against a bright sky (a giant saguaro cactus against the sunset, for example), but it's just as easy to create a shape silhouette against any other bright background—a wall, the surface of a lake or, as in this shot, a field of bright grass on an Iowa farm.

When I first saw this vine growing along a barbed-wire fence, I tried to expose to show some color and detail in the vine, but the green color of the vine was getting lost in the color of the grass behind it. Also, because the background was so overwhelmingly bright, it was washing out badly. Any time that a situation like that pops up, an silhouette alarm bell should go off in your head: strong shape + bright background = great silhouette potential!

To capture the vine in silhouette I simply put the camera in the manual mode, metered the bright green grass behind it and set that exposure setting. I then recomposed the scene, focused carefully on the vine and shot. If you don't have a manual exposure mode, you can simply use your camera's exposure lock feature. On most digital cameras, just holding the shutter release halfway down will lock both exposure and focus--and some let you lock each of those things separately. It's far better if you can lock the exposure and not the focus since that lets you take a reading from the bright area, but still use your autofocus when you recompose the scene.

In most cases, by the way, it's a good idea, by the way, to use your aperture priority mode to select a wide aperture and keep depth of field to a minimum, otherwise you run the risk of details in the background conflicting with details in your main subject. With some subjects (again, a saguaro at sunset is a good example) this may not be an issue, but with other very detailed subjects like this vine, you want as plain a background as you can get.

TECH SPECS: LENS: 24-120mm
FOCAL LENGTH: 230mm
EXPOSURE SETTING: 1/100 @ f/7.1
EXPOSURE MODE: Aperture Priority
WHITE BALANCE: Cloudy / FILE FORMAT: JPEG / ISO: 200

Take a Walk on the Weird (and Goofy) Side

It's always amazing to me how creative (and silly) some people are in their everyday lives. Some folks just have a talent for turning everyday situations into something ridiculous and, as a photographer, stumbling across those little oddities is a lot of fun.

On the way home from one of my many weekend shooting trips to Rhode Island, I decided to wander along the coast of Narragansett Bay and revisit some old haunts. Narragansett Bay is one of the world's most beautiful ocean bays and it's dotted with tons of interesting small towns and unique vantage points. One of prettiest of these places is the tiny town of Wickford, with its small commercial and pleasure-boat harbor. If you're looking for pure New England with lots of nearby historical homes and fun shops, this is the place.

Beautiful as the harbor is, however, the thing that caught my eye on the commercial wharf was this character: a Halloween mask (I think it's Nixon hiding behind that grin) and foul-weather gear over a wood frame hawking fresh lobsters. Sure, the fisherman could have just hung up a sign that said, "Lobsters for Sale," but what fun would that be? I'm sure this great piece of folk humor helps him sell a lot of lobsters to the tourists (and probably the locals, too).

I love this kind of whimsical folk art and I'd photograph it everyday if I could find it. Finding weird little treasures like this is mostly just a matter of slowing down and paying attention to where you are. I was in such a hurry to see the view of the harbor from the end of the wharf that I drove right past this guy at first. Once I realized how cool he was with his very hip shades (not to mention his blue hand) and the late afternoon sun on his face, I spent about twenty minutes shooting him from every angle.

No matter where you travel, if you keep your eyes peeled, you're bound to see stuff just like this. Tourist towns seem to foster this kind of visual insanity—perhaps it's the locals' way for dealing with the crush of summer tourists.

When you do find something fun to photograph, don't be shy about shooting it. The artists who create this stuff are generally pretty outgoing folks and they love the recognition.

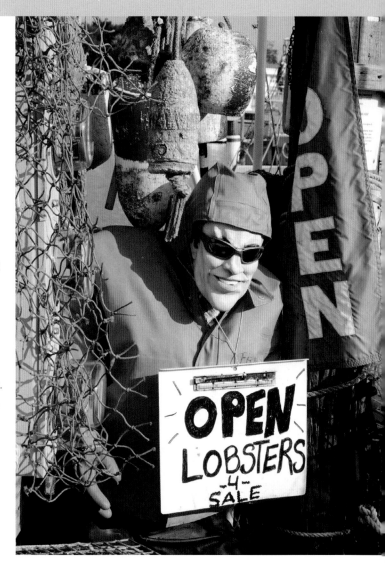

If you're looking for something fun and different to shoot on your next weekend drive, give yourself an assignment to find some inspired insanity—you'll have a great time looking for it, and you'll probably come home with some completely original pictures.

TECH SPECS: LENS: 24-120mm / FOCAL LENGTH: 72mm
EXPOSURE SETTING: 1/640 @ f/13
EXPOSURE MODE: Auto / WHITE BALANCE: Auto
FILE FORMAT: JPEG / ISO: 200

4

Visit an Indoor Aquarium

If you're like me and you live in the north and you happen to hate the cold weather (you're not one of those people that loves the cold, are you?), then winter is the time of year to take your camera on a visit to a nice, steamy indoor aquarium. I'm fortunate in that I live near the beautiful Mystic Aquarium, one of the best aquariums in the world. But lots of communities around the country have aquariums nearby and they're a great place to spend a day photographing interesting sea creatures.

The biggest problem that you'll run into in aquariums is, of course, the low light level. Flash is of little use in an aquarium because it's rarely allowed and, even if it were, you're almost always shooting through glass—which is pretty pointless with flash. Instead, you can usually get great results with a combination of a high ISO (ISO 800 or higher) and existing light. Fortunately, most aquariums do a great job with dramatic lighting and so while the lighting may be of very low intensity, it's usually designed to illuminate the subjects in an interesting way. I shot the image here at Mystic in an indoor tide pool by raising the ISO to 1600 and then resting the camera (gently) on the edge of the exhibit. I had to play around a bit to find an angle that let me pierce the surface glare of the water, but the exhibit was so nicely lit that once I found the right angle, the shot looked totally natural.

Try to visit aquariums on slow days and at slow times of day. Rainy weekend days are usually mob scenes, and the few weeks at the beginning and end of the school year are typically crowded with field trips. It pays to call the aquarium in advance and ask them when their slow times occur, and also if you can bring a tripod indoors. Most public aquariums

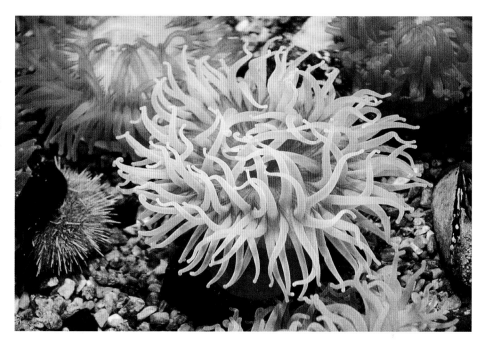

and zoos don't allow tripods, but you may find one that has early hours for photographers when they do allow tripods and monopods. The St. Augustine Alligator Farm in Florida, for example, has special "early entry" hours for photographers, for which they charge a very reasonable fee.

One last suggestion is to bring a pad and pen with you so that you can write down the species that you're photographing; that way you can caption your photos better if you post them to an online photo-sharing community. And be sure to contact the webmaster at the aquarium if you get some good shots—they'll probably be happy to post your photos (and they might even trade you for future admissions). Many aquariums have ongoing photo contests, too, so that's something to keep in mind.

TECH SPECS: LENS: 18-70mm / FOCAL LENGTH: 97mm
EXPOSURE SETTING: 1/25 @ f/4.5
EXPOSURE MODE: Program / WHITE BALANCE: Auto
FILE FORMAT: JPEG / ISO: 1600

Shoot the Moon

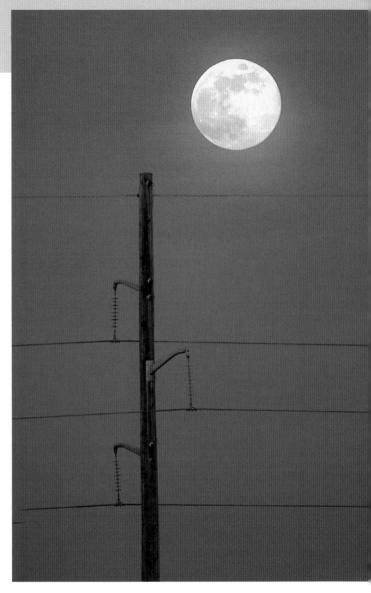

Photographing the moon always seems somewhat exotic to me because not only are you making a night (or at least a twilight) photograph, but you're also taking landscapes that aren't even on your planet! Taking pictures of the moon is also fun because you get another chance—weather permitting—almost every night. Although I prefer to shoot the moon when it's full, it's also great to capture one of those thin, silver crescents in the twilight sky.

Photographing the moon is very simple and can easily be done in your Automatic exposure mode. Interestingly enough, the correct exposure for a bright, full moon (excluding whatever landscape you have in the foreground) is the same as for a sunny day: about 1/250 at f/16 at ISO 200. And why not? After all, it's being illuminated by the sun, too. You may have to adjust your exposure a bit if you want some foreground detail, but as a starting point, I would just put the camera on Auto (or a night landscape mode) and check your first shots on the LCD. If they look too dark, add brightness by using exposure compensation.

Beware of very long exposures, however, because the moon is in constant orbit around the earth and the earth itself is spinning. Subject motion can be seen with shutter speeds in excess of about 1/30 second. Needless to say, a tripod is very handy for moon shots.

If you want the moon to appear very large in the frame, there are two things you can do (usually in combination). One is to use a long telephoto lens; I prefer to shoot the moon with a 300mm lens (which acts like a 450mm lens in 35mm terms on my D-SLR bodies). Next, you should also try to include a good ground reference. When you look at the full moon with the naked eye (especially when it's first rising in the twilight sky) it looks huge because of the horizon or some other ground reference. As the moon rises in the sky, however, the land reference is farther away and the moon appears smaller. That's why it's also good to consult a tide/moon chart so you can get to your location before a nice full moon starts to rise. That way you can find an interesting foreground (a lighthouse, for example) and get a number of exposures as the moon rises and before it gets so high in the sky that the size diminishes.

Sometimes a great moon will surprise you, too. I shot the full moon and power lines shown here in Port Aransas, Texas, after intently photographing a sunset. When I turned around to pack up my gear and saw this huge full moon, I was stunned by how beautiful it looked and quickly slapped my 400mm lens back on the camera body and started shooting. Remember, the sun sets in the west and the moon rises in the east, so next time you're photographing a sunset, turn around and look for the rising moon!

TECH SPECS: LENS: 400mm f/5.6 / FOCAL LENGTH: 600mm / EXPOSURE SETTING: 1/50 @ f/5.6 EXPOSURE MODE: Program / WHITE BALANCE: Cloudy FILE FORMAT: JPEG / ISO: 200

Bring Home Photo Souvenirs

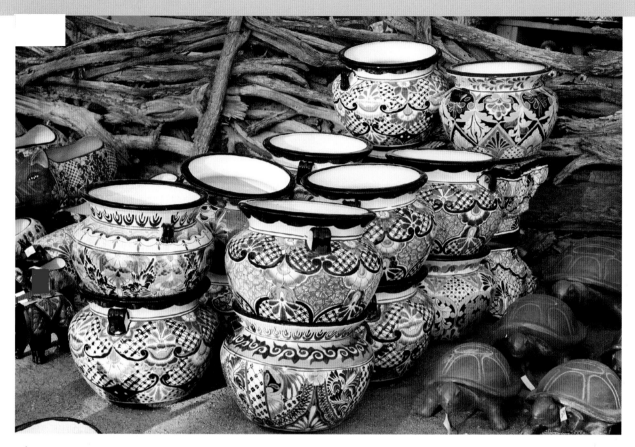

I love to travel. And when I travel, like most people, I love to bring home souvenirs. The trouble is that when you're traveling to take pictures, whether it's your job or your hobby, there's already enough gear to contend with without lugging home a lot of extra stuff. (That's what I tell myself when I'm trying to keep the credit card bills under control, anyway.) One solution I've come up with is to photograph things that I'd really like to buy but don't have the energy (or the money) to bring back home.

Photographing souvenirs on a trip is a great way to remember some of the neat things you found along the way—and best of all, it's free (and there's no chance they'll get broken on the way home). I photographed these pots in the very pretty little town of Tubac, Arizona, and fortunately for me, the shops were already closed for the day when I found this display or I would have broken my own no-buying rule. But with the shops closed and the usually harsh southwest-

ern sun getting warmer and more gentle late in the day, I had plenty of time to photograph the rows of pots in the outdoor displays. The pottery here is from Mexico, is all hand-painted, and was great fun to photograph. I ran out of sunlight before I ran out of energy and ideas.

Of course, if the shops are still open and I'm photographing something I really want and think I'll regret not buying, I usually grab a business card so I can order it later from home. But the real benefit of photographing interesting and colorful objects like these pots is that they add an interesting visual twist to your travel shots.

TECH SPECS: LENS: 18-70mm / FOCAL LENGTH: 78mm
EXPOSURE SETTING: 1/200 @ f/7.1
EXPOSURE MODE: Aperture Priority
WHITE BALANCE: Cloudy
FILE FORMAT: RAW / ISO: 400

Chill the Mood with Cool Colors

Blue Monday, blue moon, blue mood, I've got the blues—it seems that the color blue takes a lot of blame for people's less-than-sunny moods. I'm not so sure that blue is responsible for all the negative emotional connotations that it gets associated with, but it is true that any time the primary palette of your photos falls into the cooler range (blues, greens, purples), the emotional atmosphere is chilled out a bit.

Cool tones can also be a welcome visual relief on a sunny summer's day. Think about hiking up a steep hillside on a hot July afternoon and then refreshing yourself beside a cool, blue mountain stream and resting on damp, moss-covered rock. I took the photo here after a long, hot hike on the John Jay Homestead in Katonah, New York, and probably because I was tired and thirsty, I was immediately attracted to the unusual blue color of the barn. I found the coolness of the blue paint and the green lawn a refreshing and welcome relief and, of course, responded to those stimuli with my camera. Just looking at the scene in the viewfinder really did help cool me down a bit.

Film and television directors are masters of exploiting the secret power of color and mood, and they play with our emotions like puppet masters as they shift the palette from the fiery emotional moods of reds, yellows, and oranges to the somber blues, grays, and greens of twilight. Next time you're watching an action/adventure film, note how the color palette shifts from the hot tones of the action scenes (Bruce Willis igniting the elevator shaft in *Die Hard*) to the cooler palette of more solemn and ominous scenes (the boat in Jaws drifting in the cool twilight as the shark plots its destruction).

On the flipside, blue and other cool colors are also considered calming, which may be why so many people spend so much money to go to the Caribbean and stare at the blue sea for a week. The calming effect of blue is also the reason that interior decorators suggest painting your bedroom blue if you're looking for a peaceful retreat at the end of the day. (I guess if you're looking for passionate nights you should paint your room with hot colors.)

All colors have rich and complex psychological interpretations and if you're aware of them when you're choosing your palette or searching for subjects, you can use them to manipulate or intensify the mood of your photos. The more of a particular color range you use in a scene—and the more you eliminate other colors—the more dominant and obvious the mood becomes. Just don't be surprised if you come home with a card full of cool-toned subjects and someone asks why you're in such a blue mood!

TECH SPECS: LENS: 18-70mm
FOCAL LENGTH: 69mm
EXPOSURE SETTING: 1/125 @ f/4.5
EXPOSURE MODE: Program
WHITE BALANCE: Auto / FILE FORMAT: RAW / ISO: 640

Keep an Eye Peeled for Peeling Vintage Ads

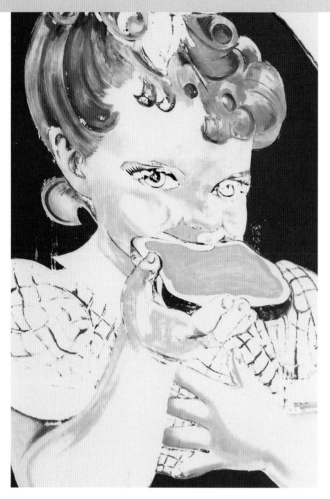

If you're approximately the same age as I am (in other words, you grew up watching Leave it to Beaver and The Andy Griffith Show), then you will probably immediately recognize the little girl seen here as Little Miss Sunbeam. Her happy face was a huge part of my childhood and was used to promote Sunbeam bread on signs, in magazine and newspaper ads, on TV and, of course, on the bread itself.

Maybe it's just nostalgia for a more innocent time, or the fact that I've been seeing this face for most of my life, but it seems to me that you just don't see art like this in advertising anymore. Or maybe it's just that we see so many images and so much advertising these days that there are fewer and fewer genuinely iconic images—all advertising has congealed into one long visual blur, an endless stream of light and color trying to snatch our attention from one instant to the next.

Signs like this are a joy to discover and they pop up at the most unexpected moments. I found this peeling and apparently forgotten sign in front of a bakery thrift store on Route 1 in Rhode Island. I was half tempted to only take a snapshot from the car window, but guilt overcame me (as it usually does) and I got out the tripod, chose the best lens, and did the sign justice. (I've come to learn that I suffer a lot less regret later if give every subject the time and energy it deserves.) I spent about twenty minutes shooting a few dozen frames of the sign and playing with different crops and angles.

The real fun of finding signs like this comes in tracking down some of their history—which is exactly what I did. Realizing that there must have been a real girl who posed for the painting, I did some research and discovered that there were actually several "Sunbeam Girls," but the one that I think is pictured in this sign (and the one who was probably the most famous) was Patty Michaels. Patty was selected as the Sunbeam Girl at age five in 1955 and went on to have a very successful career as a model, actress and singer.

The artist behind the portraits, an illustrator named Ellen Segner was also a pretty fascinating character and was one of the few women to become famous as a glamour and pin-up artist. She was also the illustrator for the famous "Dick and Jane" children's books. Her Little Miss Sunbeam portraits have been in constant use for more than 60 years.

You just never know how much of a story there is behind old advertising signs, but it's definitely worth the time and effort to photograph them and do some research. For me, finding that Little Miss Sunbeam sign was a nice glimpse back into my childhood and also led me to a fun few hours of research.

TECH SPECS: LENS: 70-300mm
FOCAL LENGTH: 360mm
EXPOSURE SETTING: 1/640 @ f/8
EXPOSURE MODE: Aperture Priority
WHITE BALANCE: Cloudy / FILE FORMAT: RAW
ISO: 200

Tino Wallenda: Life Lessons from the High Wire

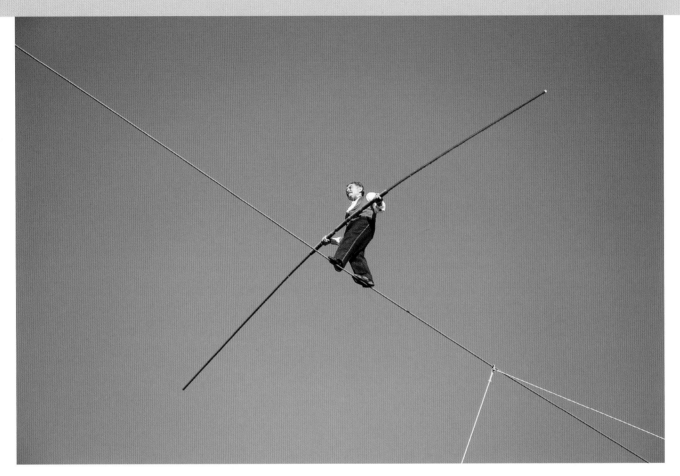

The more involved you become in pursuing your photographic passion, the more you will encounter photo opportunities that will affect your life beyond just getting good pictures. For me, one of those opportunities was photographing the great high-wire performer Tino Wallenda and his family of famous circus performers. During the assignment, I had the chance to talk with Tino a few times and found him to be as kind and charming as he is talented and brave.

As I photographed Tino walking high above the crowds, balanced on a thin wire strung between two cranes, I couldn't help but draw some philosophical and artistic lessons from his performance. For one, I was amazed by how relaxed Tino was before, during, and obviously after each performance. To have such courage and to perform with such ease is a life lesson in itself: relax and enjoy what you're doing at every moment, especially during the times when you are living

TECH SPECS: LENS: 18-70mm / FOCAL LENGTH: 105mm
EXPOSURE SETTING: 1/400 @ f/5, (+ 0.33EV)
EXPOSURE MODE: Shutter Priority
WHITE BALANCE: Cloudy / FILE FORMAT: RAW / ISO: 200

closer to the edge. When you relax, you not only perform better, but you enjoy things more (a lesson most golfers, for example, know very well).

And that made me think of lesson number two: embrace your passion. Whether your passion is to confront your own fate on a wire above a circus audience or just sitting on a beach photographing the sunset, it's important to realize that being involved in that passion—and thereby fully living in that moment—is a high point of your life (artistically and spiritually) and it's worth acknowledging the greatness of that activity. After a tragic accident in which two members of the troupe

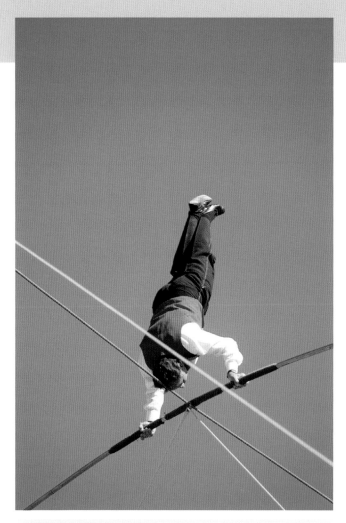

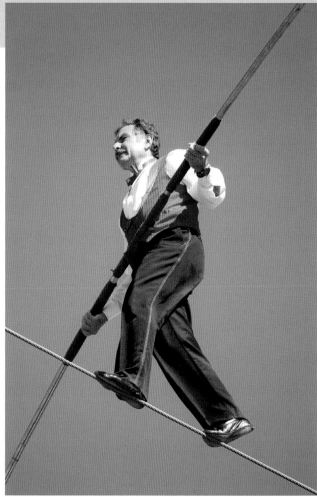

TECH SPECS: LENS: 70-300mm / FOCAL LENGTH: 300mm
EXPOSURE SETTING: 1/800 @ f/4.8
EXPOSURE MODE: Shutter Priority
WHITE BALANCE: Cloudy / FILE FORMAT: RAW / ISO: 200

TECH SPECS: LENS: 70-300mm / FOCAL LENGTH: 405mm
EXPOSURE SETTING: 1/320 @ f/5.6
EXPOSURE MODE: Shutter Priority
WHITE BALANCE: Cloudy / FILE FORMAT: RAW / ISO: 200

were killed, Tino's grandfather, the great Karl Wallenda, insisted on performing the very next night. He is quoted as saying, "Life is being on the wire; everything else is just waiting." Indeed.

Therein lies perhaps the ultimate Wallenda lesson: spend as much of your life living your passion as you can because if you have a true calling, if you hear a true voice, everything else is just waiting. The idea that life is not about clinging to safety (or standing "safely" on the ground) but rather to pushing yourself to the edge of your own destiny is one that has always fascinated me. To bring this back (ever so slightly) to photography, I once interviewed the great travel photographer Harvey Lloyd (who often hangs out of helicopters to

photograph cruise ships—just looking at his photos gives me vertigo), who told me that his credo is: "If your life bores you, risk it." Do you see a theme here?

I don't think that Tino Wallenda finds anything in life boring, or thinks about risks other than how to minimize them, but I gathered in watching his grin of pure joy as he walked the high wire that, for him, the "everything else" in life is not just waiting, but eager anticipation of the glorious moments he shares with us from the wire.

Become a Landscape Minimalist

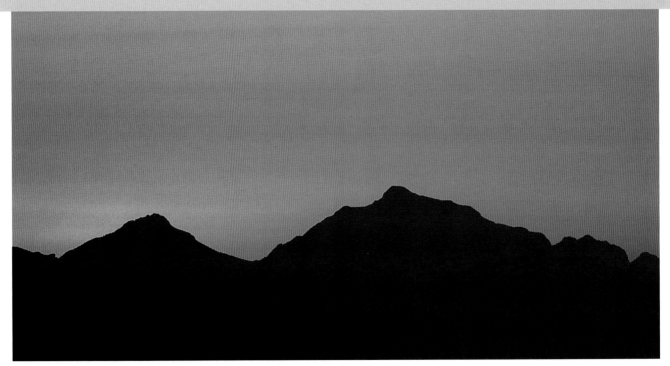

Landscape photos, by their very nature, often require including somewhat complex visual elements. If you're photographing an interesting pattern of ripples in a sandbar at the edge of the sea, for instance, and also want to include the surf, a few palm trees, and some interesting clouds, you've got to find a way to organize those elements to strike a good and non-competitive visual balance. But sometimes the best way to organize them is to simply reduce, drastically, the number of visual elements.

Over the years I've tried to play a little mental game when I'm composing a landscape by challenging myself to reduce the number of graphic elements necessary to tell the story. For example, I've shot lots of sunsets over the desert in Arizona, and they usually include a lot of elements: saguaro cactus, the sun, rock cliffs, a path, and more. The day I shot this photo, however, I was struck by how much I could distill the elements and still capture the scene before me. Did I need any shapes other than the mountain ridge? (I tried several times to include Saguaro cacti on an adjacent ridge, but they seemed lost in the boldness of the mountain's shape.) Did I need any colors other than that beautiful orange sky? Wouldn't I dilute the sky's color if I tried to include color in the foreground?

After experimenting with a lot of compositions—and getting frustrated by trying to include too much—I ended up using just two bold ingredients: the black silhouette of the mountain and the colorful sky. What else did I need? This is exactly what sunset feels like to me in Arizona, so why clutter it up? In this case, one of the things that helped me to isolate and simplify the shot was using a very long zoom lens on my D-SLR: a 70-300mm (105-450mm in 35mm terms). Being able to "reach out" and crop distant scenes is a huge help in capturing landscapes like this.

You may not always be able to reduce a landscape to two elements, but the more you whittle down and refine the primary ingredients, the more powerful each of them becomes. By doing that with this scene, I established a fierce contrast of earth and sky and created what, for me at least, is an iconic view of the Arizona desert.

TECH SPECS: LENS: 70-300mm
FOCAL LENGTH: 375mm
EXPOSURE SETTING: 1/60 @ f/10
EXPOSURE MODE: Aperture Priority
WHITE BALANCE: Auto / FILE FORMAT: RAW / ISO: 200

Listen to the Sound of Pictures Calling You

Most of the time when you're out looking for photos, it's an entirely visual process. You see something pretty or curious or dramatic and you decide to explore it further. Photography is, after all, a visual art. Occasionally though it's another of our senses that draws us to a potential photograph. And in this case, for example, it was sound that led me to this stream—the sound of water splashing over rocks.

Believe it or not, I shot this photo just a short distance from the local sewage treatment plant. No, I hadn't gone to the plant looking for photos (trust me), but that is where I discovered this pretty stream. I was out testing a new camera and had driven down to a small park on the shore of the Housatonic River just a few miles from my home. I was hoping I might find some interesting ducks on the river, or perhaps some of the local oystermen at work, but it turned out that the river that day was pretty boring and there wasn't a duck or a boat in sight.

While I was sitting in my car trying to decide where else I might head to look for some photo opportunities, I became aware of the faint and unexpected sound of a gurgling stream—and it wasn't coming from the direction of the river. I've been to this park hundreds of times and I know the setting pretty well, so I was a bit puzzled. But (being the lazy soul that I am) I drove my van over to a stand of tall Phragmites (which are a type of reed) in the direction of the sound and much to my surprise, as I got out of the car and pulled some of the reeds aside, I found this pretty stream just bubbling merrily along behind the tall grasses.

It wasn't the most beautiful stream I'd ever seen (and I was trying to ignore the idea that it might be coming directly from the sewage treatment plant), but the light was fading

fast and I wanted desperately to take some photos. So, once I got past the idea that I might be photographing a sewage stream, I hauled out the tripod and started shooting. Before it got dark I was able to pop off a few dozen different exposures, hoping to get a nice flow of water over the rocks.

Next time you're out looking for photos and you don't see anything obvious, pay attention to the rest of your senses; they may be doing some scouting of their own. Who knows, you may smell a fragrant patch of wildflowers hidden just a few steps from a wooded path or hear ducks squawking on a nearby pond. I'm just grateful it was my sense of hearing and not smell that led me to this shot!

TECH SPECS: LENS: 70-300mm
FOCAL LENGTH: 247mm
EXPOSURE SETTING: 1/15 @ f/10
EXPOSURE MODE: Shutter Priority
WHITE BALANCE: Auto / FILE FORMAT: RAW / ISO: 200

Time Sunsets Carefully

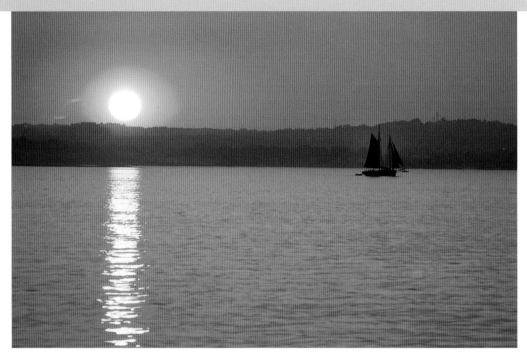

When it comes to creating a really great sunset photo, timing is everything. While sunsets are always pretty to watch and photograph, paying close attention to the exact placement of the sun itself will often turn a good photograph into an exceptional one. I always scout sunset photos long before the sun actually begins to go down, and then I typically begin to shoot preliminary shots as color begins to fill the sky. Inevitably though, the best shots happen just a few seconds before the sun hits the horizon.

The reason these photos are more powerful is because there is an added element of visual tension when you capture that instant just before the sun disappears. Not surprisingly, artists and photographers refer to the point where the sun is actually touching the horizon (or is about to touch it) as a "point of tension." The gap between the bow of the boat and the edge of the frame is a larger and somewhat subtler point of tension. The eye tends to gravitate to these tension points because your brain realizes something in that spot is about to change. Interesting.

If you've spent any time photographing sunsets, you've no doubt also noticed an interesting (and at times frustrating) visual phenomenon where the closer the sun gets to the horizon, the faster it appears to be setting. When it's a few degrees higher in the sky, it seems that the sun is taking its sweet time setting—perhaps getting one last look at the landscape before it slips away. But once it gets closer to the horizon it slips past much more quickly; you can easily imagine why a lot of primitive cultures thought it was falling right off the edge of the earth.

In many sunset situations there may be other moving objects that have to be contended with and timed as well. In this shot, I wanted the sun at the horizon and, of course, also wanted to catch the boat in the frame. As it was sailing past, I kept hoping the boat would slow down because it was moving pretty quickly and the sun wasn't yet in the perfect position. I'm sure the other people on the beach thought I was nuts as I stood behind my tripod shouting, "Slow down, slow down!"

Fortunately, I got off this one frame with both sun and boat very close to where I wanted them. If that boat had been moving a tiny bit faster, it would have left the frame too soon. You can't control the motion of the sun (or someone else's boat), but just being aware that timing and motion (and planning ahead) are important elements in your sunsets is very helpful.

TECH SPECS: LENS: 70-300mm
FOCAL LENGTH: 195mm
EXPOSURE SETTING: 1/500 @ f/5
EXPOSURE MODE: Program / WHITE BALANCE: Cloudy
FILE FORMAT: JPEG / ISO: 200

Lay Down, Look Up (The Beauty of Articulated LCD Panels)

When I first got into digital photography I bought an Olympus C5050 camera that I still own and dearly love. It's a great five-megapixel camera and it has a very fast (f/1.8) and supremely sharp lens. One of the things I like most about the camera is that the LCD is partially articulated—in other words, you can pull it away from the back of the camera body and angle it up. One of the many fun things that this makes possible is laying the camera on the ground to shoot up at low-lying subjects.

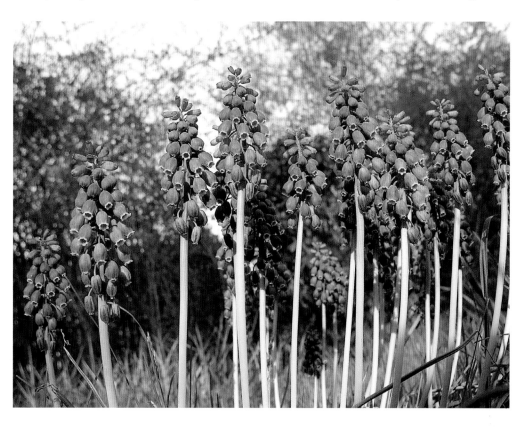

The first summer I had that camera I crawled around on my lawn and in my gardens looking for things I could shoot up at from ground level. The neighbors must have thought I was photographing worms—but who cares? I got a lot of great photos that summer. Some of my favorite subjects for shooting like this are the thousands of grape hyacinths that grow in my yard. By laying the camera bottom on the ground and aiming it up slightly, I was able to shoot these tiny flowers (which are about four inches (10.2 cm) tall) as if they were towering trees.

The articulated LCD isn't necessary to get shots like this, of course, but it sure does make it easier to compose them. I have since bought a Canon camera that has a fully articulated LCD (you can even turn it backwards so you can shoot photos of yourself—something I find my girlfriend doing in front of places like the Eiffel Tower) and I still enjoy and use that feature. If you're thinking of buying a new camera, consider getting one with an articulated LCD, especially if you're deciding between one camera that has it and one that doesn't. The ability to pull, twist, and turn the LCD really has some other nice benefits, too—like being able to hold the camera over your head in a crowd and still see what you're shooting.

But regardless of the camera, next time you're shooting flowers, mushrooms, or other low-lying subjects, try laying the camera on the ground and shooting up. And if the neighbors ask what you're photographing so close to the ground, just tell them you found an interesting snake and they'll probably leave you alone.

TECH SPECS: LENS: Built-in zoom
FOCAL LENGTH: 35mm
EXPOSURE SETTING: 1/200 @ f/4
EXPOSURE MODE: Auto / WHITE BALANCE: Auto
FILE FORMAT: TIFF / ISO: 64

Pump Up the Volume with Bold, Brash Colors

On a recent summer day I was driving through one of the local beach parks, just cruising around hoping to see something that would entice me to take some pictures (or "cruising for snaps," as I like to call it). I was shocked and delighted to see that the old concrete bunker of a snack bar had recently been painted a wild Caribbean blue. Wow! What a color. We're not talking a pretty seaside blue or a gentle sky blue, but a downright radiant spin-your-head-around blue.

This color was just screaming to be photographed and I was determined to find some detail or composition that really let it be the star of the shot. Then I saw this drinking fountain: perfect. Nice, shiny, and polished, and bold enough to stand up to the wall of blue. I shot about 50 different compositions, just tweaking the placement and playing with different ideas. Talk about fun! I shot the photo with my D-SLR and an 18-70mm zoom, but it could have easily been shot with any point-and-shoot camera. It was a simple, direct shot.

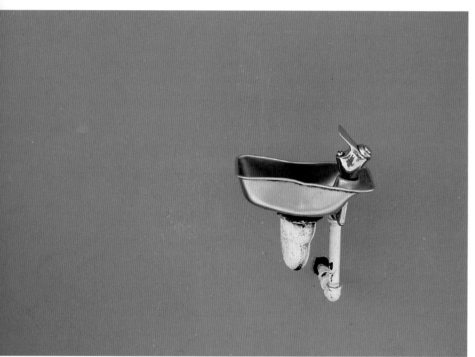

I shot a lot of different views and details of the building and will probably return to shoot more—it was that much fun. So far though the drinking fountain shots are my favorites. One of the things that I liked most about finding such a wild and strong color was that it reminded me of some photos by Pete Turner, who is my hero in color photography. Pete is the master of brash, wild colors and one of his photos of a yellow and red plastic garbage can (also shot on a beach) has stayed in my head since I first saw it decades ago. Some photos affect you that strongly and plant themselves in your imagination.

Keep your eye and your imagination open for bold, wild colors, because you never know where you'll find them. Pete Turner found a classic shot in a garbage can at the beach and I found this eye-grabbing shot at my local beach. The shots are there, just keep looking—and when you find them, isolate the color as much as possible (or contrast it against a second color) to turn the volume even higher.

I knew I wanted to photograph the building, but really wasn't sure what I wanted to say with the pictures. Should I shoot the entire building? I tried that and the shots were colorful, that's for sure, but I wanted something slightly more abstract. I tried shooting one corner of the building with the beach in the background, but it looked too local. I really wanted to find a shot that could have been made in Jamaica or perhaps Bermuda. I was kind of lazy at first and really hadn't committed to any particular shot, but the closer I got to the building and the more I began to study the details, the more intrigued I got.

TECH SPECS: LENS: 18-70mm
FOCAL LENGTH: 78mm
EXPOSURE SETTING: 1/100 @ f/10
EXPOSURE MODE: Aperture Priority
WHITE BALANCE: Auto / **FILE FORMAT:** RAW / **ISO:** 200

Weather & Photography: Abandon Your Preconceptions

Preconceptions in photography can be dangerous things creatively. They can make you so focused on looking for the images that you see in your mind's eye that you ignore even better possibilities that are right in front of you and, even worse, they can cause you to get discouraged if you're not finding the types of images you wanted to find.

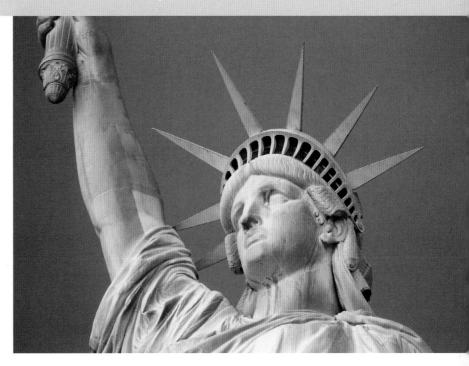

Preconceptions are especially problematic when it comes to weather because you simply can't predict (or change) it. But you can work with it. Lady Liberty is something I've always wanted to spend a day or two photographing and to do so I had to make some relatively elaborate (and expensive) arrangements to make the weekend happen—car rental, hotel, ferry tickets, etc. The one thing I hoped for was a nice, crisp blue sky on the days I'd be shooting (which is why I went for several days and not just one—I figured I might get lucky and hit one great day). I'd done a lot of picture research leading up to the weekend and I knew exactly what I wanted: Liberty's green copper face against a rich blue August sky.

Naturally, as the weekend drew closer the weather reports were anything but encouraging (this is a perpetual pattern in my life) and, in fact, the weather people were calling for possibly the worst of all weather options: rain, thunderstorms, and heavy cloud cover. Yuck. No blue skies were forecast. Surprisingly though, when I got out to Liberty Island, the weather dudes were wrong once again—the sky was perfectly blue with occasional puffy clouds giving relief from the intense sunshine.

As I was shooting, I realized that the statue didn't look as great against a blue sky as I had thought it would; the sunshine was creating really contrasty and unattractive shadows on her face. But by mid afternoon, clouds started gathering and I lost the blue sky. Then it became very apparent that a big storm was headed our way and the skies darkened and thunder and lightning began to scatter the crowds.

Suddenly, with the sky getting darker and darker, Liberty's face began to take on a strange luminescent glow. Her face seemed to posses a far more soulful expression with the sunlight gone. It became clear to me that the beautiful sunny day shot I had envisioned wasn't the only great image—and perhaps not even the best one. With rain and hail starting to pelt me, I kept shooting until the sky behind her crown was nearly black. These were the far more dramatic shots that I had been looking for. Finally, the skies opened up and I had to pull on a poncho and stop shooting, but I'd managed to get several shots that I liked a great deal, and none of the best shots had blue sky.

Don't let bad weather stop your shooting and don't let your preconceptions of good weather and good lighting close your imagination to even better opportunities. You can't control the weather, but you can alter your creative vision to match it.

TECH SPECS: LENS: 70-300mm / FOCAL LENGTH: 270mm
EXPOSURE SETTING: 1/200 @ f/45
EXPOSURE MODE: Program / WHITE BALANCE: Auto
File format: RAW / ISO: 400

Working a Subject

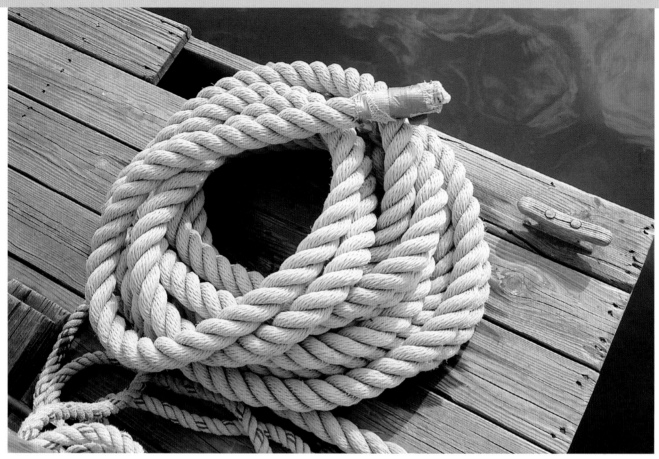

Finding a potentially interesting photograph is a pretty exciting moment for most photographers since it's the reason that we own cameras and spend our free time picture hunting. Once you've found a subject with promise, however, it's important that you push past the first flush of attraction and take time to "work" the subject a bit. Refining the shot and looking more closely at what attracted you to the subject in the first place really helps to simplify and strengthen compositions.

Often what attracts you to a scene is a clash of color, a particularly interesting bit of lighting, or perhaps just a interesting shape or texture. In the case of this bright yellow rope that I found on a dock in Camden, Maine, it was pretty much all of those things: the yellow rope, the bright but soft late-afternoon lighting, as well as the shape and texture of the coiled nylon rope. The first few shots I took (left photo)

were somewhat predictable: I included the entire coil of rope, as well as some of the dock and the water. I actually left the dock after shooting those first few photos and returned a few minutes later, nagged by that voice in my head that tells me when I haven't looked hard enough yet.

When I returned to the rope, I began refining the composition by finding a more directly overhead view (which meant leaning out somewhat precariously over the dock from the gangplank I was standing on) and by zooming in more tightly with my 18-70mm zoom. By extending the zoom almost all

TECH SPECS: LENS: 18-70mm / **FOCAL LENGTH:** 27mm
EXPOSURE SETTING: 1/400 @ f/9
EXPOSURE MODE: Aperture Priority
WHITE BALANCE: Cloudy / **FILE FORMAT:** JPEG
ISO: 200

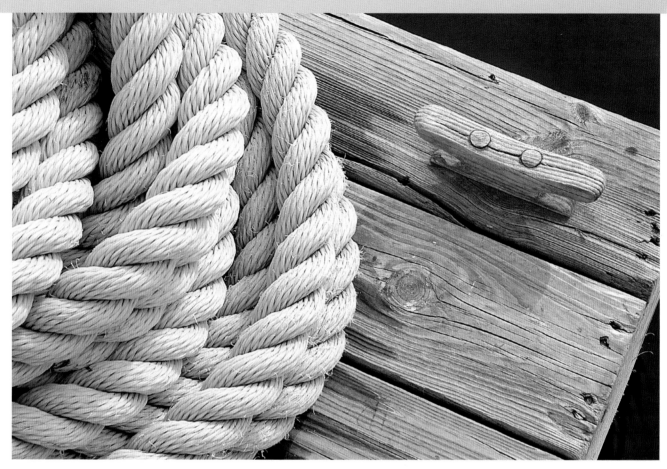

the way, I was able to crop out all of the excess baggage from the left side and lower parts of the frame. Finally, I played with the angle of the dock in the viewfinder until it created that nice diagonal line. I still like the first photo a bit, but I feel the second image is much more graphic and dynamic.

Normally, I would shoot this type of scene with a tripod, but because I was hanging out in space on the gangplank, I wasn't able to use one. Fortunately, there was enough light to shoot at 1/250 second while still using a relatively small aperture (f/11) to get the depth of field I wanted. By the way, if you look carefully, you'll notice that the shadow of the cleat (upper right) has become substantially longer and more

gentle in the second shot—an indicator of how long I spent trying to find the best shot.

Take time to work the subject and you'll give yourself a lot more options in editing and printing, and as I say so often: it's free to shoot, so what the heck.

TECH SPECS: LENS: 18-70mm / FOCAL LENGTH: 93mm
EXPOSURE SETTING: 1/250 @ f/11
EXPOSURE MODE: Aperture Priority
WHITE BALANCE: Cloudy / FILE FORMAT: JPEG
ISO: 200

Plump Up Your Pumpkins with Side Lighting

I was going to call this tip "Steal Someone Else's Pumpkins" because that is pretty much what I did to get this shot. While visiting a pick-your-own pumpkin farm in Connecticut, I was too busy photographing pumpkins and the people picking them to pick any of my own. As I was wandering around shooting, I kept seeing people pulling wagonloads full of bright orange pumpkins, making me wish I'd had time to do some picking of my own. A wagon full of pumpkins would make a nice shot, I thought.

Then, as if fate heard my wishes, at the end of the day, as late-afternoon sun was glancing the top of the hill, a woman parked her wagon right in front of me in a beautiful pool of warm sunlight. While she stepped away for a moment, I "borrowed" her wagon and photographed it. I wanted to tell her what a nice job she'd done arranging them upon her return, but she had an armload of kids in tow and off she and her wagon went, oblivious to my artistic larceny.

The thing that I like about this shot (other than the very nice arrangement that my anonymous accomplice created) is that the side-lighting coming from the late rays of sun is giving the pumpkins a nice and plump round feeling of volume and weight. Volume is an important visual element, particularly in still life photographs, because in addition to creating a three-dimensional reality, it also helps the brain imagine the size and bulk of objects.

The key to revealing volume is using oblique lighting (from the side or the rear, usually) to enhance the three-dimensional appearance. If you want to experiment with this concept, just take an apple and a desk lamp and first only light the apple flatly from the front. While the color and even the shape of the apple will be realistic looking, you won't get any sense of its fullness. If you move the desk lamp to the extreme side and shoot another frame, you'll see that the

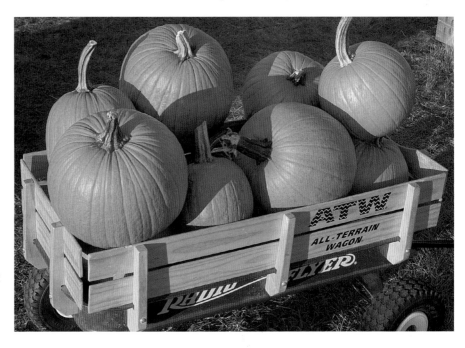

shadow side is helping to define the roundness and girth of the apple. Voila! Instant volume.

You can use this concept to help create volume and dimensionality in much larger objects like trees and houses, or even mountains in a landscape. By waiting until the light is illuminating your subject from the side (or from the rear if you have a high enough shooting angle to see both the highlight and shadow sides of the object), you heighten the reality of the scene. Sidelight also enhances texture—in this shot, you can almost feel the rippled surface of the pumpkins—and texture also helps to enhance the sense of volume.

All of this goes to show that you just never know when stealing someone else's pumpkins will help you learn a valuable lesson in vision. If only my friends and I had thought of that excuse when we got caught stealing pumpkins when we were kids! "I did it for art's sake, dad!"

TECH SPECS: LENS: 18-70mm / FOCAL LENGTH: 60mm
EXPOSURE SETTING: 1/100 @ f/9
EXPOSURE MODE: Program / WHITE BALANCE: Auto
FILE FORMAT: RAW / ISO: 200

Look Back Through Tourism Time

As a somewhat sad side note, I recently heard that the famous (and oh-so-beautifully tacky!) Cypress Gardens has, at long last, been sold and is now a more modern amusement park. Cypress Gardens was the quintessential Old Florida amusement park and was filled with Southern Belles in full dress wandering the grounds, water ski shows performed to Elvis songs, and beautiful footpaths decorated with thousands of twinkling lights at dusk. It's gone now and I'm so glad that I went out of my way to visit it while it was still there.

Of all the places I travel, Florida is one of my favorites. Any place that has lots of beaches and sunshine and has oranges growing in almost every yard is a great place to me. As beautiful as the natural places of Florida are, however, one of the things that I like to do most when I am traveling there is to haunt the back roads looking for signs of "Old Florida."

Florida has a rich and curious past of peculiar tourism destinations. Back in the 40s and 50s, when Florida was first being discovered by the rest of the country, it led the world with wild, outlandish (some might say garish), and curious roadside signs and attractions. After all, if you were going to lure tourists down to see alligator wrestling on your gator farm, you might as well stick a giant alligator on your front lawn and make your entrance from a 30-foot (9 m) high gator jaw. And if you were going to sell them oranges, why not sell them from an orange-shaped roadside stand? I found this abandoned fruit stand near Ocala and I was so excited to see it that I couldn't believe there weren't other photographers lined up to shoot it. (I obviously have a different set of values when it comes to great Florida attractions.)

While Florida is probably unique in its volume of bizarre tourist icons, almost every community in this country has some interesting reminders of a more innocent time. Search them out online (websites like flickr.com are great for finding the oddities of the tourism world) and then go hunt them down with your camera. These fascinating glimpses into our quirky past are disappearing fast, and once they're gone, they're gone. We'll likely not see a rebirth of giant alligator heads in Florida any time soon—and isn't that a shame?

TECH SPECS: LENS: 10-20mm
FOCAL LENGTH: 22mm
EXPOSURE MODE: Aperture Priority
WHITE BALANCE: Cloudy
FILE FORMAT: JPEG / ISO: 200

Isolate Color Contrasts

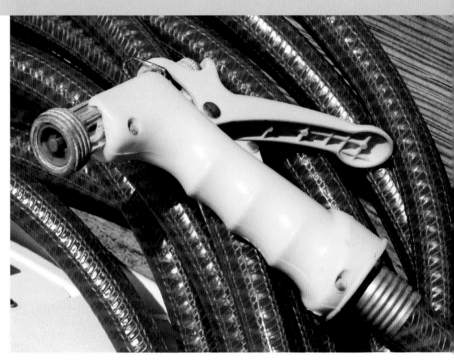

Bright, contrasting colors are very effective at getting people's attention in a photograph because the eye is naturally curious about the interaction of colors. Nature is full of color contrasts and all you have to do is flip through a flower seed catalog to see some of the wild combinations that exist. But you can also find a lot of strong contrasting colors in manmade objects. I spotted this yellow and blue color contrast on a dock on Cape Cod. I thought the hose and the sprayer were such an interesting combination that I spent about 20 minutes shooting various compositions.

The key to capturing strong color contrasts is to isolate them from their surroundings: crop away anything that isn't a part of the contrasting colors. If I had included more of the wooden dock, for example, it would have diluted the color impact and added nothing. Zoom lenses are great for this type of subject because they let you experiment with various compositions without having to change your shooting position.

You'll know when the impact is strongest because you'll see it right on the LCD. But here's a trick: when the LCD pops with color contrast, zoom in just a tiny bit further and shoot another frame. The reason that this last bit of composition tightening is important is because when you are concentrating intently on a subject, your brain focuses on what you want to be photographing rather than what you might actually be shooting. You sometimes have to force your brain to do a reality check (photographically speaking) by forcing yourself to push past what you think is a tight composition and create an even tighter arrangement.

It really doesn't matter if the subject is "real" (like this one) or more abstract—like drips of paint on a Caribbean wall—the interaction of the colors will carry the photo if you compose it tightly enough. If you zoom in too tightly and the subject starts to become abstract, don't be alarmed. Some of the best abstract photos start out as a "realistic" compositions that, when pushed to extremes, become an even stronger abstract.

Finding color contrasts is a good self-assignment, so if you're bored some Saturday afternoon, take a walk around and see what you can find. And if you can't find a good subject, create one—lay out some bright neon crayons on a black sheet of poster board or shoot some bright pieces of glassware (I collect Fiestaware just for this purpose) and create a bold and colorful still life.

Should you turn up the volume on your color contrast with the Hue/Saturation slider during editing? Sure, use it sparingly if it works; sometimes just a slight tweak brings out contrast nicely. But don't overuse the saturation or people will think you created the image in the computer—and there are plenty of great color contrasts waiting to be discovered in the real world.

TECH SPECS: LENS: 18-70mm / FOCAL LENGTH: 46mm
EXPOSURE SETTING: 1/2000 @ f/6.3
EXPOSURE MODE: Manual / WHITE BALANCE: Cloudy
FILE FORMAT: JPEG / ISO: 200

Don't Be Afraid to Use Flash on Flowers

Gardening and photography have been hobbies of mine since I was a kid and they go together nicely: I get to photograph the flowers in my garden all summer long and I have an excuse for spending a lot of money on new flowers. To be honest though, I probably spend more time photographing my gardens than weeding them; after all, cropping out weeds with a zoom lens is so much easier than plucking them. (On the other hand, as long as I water the garden it will continue to produce new flowers all by itself—I wish photography was that simple!)

Most of my garden photography is done very late in the day for two reasons: because I'm not a morning person, and the light is so soft and warm. The problem with shooting late in the day is that the light disappears very fast, so sooner rather than later, you run out of good light. It seems that the moment that I find a good composition and the breeze dies down long enough for me to get a sharp picture, the light has slipped away. In these last moments of daylight, the light is frequently so dim that I have to shoot with the aperture wide open and often at very slow shutter speeds. And even with a tripod, I still have to worry about the breeze keeping the flowers from looking their sharpest.

While I much prefer natural light to flash, often the only solution for me is to turn on the built-in flash. The flash fires at such a brief duration that it's like using a much faster shutter speed; it freezes the motion of the plant and, on the rare

occasion that I am shooting handheld, usually eliminates any camera shake. In addition, by setting the exposure using your Aperture Priority mode, you can use a smaller f/stop to get a bit more depth of field (and with flowers close-ups you need all the depth of field you can get). Most digital cameras are very good at balancing flash in daylight and often you'll get surprisingly natural-looking results.

If the flash does begin to overpower the natural light (and it will sometimes), read your manual to see if your camera allows you to use negative compensation for the flash. By reducing the flash output by a half to a full stop (and we're talking only about manipulating flash output using flash compensation here, not overall exposure compensation), you get the benefits of flash photography without the shots looking like they were lit by flash.

Next time that you're out in the garden or in a park and the light starts to fade, try popping on the flash and keep shooting a while longer. I think you'll find the results are surprisingly nice.

TECH SPECS: LENS: 105mm / FOCAL LENGTH: 150mm
EXPOSURE SETTING: 1/200 @ f/3.2
EXPOSURE MODE: Program, with built-in flash
WHITE BALANCE: Sunny / FILE FORMAT: JPEG
ISO: 200

Pack a Pocket Compass When Traveling

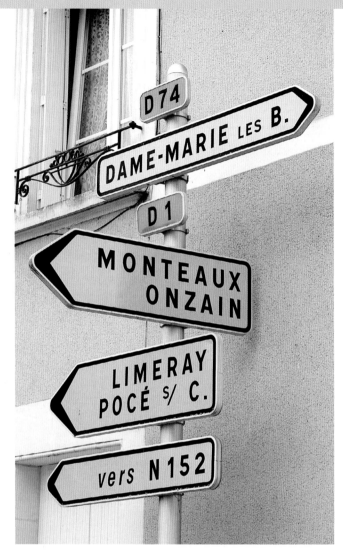

With the advent of GPS systems in cars and those cool compass apps that are found in some (expensive) cell phones, you wouldn't think there would be much need for a handheld compass when you're traveling. The problem is that you don't (hopefully) take all of your photos from inside your car and cell phone batteries go dead at the most inopportune times (like when you're already lost). Or what if you lose the signal? So the minute you step away from your car or your phone goes dead, you're essentially up a creek without a direction.

Enter the Boy Scout's handy companion: the pocket compass. The primary use of a compass, of course, is to know which direction the rest of the world is situated relative to your position—and using a compass for this basic concept is extremely simple. Since the needle on a compass always points north, if you turn yourself until the needle is overlaying the "N" (or turn the dial on an adjustable face compass) then you'll know where north is and then south, east, and west will all be very obvious to you.

This is pretty important information if, for example, you are leaving Paris on your bicycle and want to peddle toward the Loire Valley, which is (roughly speaking) south of the city. It's even more important if you decide to explore scenic back roads (which is, after all, why you came to France, isn't it?). Without a compass, you would be left to follow the sun or trust the directions of French signs which, as you can see from the shot here, can set your head spinning.

But an even more crucial reason for photographers to have a compass handy is to keep track of where the sun rises and sets. This may be pretty obvious at home or during sunrise or sunset, but in a strange city at midday with the sun overhead, you won't have a clue. If you want to photograph a harbor at sunset, for example, it would be nice if you could scout locations during the day knowing approximately where the sun will set.

There are many more fun and practical uses for a compass and if you do any wilderness hiking or camping, you should absolutely know how to use one and always keep it (and a local map) in your bag. As a side note, I'm shocked by how many maps there are online that have no compass rose—the indicators of direction that should be on all maps. Be sure that if you print out a map from an online source that you choose one that has compass directions included. Assuming that the top of the map is north is an assumption that could have you looking for polar bears in Louisiana.

TECH SPECS: LENS: 18-70mm / FOCAL LENGTH: 62mm
EXPOSURE SETTING: 1/200 @ f7.1 (+0.33EV)
EXPOSURE MODE: Program / WHITE BALANCE: Cloudy
FILE FORMAT: JPEG / ISO: 200

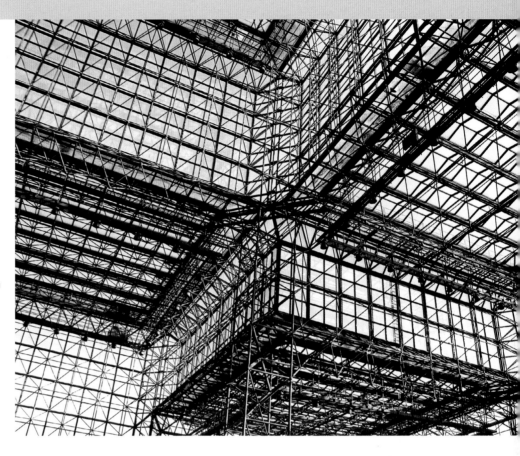

I love looking at buildings to see how they're constructed. And if, like me, you happen to live near a great architectural city like New York, you get to see some of the world's most beautiful buildings on a regular basis. One of the things that you notice when you investigate buildings closely is that they contain some fascinating and intricate patterns. In fact, since the very construction of buildings relies on the repetition of shapes, angles, and beams—in other words, patterns—it's almost impossible not to find them in both their design and their decoration.

You can find a lot of great patterns in the exterior ornamentation of buildings—in the intricate mosaics of a Muslim mosque, for example, or the fractured-mirror face of a modern skyscraper. I've also found great patterns in the structural details of buildings—in the stairways, domes, doorways, façade carvings, etc. And sometimes the construction of the building itself is like one huge pattern. The Jacob Javits Convention Center in New York, shown here, is a great example of a building wearing its structural pattern on the outside, and I defy anyone with a camera to enter that building and not shoot some pictures. The building always looks to me as if someone has come along and stripped off the façade, revealing the structural skeleton underneath.

Architectural patterns work best when they are entirely isolated, which usually means shooting just sections of the building rather than the whole building. For the shot here I was lucky; there wasn't much in the way (other than some banners hanging from the lower ceilings), so all that I had to do was point the camera up and shoot. Usually you can isolate a pattern just by zooming the lens in a bit and getting rid of clutter.

By the way, churches and temples, as well as important public buildings like state capitols, are very rich with ornamental patterns both inside and out, so those are other nice places to look. If you're looking for likely subjects in your area, just do a Google Image or flickr.com search on your state or city capitol and you'll see what other photographers have shot there.

TECH SPECS: LENS: 28mm / FOCAL LENGTH: 56mm
EXPOSURE SETTING: 1/60 @ f/2.8
EXPOSURE MODE: Auto
WHITE BALANCE: Sunny
FILE FORMAT: JPEG / ISO: 200

Consider the Beauty of the Lowly Dandelion

It's a good thing that I don't take better care of my lawn, because if I did, I would probably lose all the interesting weeds and wildflowers that grow there. Among my favorite "weeds" are the dandelions that I have by the hundreds in the back yard. Dandelions may be the scourge of lawn fanatics, but to me they're cheerful and bright, and the bunny rabbits love to eat them. And if you've never gotten down on the lawn and looked face-to-face with a dandelion, try it—they're

I realized while shooting this photo, however, how much I wished I was working with a zoom lens. When you're limited to one focal length you have to physically move closer or farther away to change the subject's size. Using a prime lens (a single focal-length lens) is a lot more restrictive because you can't change the composition by simply twisting the lens barrel, but it does force you to try to find subjects and compositions that match the focal length. It's an interesting challenge.

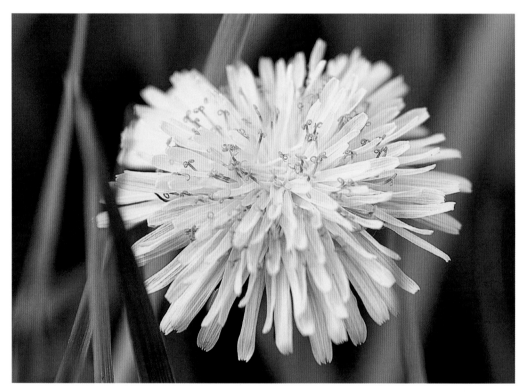

I've also photographed dandelions with point-and-shoot digital cameras and have gotten some great photos. Unfortunately, some point-and-shoot cameras set the lens to a single focal length once you put it in the macro mode so you have exactly the same issue as with a prime lens: you can't zoom. Still, some point-and-shoots do let you focus and continue to zoom even with extremely close subjects, so there's almost no flower too small to shoot.

Next time you're thinking of killing off

amazingly intricate flowers. Amid the many layers of delicate yellow petals are dozens (if not hundreds) of little curly florets, or tiny flowers. Most people, unfortunately, poison or whack them into oblivion without really appreciating them.

Photographing a dandelion is mostly a matter of lying on your face on the lawn and having a camera that lets you focus very closely. For this shot, I was using a 105mm lens, which is a great focal length for macro work because it lets you fill the frame with small subjects while remaining far enough away so that you're not blocking the light.

the dandelions, grab the camera and take a few minutes to photograph them first. You may find yourself so enamored of them that you'll have to join the North American Dandelion Preservation Society (and yes, there really is one).

TECH SPECS: LENS: 105mm / FOCAL LENGTH: 157mm
EXPOSURE SETTING: 1/100 @ f/5.6
EXPOSURE MODE: Aperture Priority
WHITE BALANCE: Auto
FILE FORMAT: JPEG / ISO: 200

Create a Shooting Checklist

If you haven't used your camera in several days or a few weeks, chances are that you forgot where you left all the settings the last time you used it. You may have used exposure compensation the last time you were out shooting, for example, and forgot to zero it out when you finished, so next time you'll be shooting with compensation without realizing it. This kind of thing used to happen to me all the time, but these days I am constantly on guard against my own forgetfulness and try to sit down with my gear for a few minutes before each shoot and make sure the settings are where I want them.

To prevent yourself from making easy camera-setting mistakes, it's a good idea to have a written or mental checklist to go through each time you pick up the camera, just to be sure the settings are where you want them. Here are a few of the things I check each time I go out on a shoot:

◆ **ISO:** Set the camera to its default ISO if you have plenty of light. This speed provides the best image quality.

◆ **Exposure compensation:** This is my biggest mental challenge! I seem to always forget to zero it out and I use compensation a lot, so I end up shooting with compensation that I don't want the next day. Check it.

◆ **File size:** Check to be sure you're using the maximum (largest) file size and the best quality level. Memory cards are cheap these days—so always shoot at the largest file size. (I shoot RAW almost 100% of the time, so I generally don't change that setting.)

◆ **White balance:** Either set it to the type of light you're shooting or just set it to Auto and the camera will adjust for the existing light color.

◆ **Exposure mode:** I usually keep my camera set to Aperture Priority to start and then move to another mode (like Manual) if I need to. Don't just assume it's in the correct mode; check to be sure.

◆ **Battery level:** Ideally you should have checked this the night before, but always be sure you have battery power. I own several extra batteries and so I always have at least one fully charged.

◆ **Clean lens:** Be sure that your lens (or lens filter) is free of major smudges or dust. I keep filters on all of my lenses and so rarely have to clean them, but the filters are sometimes a real mess. Use a microfiber cloth to clean them.

If you are consistent about running down a checklist each time you shoot pictures, you'll avoid a lot of nasty little surprises. Now, if I could just follow my own advice every day.

TECH SPECS: LENS: 18-70mm / FOCAL LENGTH: 33mm
EXPOSURE SETTING: 1/200 @ f/13
EXPOSURE MODE: Aperture Priority
WHITE BALANCE: Cloudy
FILE FORMAT: JPEG / ISO: 200

Bring a Monopod Where Tripods Won't (Or Can't) Go

One day while I was shooting up on a rock ledge in the desert outside of Tucson, Arizona, and using a monopod to steady the camera, a passing hiker said she'd never seen one and asked what it was. I told her that I used it partly for steadying the camera but mostly to fend off rattlesnakes. Her eyes grew big and she looked carefully at the path around her feet. I was joking, of course, and I hope to never get within a monopod's length of a rattlesnake, but I think I put some extra fear into her heart.

Snakes aside, I rarely travel anywhere without a monopod to back up my tripod. Given a choice, I will always choose to shoot with a tripod because a tripod is like a security blanket to me; it provides a steadier platform, forces me to slow down, and takes the weight of the cameras out of my hands (and off of my shoulders). There are many public places, however, such as cathedrals and public gardens, where tripods are simply not allowed. And there are places (like the top of a ridge in Tucson) where even a tripod addict won't carry that much weight.

In those situations I almost always bring a monopod to steady the camera. A monopod is essentially a one-legged tripod (your two legs provide the other legs to form a tripod), and while not as steady as a tripod, they can help you shoot at much slower shutter speeds than you could handheld (even with vibration reduction).

Yes, the advent of image stabilization has helped to reduce the amount of camera shake in some photos, but there are other benefits to using a monopod. For one, like a tripod they force you to slow down a bit. Often I see people shooting quick snapshots of subjects that might be truly interesting photos if only they'd given the shot a few moments more consideration. Also, monopods may be a small burden to carry at times, but they can actually save some wear and tear on your body—saving your shoulders, for example, by supporting the weight of longer lenses and keeping the camera strap from pulling on you neck.

A good monopod will cost you under $100 and you can add a small ball head with a quick release for about another

$100. When it comes to choosing your monopod, put some weight (camera weight and your body weight) on it to be sure it won't slip in use. I have monopods that are 20 years old and are as reliable as the day I bought them, so try not to cheap out. Years from now you'll be glad you spent the extra few dollars for a top-quality monopod.

TECH SPECS: LENS: 10-20mm / FOCAL LENGTH: 16mm
EXPOSURE SETTING: 1/200 @ f/7.2 / EXPOSURE MODE:
Aperture Priority / WHITE BALANCE: Cloudy
FILE FORMAT: RAW / ISO: 200

Expose for Action: Select Shutter Priority Mode

Here's a simple tip: the faster the shutter speed you choose, the sharper your photos of action will be. Unfortunately, your camera doesn't know what type of subject you're shooting; in fact, it can't tell the difference between a sleeping cat and a leopard running right toward you (hopefully, if you're in leopard territory, your guide will know the difference). In order for you to get the sharpest photos of action, you need to communicate to your camera that what you're photographing is likely to be moving when you photograph it.

That's where the Shutter Priority exposure mode comes in handy. In this mode, you're telling your camera that stopping the action is of utmost importance to the success of this particular shot. You get to choose the shutter speed you think is appropriate for the action and the camera simultaneously

selects the correct corresponding aperture (f/stop) to give you a good exposure.

As long as you have a decent amount of light and choose an appropriate shutter speed, this mode will almost always assure that you get sharp action photos. If the lighting is dim (you're stalking leopards in a dark jungle, for example), the camera will try to give you an action-stopping shutter speed, but it may not be able to do that. Some cameras may warn you (usually with a blinking setting—the universal sign that the camera thinks your commands are at odds with reality) that at this combination of settings, the light is too low to provide a good action-stopping shutter speed and a proper exposure. Your options at this point are pretty much limited to either raising the ISO (each doubling of the ISO speed buys you one extra shutter speed setting) or switching to a lens with a faster maximum aperture, if that's an option in your lens kit.

Keep in mind, by setting the Shutter Priority mode, you're telling the camera that what's most important to you is freezing the action and that depth of field (near-to-far sharpness) is a secondary consideration. So unless you have oodles of light (as I did with this shot of a girl at a carnival), you might get a sharp action photo but have limited depth of field.

You can also increase your odds of getting sharp action photos if you time your shots for the peak of action. To capture this moment, for example, I watched the girl bounce a few times to gather some mental data. I then waited until I thought she had reached the apex of her bounce and shot. I worked out a pretty good timing sequence by watching her for two or three jumps and was able to get quite a number of sharp photos of her. You won't have the casual observation option if you are shooting leaping leopards, of course, but with most other subjects it's a great idea.

TECH SPECS: LENS: 24-120mm / FOCAL LENGTH: 57mm
EXPOSURE SETTING: 1/640 @ f/5
EXPOSURE MODE: Shutter Priority
WHITE BALANCE: Cloudy
FILE FORMAT: JPEG / ISO: 200

Organize This!

You'd never know it to look at the jungle that is my writing office, but when it comes to composing photos, I am very devoted to organization. In fact, I spend the largest part of my time finding vantage points and angles of view that allow me to create the most organized image design possible. I suppose this comes from the fact that I grew up with a mother who saw the precise placement of a lamp on a table as an important artistic challenge and for whom the orientation of a couch relative to the television had deep philosophical overtones. In other words, I inherited my design obsession.

In the photo here, for example, I was fascinated by the intense and very creative architectural design that went into this simple lifeguard station in Fort Lauderdale, Florida, and I wanted the building to be (as they say in Hollywood) the hero of the shot. I was really taken with the cool concrete spirals of the low seawall and the combination of straight and slanted lines in the hut itself, but I also wanted to include the windswept palm and the very ornate (and somewhat out-of-place looking) street lamp. I spent about an hour walking around this tiny building and up and down a hill across the street looking for just the right angle to show off the elegance of the design in the simplest possible way. I also wanted to include the hard line of the sea in the design, as well as the ship that was anchored offshore.

Finding just the right composition for scenes like this is almost always a matter of trial and error and of paring down the number of visual elements. I always find it's best to shoot a few informal frames when I first come upon a subject and then analyze the shot to see what I can delete while still retaining the scene I'm after. I then slowly refine the shot, checking the LCD continually, moving closer or farther away (optically or by foot), finding higher or lower vantage points, and experimenting with different subject placements, until I find the right combination.

At times you will get lucky and the image will come to you quickly, but at other times it will be a frustrating battle of wits between you and the subject. Above all, take the time to minimize, organize, and keep refining the image—you'll know when you've found the best shot. There may be times when the subject wins and you walk away frustrated, but even Picasso tore up canvases in utter despair. The fact is that if you spend time working the scene, you will almost always get a better photo than if you had simply surrendered to the easy shot.

And, of course, the beauty of shooting digitally is that you can do all of the experimenting you like and it won't cost you a dime for film and processing.

TECH SPECS: LENS: 24-120mm
FOCAL LENGTH: 57mm
EXPOSURE SETTING: 1/1000 @ f/8
EXPOSURE MODE: Aperture Priority
WHITE BALANCE: Cloudy
FILE FORMAT: JPEG / ISO: 200

Go Wild! Visit a Wildlife Sanctuary

One of the greatest challenges in photography is getting a good close-up shot of a bird or animal. Much of the reason that it's so difficult, of course, is that birds and animals are intensely shy and tend to avoid human company (and considering how we've turned most of their neighborhoods into strip malls, who can blame them?). One way to get closer to wildlife of all types is to visit local or national wildlife refuges, from tiny neighborhood sanctuaries to the giant national parks.

While the wildlife in sanctuaries still won't walk up to you and pose for your camera, they feel much safer in a protected area and so act far more naturally. Many sanctuaries have walking trails and boardwalks that will bring you closer to the

local wildlife, and some of the larger ones even have wildlife drives that let you observe animals from the safety (yours and theirs) of your car.

I shot the photo of the Great Egret seen here at the Merritt Island National Wildlife Refuge in Titusville, Florida, from the very beautiful 10-mile Blackpoint Wildlife Drive. The drive follows a canal and tidal flats where thousands of birds gather at certain times of year (particularly during migrations), and you can get great photos from inside your car. In fact, shooting from a car is a great way to get close to the birds because

they don't seem to see a car as a threat. As long as you remain in the car you can get within good shooting range for even moderate telephoto lenses (200-300mm in 35mm equivalents). Also see tip 57 on shooting wildlife from your car.

To find nearby sanctuaries and refuges, just do an online search on "wildlife sanctuaries" or "wildlife refuges" and the name of your town or the towns you'll be visiting. Some states (like Florida and Alaska) have an embarrassment of riches when it comes to places to find accessible wildlife, and just doing an online search will give you plenty of inspiration. Search for nearby state park sites, too, since most have well-established wildlife viewing areas.

Once you arrive at a refuge, be sure to stop by the visitor center (which can range from a bulletin board to a modern welcome center) and pick up a map, birding and wildlife checklists, and any other literature you find. And don't be shy about telling park staff that you're there to photograph wildlife (believe it or not, not everyone is) and ask for their suggestions. Often they can tell you not only where to find certain animals, but what time of day they'll be most active and within shooting range.

Bear in mind that many refuges allow hunting at certain times of year, so be sure to check out the dates of their hunting seasons—often, the refuges are completely closed.

Finally, be sure to make a donation at the visitor center or in the trail collection box; like everyone else, these sanctuaries are hurting for donations and a few dollars from each visitor really adds up.

TECH SPECS: LENS: 400mm f/5.6
FOCAL LENGTH: 600mm
EXPOSURE SETTING: 1/800 @ f/5.6
EXPOSURE MODE: Manual
WHITE BALANCE: Auto / FILE FORMAT: JPEG / ISO: 200

S-t-r-e-t-c-h Your Vision with an Ultra-Wide Lens

OK, time for a pop quiz. The most obvious reason to own a really wide-angle lens is to take in really big spaces in one shot, right? Wrong! Well, only partly wrong, actually. Yes, you can use a wide-angle lens to capture a wide, sweeping view like the Grand Canyon or a mountain range. The problem with shooting views like that with a very wide-angle lens, however, is that everything in the shot gets smaller and the view tends to lose grandeur rather than gain it.

In reality, if you want to take in expansive landscapes or scenic views, you're better off shooting a series of images with a normal or moderate telephoto lens and stitching them into a panorama. Panoramas shot with a normal or slightly telephoto lens usually offer a much more realistic interpretation of a wide view or vista.

So what's the point of owning a super wide-angle lens (a super-wide lens in 35mm terms would be anything wider than about 21mm and as wide as 10mm or so)? For me, the beauty of a super-wide is its ability to stretch and elongate objects or to really exaggerate the spaces between parts of a scene. If you photograph a rowboat sitting on the beach using a normal lens, for example, the boat will look pretty much like it looks to you without a camera in front of your face—the proportions will seem very natural. But if you photograph that same boat (shooting from a very close perspective of, say, a few inches from the bow) using a super-wide lens, the boat will seem much longer than it really is and its exaggerated shape will dominate the design of the image.

As I said, you can also use a very wide lens to exaggerate the spaces between near and far—which can be quite an effective tool in landscape photography. If you're photo-

graphing a farm scene with a tractor in the foreground and a dirt road leading to a barn behind it, you can move in close to the tractor and it will dominate the shot, making the road seem long and the barn seem much more distant. That type of spatial stretching provides a great feeling of presence in a landscape shot, making the viewer feel as if they're experiencing the spaces involved.

One other great use of a super-wide lens is shooting in tight quarters—hotel rooms, small museum rooms, etc. It's nice to have a lens in your kit that, even though it will distort the dimensions (and probably the shape) of tight spaces, lets you include everything. Often the inherent distortion created by an ultra wide-angle lens adds to the intrigue of the shot.

TECH SPECS: LENS: 10-20mm / FOCAL LENGTH: 15mm
EXPOSURE SETTING: 1/250 @ f/8
EXPOSURE MODE: Aperture Priority
WHITE BALANCE: Sunny
FILE FORMAT: RAW / ISO: 200

Get Sea Fever!

I don't know if John Masefield, who was the Poet Laureate of Great Britain for most of his life, was much of a photographer, but I hear his poem *Sea Fever* in my head whenever I am sitting at the computer writing about photography and wishing I were out taking pictures instead. And often it's his call to the sea that prompts me to get up from my desk, grab the camera bag, and run down to the local waterfront.

I live in a town that is pretty much surrounded by water on two sides: it has the Housatonic River as its eastern border and Long Island Sound (where the Housatonic ends its run) as most of its southern boundary. Whenever I get the restless urge to spend an hour shooting pictures, I seem to instinctively head to the water's edge. No matter what time of day it is or what the weather is like, I almost always find something interesting to shoot—whether it's oystermen offloading their day's catch or a heron fishing on the beach at sunset.

Riverfronts and harbors are great places to hang out with a camera because both people and animals spend much of their time playing and working there. Unless you live in the desert, there is almost certainly some type of waterfront area near you—a lake, a river, a small pond, a big ocean. The more active the waterfront, of course, the more (and the more diverse) subjects you'll find to photograph. While waiting for the ferry to take me to the Statue of Liberty one summer afternoon, I sat at the mouth of the Hudson River and watched no less than six schooners (one of them shown here) sail past, dozens of small sailboats, a bright red tugboat, ferries, water taxies, and several freighters. I filled a memory card with pictures before the trip even began!

Harbors, small or large, seem to be most active (with both people and animals) early and late in the day, which is convenient because those times also coincide with nice lighting. If you're near a tidal harbor, keep an eye on tidal charts to get ships coming and going because, obviously, this is something they only do at high tide. You might also contact the harbormaster's office and ask them if there is a shipping schedule available.

Regardless of the size or activity level of your local waterfront, however, you will almost always find something new and fun to shoot. Come to think of it, I think I hear the sound of the waves calling me right now…

TECH SPECS: LENS: 70-300mm
FOCAL LENGTH: 450mm
EXPOSURE SETTING: 1/250 @ f/9
EXPOSURE MODE: Auto
WHITE BALANCE: Cloudy / FILE FORMAT: RAW
ISO: 200

Don't Fight the Light

It's only natural when you walk up to a subject, whether it's a person, a building, a dog—or in this case, a statue—and attempt to compose it from the front. The front view is, after all, often the view you see first and there is an instinctive human reaction that the front view must be the best view. After all, why does any object have a front if that's not the correct way to view it?

And in terms of casual observation, deciding that the correct way to view things is from the front is a pretty good assumption. But photography is not about casual observation; it's about exploring and discovering and finding the best angle for your purposes. More importantly, there are a lot of times when the lighting will dictate what is or isn't the best angle to photograph a subject from, and unless you're shooting in a studio where you can change the lighting direction, there's no point in fighting the lighting just so that you can capture the conventional viewpoint.

Take, for example, this very moving Korean War memorial that I came across in Jersey City, New Jersey. The memorial is at the end of a long avenue and when you're driving up the street and see it approaching, it's facing you and it's very dramatic. The problem I found on the day that I visited, however, was that the light was coming from directly behind and the front of the sculpture was deep in shadow.

I really wanted to take at least a cursory photo of the monument, and there were a few different options. Because I was on my way somewhere else, waiting for the light to change wasn't one of them. So instead, I shot a few frames with exposure compensation to see if that would open up the front of the sculpture, but all it did was wash out the background and it did nothing for me artistically. I also tried flash (it looked artificial and was worse) and I tried shooting a few silhouettes by exposing for the bright sky behind the statue, but the shapes really weren't defined enough to handle a silhouette.

Rather than fight the light, I decided to circle around the sculpture and see if there were any good angles from the rear, where the lighting was far better. As I walked around it, I could see that the light was falling beautifully on the backs of the two soldiers, and I really liked the view of the city street beyond them. I also really liked the gesture of the men's arms around each other—it was a very significant aspect of the sculpture that was hidden from the front, and one that the sculptor captured beautifully. Even though the sculptor knew that most people's first view of his work would be from the front, it was the view from behind that really told the story of these two soldiers and the camaraderie of war.

You can't change the direction of the sun's light, but you certainly can (and should) change your position relative to it—you never know what better shots might be waiting for you when you do.

TECH SPECS: LENS: 18-70mm / FOCAL LENGTH: 62mm
EXPOSURE SETTING: 1/500 @ f/5.6
EXPOSURE MODE: Aperture Priority
WHITE BALANCE: Auto
FILE FORMAT: RAW / ISO: 200

Be Aware (and Beware!) of Shapes

When I was a sophomore in high school, one of my favorite classes was, surprisingly, geometry. I say surprisingly because most of my friends that were a year ahead convinced me that the class would be a nightmare that would lead only to frustration, boredom, and ultimately many moments of humiliating failure.

In fact, geometry became one of my favorite courses. I think the reason that I liked geometry is because I really enjoyed learning how shapes were constructed and how they could be combined in interesting ways. I also began to get an insight into how artists like M.C. Escher were able to take relatively simple shapes and use them to create extraordinarily complex designs. I began staring at common objects to try and decipher what shapes went into their design and construction. I even found myself measuring things like the height and circumference of a soda can to try and figure out its volume. I was, in a word, obsessed with shapes.

I still love looking for and photographing shapes. And as silly as it sounds to say it, shapes come in all kinds of shapes and sizes—some easy to spot, some a bit more difficult. Certain shapes, such as circles, squares, diamonds, rectangles, cones, and triangles are obvious and predictable. Other shapes—particularly those in the natural world—are also distinct, but are often more freeform: leaves, spider webs, lily pads, frog's eyes, and even a big old trout all have recognizable shapes. And some natural shapes even do some wild shape-shifting: clouds, blowing grasses, and ripples in a sandbar change their shape almost faster than you can change exposure modes.

Often, a shape can have significant practical or emotional meaning: a snake doesn't need much more than its coiled shape to warn you to stay away. Nor does a stop sign need to have the word "Stop" printed on it in order to get its meaning across. And everyone knows to be wary of electrical danger when a lightning bolt shape is used on a sign.

Whatever the source of the shape you're photographing, the more you isolate it from distracting surroundings, then the more powerful and dynamic it becomes as a design element. The key to isolation, of course, is just getting closer: walk closer, use a zoom, or pick up the object (not the snake, I hope) and bring it home to photograph it. Repetition (like the repetition in the Iowa farm buildings shown here) is another way to emphasize shapes. By including three rounded buildings instead of just isolating one, the shape becomes more of a theme than just an individual structure. Another way to isolate shapes, of course, is by turning the subject into a silhouette (see tip 2).

Finding shapes is a good self-assignment, so next time you're out looking for something interesting to shoot, forget the specific subject and instead hunt out the shapes from which they're made. Your geometry teacher would be proud of you.

TECH SPECS: LENS: 70-300mm
FOCAL LENGTH: 200mm
EXPOSURE SETTING: 1/800 @ f/8
EXPOSURE MODE: Auto
WHITE BALANCE: Cloudy / FILE FORMAT: JPEG / ISO: 200

Back to the Future: The Fun of Black & White

It's probably been more than 20 years since I shot a lot of black-and-white film, but I miss making black-and-white photographs a great deal. There is a craft to fine black-and-white image making that is fun and challenging. I also miss the long hours I used to spend in my darkroom; the spooky look of working in a room lit only by dim red lights and the FM DJ keeping me company all night—I even miss the smell of the chemicals. While the red lights and the chemistry are gone (I still edit images to music), I still love working in black and white, only now it's digitally.

Converting your images to black and white in Photoshop (or most other editing programs) can be easy or complicated, depending on how much time you want to spend doing it and just how particular you are about the quality. Photographers who have had extensive experience working with black-and-white films and making their own darkroom prints tend to be much more picky about quality (myself included), and they generally want complete control over the output. But anyone can learn to easily make fantastic black-and-white prints from a digital file.

Most software programs have several options for conversion; the most basic of these is to simply convert the image to grayscale (in Photoshop or Elements, go to Image>Mode>Grayscale). This is a quick operation that instantly transforms images from color to black and white. That's the least sophisticated path and offers the least creative options, but it will nonetheless give you a black-and-white image.

Another quick method is to desaturate the color using the Hue/Saturation dialog box that, in effect, drains the color out of your pictures (go to Image>Adjustments>Hue/Saturation). The fun thing about this method is that you can do a partial desaturation or even a selective one, choosing to desaturate just one individual color. In the partially converted image here, for example, I simply opened the Hue/Saturation box, chose 'Reds' from the drop-down color menu, and desaturated that channel. The image is identical to the full-color version, sans red.

Yet another conversion method is to use the Channel Mixer tool. In Photoshop, go to Layer>New Adjustment Layer>Channel Mixer. This opens the Channel Mixer in the

Adjustments palette. Click the box for Monochrome, and then individually adjust the red, blue, and green channels of your image. I've done a lot of conversions using this technique and some are quite good.

The Photoshop tool that seems to work best for me—and that offers the most options—is the Black & White conversion option found in the Layers palette. To access this option, click on the 'Create new fill or adjustment layer' icon at the bottom of the Layers palette (it looks like a bisected black-

TECH SPECS: LENS: 24-120mm
FOCAL LENGTH: 84mm
EXPOSURE MODE: Aperture Priority
EXPOSURE SETTING: 1/50 @ f/8
WHITE BALANCE: Auto / FORMAT: RAW / ISO: 200

and-white circle). Choose the Black & White option from the list. This opens the Adjustments layer, where you can refine the image. At the top of the Adjustment layer is a pull-down menu that lets you select conversions that resemble the look of black-and-white film images exposed through various lens filters (blue, yellow, green, red, etc.) or to create your own custom conversion by adjusting each of six separate color channels. The latter is the method I used for the full black-and white conversion shown here—I simply adjusted individual colors until I got the look that seemed most natural.

Finally, if you're very passionate about black-and-white photography, you should consider a specialty software product like Nik Software's Silver Efex Pro, a plug-in filter that works with Photoshop, Photoshop Elements, or Aperture.

This software provides a tremendous amount of control over tonality and contrast and even lets you imitate the look for more than 20 different black-and-white films. I use Silver Efex Pro a lot in my work and it's a very fun, intuitive program, and the results look remarkably like traditional monochrome photography.

Obviously, this tip has been just a quick rundown of the various ways to convert your color images to black and white on the computer. But with practice, you'll find you can get great grayscale pictures from your digital files. Will any of these methods provide gallery-quality prints? Some of the world's greatest photographers are doing it everyday, so the answer is certainly yes. But I'll bet they still miss the smell of the chemicals as much as I do.

Black and White		
Preset: None		OK
		Cancel
Reds:	40 %	Auto
Yellows:	60 %	☑ Preview
Greens:	40 %	
Cyans:	60 %	
Blues:	20 %	
Magentas:	80 %	
☐ Tint		
Hue		
Saturation	%	

Step Right Up! (But Watch Your Step)

Part of the problem is psychological and it afflicts all photographers: because you are concentrating so intently on your subject, it appears larger in the frame than it really is. And as often as I write about this particular phenomenon in books, I still find myself falling victim to its trickery. One way that I get past it is to check the LCD screen constantly as I'm shooting to be sure that the shot that I envision in my mind's eye is the same one that the lens is seeing.

I took the first shot of this old Essex Steam Train in Essex, Connecticut, because I really liked the look of the engine. After I looked at the shot for a few seconds on the LCD screen, however, I realized that the point of the shot just wasn't obvious enough; so I literally did take a few steps forward, changed my angle slightly (to get a nicer angle on the front of the engine), and zoomed in to get a much tighter shot. (Zooming is particularly useful if you do happen to be standing at the end of a dock.) While the engine was an interesting subject, there was just too much superfluous information in the wider shot. The tighter shot of the engine's medallion has much more impact and tells a better story.

How close is too close? When your compositions start to approach the abstract zone and your subjects become unrecognizable because you're providing too little information, it's time to take two steps back. Just be sure you're not standing at the edge of a cliff before you do it.

There's an old photo adage that says that when you think you're close enough to your subject, take another two steps forward—and it's true. Unless you're photographing a sailboat from the end of a dock, the simplest way to draw attention to your main subject is to make it larger in the frame. The larger your main subject is, the less likely your friends (not to mention your critics) will look at your pictures and ask what it was exactly that you were photographing. (They wouldn't know true art if it bit them!)

TECH SPECS: TOP: LENS: 18-70mm
FOCAL LENGTH: 70mm
EXPOSURE SETTING: 1/40 @ f/4.5
EXPOSURE MODE: Auto
WHITE BALANCE: Auto / **FILE FORMAT:** RAW
ISO: 400
BOTTOM: LENS: 18-70mm
FOCAL LENGTH: 105mm
EXPOSURE SETTING: 1/30 @ f/4.5
EXPOSURE MODE: Auto
WHITE BALANCE: Auto / **FILE FORMAT:** RAW
ISO: 400

Wildlife Photos: Wait for an Interesting Moment

Every photo book you read (including this one, incidentally) tells you that one of the toughest aspects of photographing wildlife is just getting close enough to make an interesting picture. You'd think then that once you did get close enough, you could just start shooting and that would be that. You got close to the animals, you fired off several frames, your job is done, go home.

Unfortunately, at least when it comes to getting their pictures taken, animals are a lot like people: most of the time what they're doing isn't all that interesting. And pictures of animals doing nothing is kind of like taking a picture of your spouse sitting on the couch staring into space—it might document reality (perhaps a tad too well), but it's not the most intriguing situation for a portrait.

Interesting animal pictures require interesting moments. It doesn't have to be a huge moment—you don't have to wait until an eagle is swooping down to make off with your picnic lunch. But some kind of a small gesture or action is often enough to turn a snapshot into a very interesting photo. In the case of this Mute Swan, for instance, I followed her through the lens for a long time one foggy morning (to the point that my arms were starting to cramp up from holding a long lens balanced on a rock), and most of the time she looked as dull to my camera as I must have looked to her. I shot a number of frames, but mainly out of sheer boredom.

For about an hour we had a sort of Mexican standoff, each of us waiting for the other one to do something. Finally, just as I was about to stick my thumbs in my ears and wiggle my fingers at her and let her win, she gracefully tucked her bill down to her chest and created a gentle heart shape with her neck, which I shot.

It's not important that you come home with a lot of close photos of animals; what is important is that you come home with one that goes beyond a documentary moment. Do that often enough and you'll create a collection of really meaningful animal pictures.

TECH SPECS: LENS: 70-300mm
FOCAL LENGTH: 450mm
EXPOSURE SETTING: 1/250 @ f/8
EXPOSURE MODE: Auto
WHITE BALANCE: Cloudy / FILE FORMAT: JPEG / ISO: 640

Combine Window Light with Fill Flash

Like all cats, mine like to sleep in sunny windows. One of the cats, in particular, likes to sleep on a little bookcase in a sunny window in my office and she tends to lie there late in the day when the sun is at its brightest and warmest. I love the look of window light pouring in around her at that time of day because it's generally quite warm and has a nice diffuse glow, and you can almost feel the warmth of her fur from across the room.

The problem for me as a photographer is that compared to the dim interior of my house, the window light creates a major contrast problem. The best way to solve this is either to turn on a few room lights or to pop up the built-in flash. I prefer using flash in this situation only because it's more convenient—I just press a button on my camera and the flash pops up. Because most built-in flash units are designed to balance nicely with the existing daylight, it opens up the dark areas adequately without overpowering the natural light.

Photographed without flash, my cat's face in this shot would be lost in shadows and I'd lose those pretty colors in her eyes and fur.

Turn on the flash when you're working near a window and you'll see that your contrast is less intense and your pictures are much easier to print. If the flash is too bright, check your manual to see if you can use compensation on the flash to slightly reduce output.

TECH SPECS: LENS: 70-300mm
FOCAL LENGTH: 330mm
EXPOSURE SETTING: 1/60 @ f/5.0
EXPOSURE MODE: Auto
WHITE BALANCE: Cloudy / FILE FORMAT: JPEG
ISO: 200

Night Photo Technique: Zoom into the River of Night

There are a few different ways to approach photographing the city at night. One is to adhere to our obsession with reality and set the camera up on a tripod, frame an interesting scene and get a nice sharp, well-exposed photo. That's a perfectly legitimate approach; it's nice to know how to take a good night shot and it's a kick to have really professional-looking night photos to show off to your friends.

I've always felt, however, that some night scenes--particularly vibrant commercial districts like New York's Times Square--are just too exciting and too flamboyant to only be captured in a traditional way. Yet because we're such reality-based creatures, we're often fearful of leaving reality behind, perhaps because we're afraid that if our photos are too experimental-looking, people will think we goofed.

But city at night is not about doing things correctly or trying not to make mistakes, it's about diving in and taking a swim in the river of light and color that's surging all around you. Forget reality! The reality of Times Square at midnight is that reality has been suspended in favor of free-flowing imagination and an electric energy that is so thick you can almost taste it. To capture that kind of primal force you have to go with the flow and find new techniques, new visions that match the subject.

One creative way to approach city lights at night is to use a technique called zooming (see tip 118) where you rack your zoom lens from one focal-length extreme to the other during a time exposure to turn bright lights into long, colorful ribbons of light. The more color and light that you cram into the frame when you zoom the lens, the more intense and vibrant your shots will be, so look for vantage points where you are just engulfed in light. And don't worry about keeping the camera steady during the zoom exposure because a small amount of camera shake (try turning off the image-stabilization and see if that makes things better or worse) usually enhances the effect.

While places like Times Square or Las Vegas are obviously perfect for making motion shots of colorful night lights, you can even do it with the neon sign in the local pizza restaurant window. In fact, I almost always take a few zooming shots of my Christmas tree because it can create wild patterns from the fairy lights. And let's face it, what's the fun of having all those pretty lights in your living room if you can't get a little experimental with your pictures?

TECH SPECS: LENS: 18-70mm
FOCAL LENGTH: 27mm
EXPOSURE SETTING: 0.4 @ f/13
EXPOSURE MODE: Aperture Priority
WHITE BALANCE: Cloudy
FILE FORMAT: JPEG / ISO: 200

Editing Tip: Don't Use That Same Old Name!

Unless you're really a whiz at image editing, chances are that you'll go through several variations of a particular photograph before you arrive at just the version you're after. I often spend hours (sometimes over a period of a few days) on a really important image and create a dozen or more different interpretations.

When it comes to saving various versions in JPEG format, however, you have to be careful not to save the new versions with the exact same file name as the old one. For one, if you give the newest version the exact same name as the previous one and save it, you will, of course, erase the previous version. While that might not seem to matter if you like the new version more, the fact is that in the cold light of day, you may actually prefer earlier versions. All it takes is a little bit of organization (and some hard drive space) to save each different version until you're sure you have the one you want. For example, I named this shot Hebron_Fire_Engine_1-001.jpg in the first version and 001a, 001b, etc. in later files.

An equally important reason to change file names slightly is that if you open and re-save JPEG files using the same exact file name multiple times, you degrade the quality of the file because JPEG is a "lossy" format and compresses the file each time it's saved. Yes, you are actually harming the file each time you open and resave it under the same name—so don't do it. (TIFF or PSD files do not have this same problem.)

Also, if you're working with layers (and you should if your program supports them), it's important to also keep the layers open when you save the "working" images because that way you can trace exactly what changes you've made and also turn various layers on or off at will. Finally, when you're sure that you have a file you like, flatten the image, choose a final name and save it to a "finals" folder. That's the file that you'll make prints from or send to publishers if you sell your photos.

Version organization is an important thing in image editing, especially when you have tens of thousands of digital files (and you will eventually). So come up with a good naming scheme early and stick with it—you'll be glad you did.

TECH SPECS: LENS: 18-70mm
FOCAL LENGTH: 65mm
EXPOSURE SETTING: 1/160 @f/4.5
EXPOSURE MODE: Auto
WHITE BALANCE: Auto / FILE FORMAT: RAW
ISO: 640

Treasures in Your Attic: Tell the Story of Forgotten Spaces

It's easy to look for pictures in the pretty places—the beach, meadows, your garden, etc. Let's face it, beaches and meadows and gardens were made to be photographed, and it's your duty as the committed photographer that you are to bring those beautiful scenes home.

But sometimes the most interesting photos are found in places where you would least expect them to be lurking—places like your backyard tool shed, your neighbor's garage, or even in the attic of an old barn, which is where I found this shot. I discovered this fascinating little vignette at a Christmas tree farm where (snoop that I am) I had wandered off into an old barn where I'm sure I wasn't supposed to be. The roof of the barn was made of translucent panels (probably because this area had once been the farmer's workshop) that created a blissfully soft light over the entire room. Had the lighting not been so soft and enticing, I might have just taken a wishful glance at the room and moved on, but with that nice lighting just melting across the room, there was no way I wasn't going to photograph it.

The great thing about finding unexpected gems like this is that they're not only great photographic finds, but they tell a story of the places you discover. The Jones Family Farms in Connecticut, where this photo was taken, has been in the same family since 1812, and I can't help but look at this photo and wonder about all of the hands, across several generations, that have worked in this room and heaped up these old bits of tools and wood. Does the current generation peak into this forgotten corner as they pass by and think about their ancestors? I know that I would.

I grew up near an old mill pond and there was an abandoned milling house falling into ruin in the woods nearby. When we weren't fishing in the pond we used to climb through a window into the mill house and it was like being in an old tool museum—there were still hand tools on the benches, muskrat traps and ice tongs hanging from the walls, and windows full of decades-old spider webs. The mill was torn down before I took up photography, but how I wish I could travel back in time to that place with a camera!

Lots of similar places still exist. And the places you explore don't have to be so profoundly historic or even that hidden, either. How many stories are waiting to be told on your dad's workbench, or in your mother's sewing corner? These places are so familiar to us that we tend to overlook them and yet they are often the most meaningful places in our lives.

Next time you're looking for something interesting to photograph, climb up to the attic or go take a walk through an abandoned factory row. You just never know what treasures are sitting there waiting for you.

TECH SPECS: LENS: Built-in zoom
FOCAL LENGTH: 24mm
EXPOSURE SETTING: 1/25 @ f/2.8
EXPOSURE MODE: Manual
WHITE BALANCE: Cloudy / FILE FORMAT: JPEG / ISO: 100

I don't know if sign painters and designers get as much of a kick out of their work as I do, but I really appreciate the humor they inject into daily life, whether they mean to or not. Signs are one of the most common and often unexpected sources of visual humor and, considering how our world is so bombarded with signs these days, they're usually quite easy to find.

Signs always seem to catch my eye most when I'm traveling—but that's probably because I'm usually either lost or looking for something and that's what signs are there for (I think). And you find funny signs in the oddest of places—like the "hot ice cream" sign that I found in a plaza next to the Eiffel tower in Paris. France had a long, hot summer that year, and the whole country was suffering serious heat-related health problems. This ice cream vendor decided that he had the secret treatment for the heat wave: eat more ice cream (I couldn't agree more).

TECH SPECS: LENS: 18-70mm / FOCAL LENGTH: 105mm
EXPOSURE SETTING: 1/160 @ f/6.3
EXPOSURE MODE: Auto / WHITE BALANCE: Auto
FILE FORMAT: JPEG / ISO: 200

And realizing that most of his clientele at the Eiffel Tower were Brits and Americans, he naturally had the sign created in English.

Often times signs are unintentionally funny—like conflicting one-way signs that don't allow you to drive in either direction, or the "Caution: Road Wet During Rain" sign that I've seen several times in the Southwest.

Sometimes you can just shoot the sign, but other times you have to include the context of a sign in order reveal the humor: I found the wiggly road sign shown here in the bottom of Monument Valley in Utah. While there was a road nearby, the sign seemed to have more to do with climbing the hill than describing the road (the shoulder of which was a good 10 feet (3 m) from the sign). And one of the classic examples of this type of juxtaposition, of course, is the "No Exit" sign posted next to a cemetery. As often as I've seen that shot, it still makes me laugh.

Humor is a great tool in life and in photography, and anytime you can make someone laugh with a photograph, you'll get their complete attention. So keep your eyes (and your sense of humor) open and your camera handy!

TECH SPECS: LENS: 24-120mm / FOCAL LENGTH: 107mm
EXPOSURE SETTING: 1/160 @ f/6.3
EXPOSURE MODE: Aperture Priority
WHITE BALANCE: Auto / FILE FORMAT: JPEG
ISO: 100

More Humor: Juxtapose Just Because

Signs aren't the only source of manmade visual humor. Sometimes just the juxtaposition of two extremely unrelated subjects—in this case one natural, one manmade—is inherently funny. It probably shouldn't have surprised me or made me laugh to see a portable toilet in the middle of such a grand natural scene, but the contrast between man's tiny plastic structure and one of the West's most iconic symbols struck me as both funny and ironic. It's wonderful, of course, that the folks who run Monument Valley Navajo Tribal Park put portable toilets in the middle of the wilderness for the tourists (after all, we just visit the park, they live there), but in this shot it looks like nature is almost mocking man's contribution to the scene: "You call that an achievement?"

If you see something that makes you laugh or giggle, shoot it. Others may or may not see the humor that you saw, but if you don't take the picture, you'll never know!

TECH SPECS: LENS: Built-in zoom / FOCAL LENGTH: 24mm
EXPOSURE SETTING: 1/320 @ f/7
EXPOSURE MODE: Aperture Priority
WHITE BALANCE: Auto / FILE FORMAT: JPEG / ISO: 100

Get Dramatic with Contrast

Hang around with a bunch of professional photographers long enough (long enough, that is, to hear them start to complain about things related to taking pictures, which shouldn't take too long) and one of the things you'll hear them complain the loudest about is controlling lighting contrast. The very thing that makes photographs interesting—dramatic lighting—is also the source of some of the toughest parts of making a good photograph: too much contrast.

The problem is that both digital sensors and film have a limited dynamic range, or the range between the brightest and darkest tones. When you go beyond that range you start to lose detail in either the highlights or the shadows (depending on which exposure decisions you make). If you expose for the bright areas you end up with shadows that are pure black with no detail, and if you expose for the highlights, you get whites that look very washed out.

Does this mean you can't shoot in very contrasty situations? No! You can actually exploit those contrast limits to create very dramatic images. Since there's usually not that much visual information in shadows anyway (there are exceptions to that), what I tend to do is to expose for the brightest areas where I want detail and let the shadows go dark. That's exactly what I did in this shot of daffodils: I took a reading (in multi-segment metering mode) with the flowers in the center of the frame and then shot at that exposure. I knew that the flower stalks and the greenery around the blossoms were going to go dark, but I like the way the lighting spotlighted the bright yellow daffodils.

I shot this photo in the late afternoon, by the way, just before the sun disappeared behind a hill. That late sun is very low angle, of course, so it helped with the spotlighting effect. The light, while it was fairly intense, was also very warm, so that helped too. By exposing just for the highlights, it saturated the warm lighting and the colors in the flowers. The contrast is pretty extreme, but so is the drama.

Next time you're faced with a contrasty situation that seems impossible to expose for, try taking a reading from the brightest object where you want detail and let the shadows go dark—it's a contrasty look, to be sure, but sometimes also very dramatic.

TECH SPECS: LENS: 80-200mm f/2.8
FOCAL LENGTH: 232mm
EXPOSURE SETTING: 1/1250 @ f/7.1
EXPOSURE MODE: Aperture Priority
WHITE BALANCE: Cloudy / FILE FORMAT: JPEG / ISO: 200

Soften Landscapes with Hazy Light

I'm as guilty as anyone of waiting for nice, sunny days to go out and shoot pictures. Maybe it's my inherent laziness that says if it's a bit too cloudy or hazy, I don't have to bother hauling out the cameras and shooting any pictures. But soft, hazy light can be a real blessing, especially in landscape photography, and it's far better to embrace it than use it as an excuse not to shoot.

The nice thing about working on very hazy or overcast days is that the contrast is dramatically reduced, which makes getting a good overall exposure much simpler. While I shot this photo in RAW and could have easily tweaked the exposure in the conversion process, the exposure right out of the camera was fine. Hazy lighting also produces lovely muted and saturated colors that are easily blown away in bright, direct sunlight. In fact, it was the many different shades of green contrasting with the red barn that caused me to slam on the brakes (literally and unfortunately for my passenger) and hop out to shoot this photo.

One question that I often grapple with on gray sky days is whether or not to include the sky in the composition. Gray skies have a tendency to have a "blah" look in landscapes and often I opt to simply crop them out. I shot this photo toward the end of the day with thunderstorms threatening and the sky turning deep gray behind me and, in fact, a few raindrops fell on me during the twenty minutes or so that I worked the shot. A deep sky might have looked nice with all of the greenery, and I would have included it had it fit the composition naturally. But I really wanted the barn to dominate the scene and if I had zoomed back at all (to take in sky) it would have diminished its impact.

Embrace the hazy light of cloudy or pre-stormy skies and you'll love the softness it lends to your landscapes and the nice, rich colors you'll get in your prints. And if you can't decide whether or not to include the sky, shoot it both ways and decide later—hey, digital pictures are free!

TECH SPECS: LENS: 24-120mm / FOCAL LENGTH: 117mm
EXPOSURE SETTING: 1/8 @ f/18
EXPOSURE MODE: Aperture Priority
WHITE BALANCE: Cloudy / FILE FORMAT: RAW / ISO: 800

Turn Your Scanner Into a Camera

If you have a flatbed scanner attached to your computer then you might not know it, but you have one of the world's best digital cameras sitting on your desktop. Your scanner is not only great at copying old photos and documents, but it can take a scan (i.e., a photograph) of anything that you can fit on the platen: an arrangement of seashells, your antique button collection, or even some flower blossoms fresh from the garden.

I laid this eggplant blossom on my inexpensive Epson scanner moments after I picked it, turned off the room lights (to get a black background), and scanned it. The great thing about scanners is that, while they can only "see" one surface of your subject, they have incredible depth of field (near-to-far sharpness) so almost everything the scanner sees will be sharp. Wild, isn't it?

Some scanner artists create a "black box" (a shoe box painted with matte black paint inside) to fit over the platen so that they can scan with a black background in full room light. You can even suspend parts of your subjects from clean monofilament fishing line to get "layers" of objects in your scans. Think of your black box scans as dioramas that you're photographing with your scanner and you'll get the idea. If you have young kids, ask them to help with your designs—they really get the idea of creating dioramas and as soon as you show them how you're scanning the contents, they'll be all over your project!

Here are some quick tips for success:

◆ Scan at a high resolution (at least 300dpi) so that you can make nice quality prints.

◆ Keep the glass clean.

◆ Turn off the room lights or use a sheet of black paper or a black box over your subject to keep the background black (or any other color).

◆ Experiment with common subjects like slices of fruit or a collection of antique buttons.

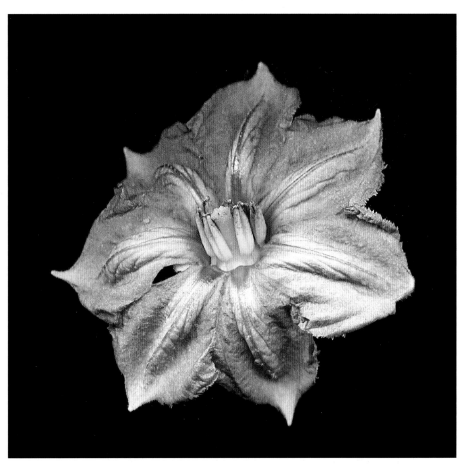

If this idea appeals to you, visit scanner artist Ellen Hoverkamp's website at www.myneighborsgarden.com and you'll see some remarkable and beautiful scanner photos of flowers, veggies, and other interesting subjects.

TECH SPECS: CAMERA: Epson flatbed scanner
RESOLUTION: 600 dpi

Creative Shutter Speed Technique: Create Ribbons of Water

One of the nice things about being able to adjust the shutter speed on a camera is that it lets you add your own creative interpretation to moving subjects. You can freeze movement with a very fast shutter speed or blur it with a long exposure. One of the most common examples of the latter idea is turning moving water—a stream or waterfall, for instance—into flowing ribbons of white water. Done well, the technique is very effective and it's the stuff that calendars are made of and it always reminds me (in a good way) of those cheesy "moving water" photos you see hanging on diner walls. Personally, I love those pictures (not to mention cheesy diners) and I always try to get a booth next to one.

Creating the effect is very simple: to turn flowing water into pretty ribbons of motion, just set your camera to the Shutter Priority exposure mode and select a longish exposure. The actual length of the exposure depends on how fast the water is moving and how much you want it to blur (not to mention how much light you are shooting in). I find that most moderately fast-moving streams and waterfalls blur nicely between a half second and one full second. Any longer than that and you lose all detail in the water and, while that sometimes works, often it just looks like overexposed highlight areas where water should be.

I think it's better if you start with shorter exposures and then begin to double the duration for each succeeding exposure; that way, you'll have several options during editing. I exposed this shot of Kent Falls in Kent, Connecticut, for 1/2 second at f/16, for example, but also shot some at 2 seconds and 4 seconds, but I thought the water was too soft and blurry in those shots. Again, it really depends on the speed of the water and just how much of a blur you want.

By the way, you may get frustrated when working in bright light that you simply can't select a slow enough shutter speed without the photo overexposing. That's because your camera doesn't have an aperture small enough to balance out the long exposure (remember, when you double the exposure time you need to reduce the aperture size by one stop to keep the same exposure). The best solution is to use a neutral-density filter over the lens. These filters reduce the light hitting the sensor without changing its color and are very handy when it comes to making long exposures in bright light. Also, don't forget your tripod!

TECH SPECS: LENS: 24-120mm
FOCAL LENGTH: 147mm
EXPOSURE SETTING: 0.5 @ f/16
EXPOSURE MODE: Shutter Priority
WHITE BALANCE: Auto / FILE FORMAT: RAW / ISO: 200

Tweak Your Color Balance With Digital Filters

Back in the days of film (when dinosaurs still roamed the earth), among the many accessories that I used to load my camera bag with were a fistful of expensive (and heavy) glass filters for various photo effects: cooling, warming, soft focus, etc. Using filters was just a normal part of every photographer's shooting and there weren't any alternatives. These days, while I still carry a polarizing filter and a few neutral density filters, I do most of my filtering—especially basic warming and cooling—in Photoshop.

In this rural Iowa farm scene, for example, I used the #85b warming filter option to tweak the overall warmth. I then used the Density slider to adjust the intensity of the warming filter to about 20% density. I tend to work at about 15-25% density when I'm adding warmth or cooling, but it really depends on the image and the effect I'm after.

Using the filters is very quick and very simple, and while I generally prefer to create balances using more controllable tools (like the Curves and Selective Color tools), the Photo Filters are great for a quick fix or just to get a preview of how a particular shot might look with a different color balance.

Remember that, as with most Photoshop filters, you can also make a selection first and just add the filtering to the selected area—very useful for warming up a red barn or even just a single flower blossom, for example, or for cooling a blue sky.

I have to admit that while I have romantic memories of choosing just the right color filter when I was in the field

The fastest way to add warmth (or cooling) to a file in Photoshop is using the Photo Filter option that you'll find in the pop-up menu at the bottom of the Layers palette (click on the bisected black-and-white circle icon for the menu). Once the Photo Filters toolbox opens, you'll find 20 preset filters (warm, cooling, blue, yellow, emerald green, etc.) and a second box that you can click to create a custom filter from virtually any color that you want. Using the presets is simple: just pull down the menu, highlight the filter you want to try, and select it. If you don't like the look, just slide the menu back down and try again with another filter.

shooting, and took some sort of silly pride in my collection of expensive glass filters, I really don't miss them (or the hassle of keeping them clean). Those lens filters were expensive, delicate, and heavy—and they also degraded sharpness. Viva la Photoshop!

TECH SPECS: LENS: 300 mm f/2.8
FOCAL LENGTH: 450mm
EXPOSURE SETTING: 1/40 @ f/22
EXPOSURE MODE: Aperture Priority
WHITE BALANCE: Cloudy / **FILE FORMAT:** JPEG / **ISO:** 200

The Ups & Downs of Horizon Placement

reference point for infinity—that which cannot be measured or comprehended. (Whew, I better stop reading those Isaac Asimov books!)

Probably the worst place to put the horizon is smack dab in the middle of the frame because that cuts a scene in half and divides the viewer's attention. A centered horizon line creates a static scene because both upper and lower portions of the frame are spatially the exact same. It pits the power of the sky and the earth against one another on an equal footing. There are exceptions to this concept, of course, and sometimes putting the horizon through the middle of the frame (to draw attention to a smooth, perfect reflection of trees in a lake, for example) can create a very graphic look.

Here's a quick tip that will help you organize the spaces in almost any landscape photo: watch where you place the horizon.

Where the horizon line is placed in a landscape photo has a big impact on how the spaces in a photo are perceived. Placing it high in the frame (as I did here in this shot of Stonington, Maine) increases the sense that there is a substantial amount of space between the photographer's position (and, by extension, the viewer's position) and the boats. A high horizon always enhances the perception of distance in a photograph.

Conversely, placing the horizon low in the frame accents the sky, diminishing the size of the foreground subjects and making the horizon seem closer. Also, because the sky is the largest size reference with which humans are familiar, whenever there is a large area of sky, psychologically that area seems larger still. The sky is our cute little human

In deciding where to place the horizon, just ask yourself which part of the scene you want to dominate the frame or which spaces you want to exaggerate. If you want more emphasis on the foreground, place the horizon high. If you want to show off the sky (in a sunset, perhaps) lower the horizon. And if you are suffering from an acute bout of indecision, shoot several variations of the scene and make your decisions in editing.

TECH SPECS: LENS: Built-in zoom
FOCAL LENGTH: 78mm
EXPOSURE SETTING: 1/220 @ f/7.6
EXPOSURE MODE: Aperture Priority
WHITE BALANCE: Auto / FILE FORMAT: JPEG / ISO: 100

Focus Selectively

While there are many photo situations where your goal is to make the entire frame sharp, such as landscapes, there are other times when you might want to limit focus to a very shallow area of the frame. This technique is called selective focus and it requires restricting the depth of field, or the near-to-far area in a frame that is in acceptably sharp focus. Selective focus is particularly useful in outdoor portraits (human or animal) because it enables you to subdue distracting backgrounds and focus attention on just your subject.

There are three primary things that affect how much of the image will be sharp: aperture, focal length, and your distance to the subject. All other things being equal, using a wider aperture (f/5.6 instead of f/11, for example) will create a much more shallow depth of field. Longer focal length lenses also limit sharp focus. In order to separate this pink flamingo from the distracting surface of the pond behind it, for example, I combined using a long lens (300mm) and a wide lens aperture (f/5) to limit sharp focus to just the eyes and neck feathers. Also, because I was relatively close to the flamingo, the depth of field was even more restricted.

When you are keeping focus targeted to a very limited area, it's important that you focus with great care. If you are taking a portrait, for example, and intentionally toss the background out of focus, it's vital that you focus carefully on the eyes so that your use of selective focus looks intentional. Let's face it, if you focus on the tip of someone's nose and throw their eyes out of focus, there is bound to be some grumbling from your subject.

Just remember the three keys to limiting focus to a narrow zone: use a wide aperture, a lens with a relatively long focal length (longer than a normal lens, at least), and get as close to your subject as you can. Then, if someone complains about the emphasis on their nose, well, at least you did your part.

TECH SPECS: LENS: 70-300mm
FOCAL LENGTH: 300mm
EXPOSURE SETTING: 1/160 @ f/5
EXPOSURE MODE: Auto / WHITE BALANCE: Cloudy
FILE FORMAT: JPEG / ISO: 200

Plan Your Spring Photography Garden

As I write this tip, my gardens are covered in snow, the temps are in the low 20s (and expected to go below zero by the end of the week), and spring seems a million miles away. But in reality, the first day of spring is only about 10 weeks away and already my mailbox is filling up with garden catalogs—they save my life every winter!

I spend a lot of winter nights daydreaming about what plants I'd like to grow and which would be the most interesting to photograph. The bleeding heart shown here, for example, is an incredibly easy-to-grow shade plant but provides one of the most photogenic flowers you'll ever see.

TECH SPECS: LENS: 105mm Micro
FOCAL LENGTH: 157mm
EXPOSURE SETTING: 1/20 @ f/11
EXPOSURE MODE: Aperture Priority
WHITE BALANCE: Cloudy / FILE FORMAT: JPEG / ISO: 200

And seedlings of this plant are really cheap online (under $5). Most seed catalogs list literally thousands of flower (and veggie) seeds and it warms my photographer's soul just to look at all of those interesting colors and shapes.

One of the things that you can do if you plan your garden with catalogs in your lap is to create very specific color schemes: creating a "hot" garden of reds, yellows, and oranges, for example. Or as I did here, creating a cool garden of purple iris and green foliage. And speaking of foliage, remember that a good photographic garden (and a good garden in general) is made up not just of pretty blooms, but of plants that provide foliage in a variety of textures, shapes, and sizes.

Most important, you don't need a big yard (or any yard at all) to grow flowers in a container, and if you are clever with your compositions, none of your friends will know that you grew your "garden" in a small pot on the windowsill.

TECH SPECS: LENS:18-70mm/ FOCAL LENGTH: 105mm
EXPOSURE SETTING: 1/10 @ f/20
EXPOSURE MODE: Aperture Priority
WHITE BALANCE: Cloudy
FILE FORMAT: RAW / ISO: 200

Shoot Pictures Through Airplane Windows

There is nothing I love more than flying. I hate the security lines, the luggage shuffle, and the tiny seats, but I just love to sit back and fly somewhere—almost anywhere. And I love getting a window seat because I am absolutely fascinated by watching the clouds, the cities, and the towns and geography below. I can easily sit there for five or six hours and never take my eyes away from the window. Naturally then, I like to take pictures of what I see.

Taking photos through an airplane window is very simple, and while there aren't many choices to make about technique, there are some tricks to getting good quality. Even though the photos are obviously not as sharp as they could be since you're shooting through thick glass, you can help the sharpness by making sure your camera is selecting a high shutter speed (1/125 or faster is good) in the Auto mode; if not, try bumping up the ISO one or two stops. Also, don't rest the camera right on the wall of the plane or the window or the vibration will shake the camera; instead, either hold it an inch (2.5 cm) or so away from the wall or roll up a sweater to absorb the shock.

To prevent reflections, turn off the overhead light and keep the camera as close to the glass as possible. If reflections are still a problem and you're traveling with a friend, try to coerce them into holding a dark airplane blanket or sweater behind the camera to block interior lights. Also, check to see if the window is clean inside (they probably won't let you climb out on the wing to clean the outside surface), and if not, use a napkin to get the smudges off.

There are lots of things to shoot from airplane windows, including geographic features (mountains and lakes look cool), rivers, sunrises and sunsets and, of course, cloud formations. If you're obsessive like me, you can even take notes on what you think the features are that you're shooting and then look them up on a map later. Taking photos from airplanes makes the times pass more quickly, I think, which can be a good or a bad thing!

TECH SPECS: LENS: 28mm / FOCAL LENGTH: 42mm
EXPOSURE SETTING: 1/500 @ f/4
EXPOSURE MODE: Auto / WHITE BALANCE: Auto
FILE FORMAT: JPEG / ISO: 64

Photograph People at Work

Every day we're surrounded by people at work doing relatively ordinary jobs: men putting a new roof on the house next door, people selling produce at the farmers' market, crossing guards getting the kids to school safely—all kinds of jobs that most of us barely notice, let alone photograph. In large part these are the people who keep the fabric of our lives together and yet somehow we develop a blind spot to them. But the things people do to earn a living are often quite visually interesting and they're so rarely photographed that they become even more interesting in their rarity.

Recently, I had a big maple tree taken down in my backyard and I became fascinated watching the tree cutters at work. These young guys, most of them from Central America, hung out of ladders and swung around on ropes that were 75 feet (22.9 m) off the ground, and it looked like they actually enjoyed what they were doing (I was getting vertigo just watching them). I decided to document their amazing skills (and courage) and I probably shot 50 or so images during the several hours that they worked. They were so engrossed in their work I'm not even sure they noticed that I was taking pictures.

Once the tree cutters had the tree down, I went inside, downloaded the images, and printed a few 8 x 10-inch (20.3 x 25.4 cm) prints of the guy that did most of the cutting. When I gave him the print he seemed somewhat shocked. At first I thought he was just surprised that I was able to give him a print in just a few minutes. But the story was far more interesting: it turns out he'd never seen a photograph of himself at work and—even more incredibly—his mother back in Central America hadn't seen any photo of him in the 12 years he'd been living and working here. I was stunned. In all the time he was living here he'd never had a single photo of himself taken to send home.

Of course, I gave him extra prints to send home to her and he was overwhelmed and very grateful. Here I was just trying to pass the time and put some more images into my library and those photos became a connection between a mother and son thousands of miles apart. Everyone has a story to tell; as a photographer, it's your job to help them tell it visually.

TECH SPECS: LENS: 24-120mm
FOCAL LENGTH: 180mm
EXPOSURE SETTING: 1/320 @ f/9
EXPOSURE MODE: Aperture Priority
WHITE BALANCE: Cloudy
FILE FORMAT: JPEG / ISO: 200

Ignore the Composition Police

For something that's supposed to be as creative and free-flowing as composing a photograph, there sure seem to be a lot of rules and regulations about what not to do: don't put your horizon in the middle, don't tilt the horizon, always divide your frame into thirds. You'd think there were composition police lurking in photo labs waiting to nab unsuspecting rule violators. I've been in a lot of labs though, and so far I haven't seen any arrests.

Most composition "laws" are better described as useful guidelines and there's no need for slavish devotion to them. In fact, often breaking the rules and putting convention aside is not only an acceptable thing to do, it's the creatively superior thing to do. The tricky bit is knowing when to do it.

How do you know when it's right? When it looks right to you in the viewfinder, or better, when it feels right. In shooting this photograph of my girlfriend in Monument Valley, for example, I decided to break one of the cardinal rules of composition that says your main subject should never be dead center in the frame. The reasoning behind this is that centering a subject creates a very stagnant design. At the moment I shot this frame, however, she was engulfed by the incredible environment and it seemed to me that putting her smack dab in the center of the frame—both horizontally (the center of the frame runs right through her waist) and vertically (she divides the frame in half)—was exactly the right thing to do. It not only felt natural but, in a gently surrealistic human-in-the-environment level, it seemed to be symbolically correct. This has always been one of my favorite shots of her and of Monument Valley.

I love reading books about composition, including those written for photographers as well as painters, and I've learned a great deal about what makes one picture stronger than another. So-called rules become rules largely because a lot of people have success with them. And I try to incorporate as many of the successful ideas into my work as possible. But there are times when you'll encounter a situation where none of the rules seem to fit, or where tearing the rule book to shreds seems like the best option. If that happens to you, go with your gut. Soon enough you'll find out that the only design principles that really matter are the ones that work for you.

TECH SPECS: LENS: Built-in zoom
FOCAL LENGTH: 35mm
EXPOSURE SETTING: 1/720 @ f/5
EXPOSURE MODE: Aperture Priority
WHITE BALANCE: Auto / **FILE FORMAT:** JPEG / **ISO:** 100

Collect Photos of Weird Things

Almost everyone collects something, whether it's books, baseball cards, old records, or (heaven forbid) pieces of burnt toast with Elvis' face on them. The trouble with collecting actual things of course, is that things take up lots of room—which may partly explain the extraordinary popularity of self-storage locations these days. I collect photography books, for example, and trust me, pretty soon either some of the books are going to have to go or I'm going to have to add on another room. Or I'll have to leave the books here and move myself into a storage unit.

One clever way to collect things without actually storing them, however, is just to photograph them. Then you can have a collection of something fun and your wife or husband won't threaten to move it (and you) out to the garage. Also, collecting pictures of interesting things, as opposed to collecting the actual thing, is much cheaper and you can amass quantities of stuff that might not be particularly practical to keep in the spare bedroom—surplus military aircraft, for example.

A few years ago I started collecting photos of unusual manhole covers. What got me started one day was noticing that the manhole covers on my street have the town name and the year they were installed engraved on them. Cool! I had to shoot a picture of one of them. And that's how collections usually start: you bring home one manhole cover (or one hippopotamus) and pretty soon you have an entire den full of them. I found the one shown here near the Eiffel Tower in Paris and was taken by the very artistic design of the rain holes. And only in Paris could I spend 10 minutes photographing a manhole cover without getting a second glance from anyone.

As with all collections, the more peculiar or esoteric the object, the more fun it is to collect (and the more eccentric your friends will think you are). But no matter how obscure the objects of your passion, you won't be the only person collecting them. I guarantee someone else is gleefully hoarding them, too! How do I know? A few days after I posted this shot of the manhole cover on my flickr.com photostream, someone invited me to add it to their group of—you guessed it—unusual manhole cover photos. Artistic minds think alike.

TECH SPECS: LENS: 24-120mm
FOCAL LENGTH: 70mm
EXPOSURE SETTING: 1/125 @ f/5.6
EXPOSURE MODE: Program / WHITE BALANCE: Auto
FILE FORMAT: JPEG / ISO: 200

Listen to the Light

Thanks to a brilliant man named Harold "Doc" Edgerton, the inventor of the electronic flash, there's almost no place that's so dark that you can't take a well-exposed photograph. A black bat in a dark cave at midnight is almost no challenge for a tiny electronic flash unit.

Bats in black caves aside, the problem with turning on the flash when the light grows a bit dim is that it's often akin to using dynamite to clean out a gutter: it's a bit of an overreaction. Just because the light is low doesn't mean that flash is

Instead, when you encounter what appears to be an illumination-challenged scene, sit quietly for a moment and "listen" to the ambient light around you. Unless you're sitting in complete darkness, there is some light available and that light is speaking to you, luring you to its presence. No doubt it was that small presence of light that caught your imagination in the first place.

It's surprising, for example, how many wonderful photos you'll find just by listening to the quiet light pouring in a

window (particularly a north-facing window); soft, unusually flattering, and very color-neutral, window light is the portrait light the masters used. I found my cat sleeping in the dim but quiet light of a bay window one day and while I was tempted to pop on the flash, I instead let the gentleness of the north light speak and shot only with existing light. The light was creating a gentle moment and I wanted to preserve that. Because I didn't turn on the flash, the cat endured my shooting several photos; had I blasted her with the built-in flash, she probably would have bolted after one shot.

the only solution. Sometimes, in fact, there's more light in a scene than you might think. By switching to a lens with a wider maximum aperture or cranking up the ISO speed (or both), you can often shoot photos in what looks like a complete absence of usable light. More importantly, turning on flash often ruins the delicate ambience of the existing light.

Light will speak to you; it is there, just perk up your eyes and listen!

TECH SPECS: LENS: 50mm f/1.8 / FOCAL LENGTH: 75mm
EXPOSURE SETTING: 1/50 @ f/4.5
EXPOSURE MODE: Auto / WHITE BALANCE: Cloudy
FILE FORMAT: JPEG / ISO: 200

Use Exposure Compensation with Snow Scenes

As much as I hate cold weather (and the farther into winter we get, the more I hate it), I have to admit that snow is wonderful to photograph. Just a few inches of fresh snow can transform even the most ordinary landscape into (dare I say it?) a winter wonderland. It would be nice if I could photograph all of that wonder from inside a nice, warm cafe, perhaps, but I suppose that's asking a bit much.

One problem with photographing snow is that it fools light meters into thinking that there is more light than there really is. This causes the camera to underexpose the snow (by giving too little light), which creates photos of gray rather than white snow. Bing Crosby would be appalled: I'm dreaming of a gray Christmas…it just doesn't work. The solution is simple, though: just add some extra exposure using your camera's exposure-compensation feature. This feature lets you add or subtract light from the exposure, usually in 1/3-stop increments (also referred to as exposure value, or EV). The typical increase for snow is about 1 2/3 stops of + compensation. If the snow is very bright, you might even want to give it a full +2 compensation. Experiment a bit and you'll learn which settings work best.

You might also try the exposure-bracketing feature if your camera has one; have it expose for the normal scene it is metering, plus one and two extra stops of exposure. Then your camera will fire three quick frames, automatically adjusting the exposure for you. Read your manual for more on this feature. For more advanced photographers, a technique known as HDR (High Dynamic Range) is a great solution to high-contrast snow scenes, and you can read more about it online or in the book *The Complete Guide to High Dynamic Range* from Lark Photography Books.

Regardless of exposure technique, the best time to photograph snowy scenes is usually early or late in the day when the light is more gentle, the contrast is less intense, and there is often a slight warmth in the lighting color.

TECH SPECS: LENS: 24-120mm / FOCAL LENGTH: 42mm
EXPOSURE SETTING: 1/400 @ f/10 (+ 0.66EV)
EXPOSURE MODE: Manual / WHITE BALANCE: Auto
FILE FORMAT: JPEG / ISO: 200

Make an Accessory Survival Kit

If there is one thing photographers like almost as much as buying a new camera, it's buying lots of little toys to go with it. Unfortunately, a lot of the more important accessories—flash units, filters, tripods—can be quite expensive. But there are lots of really inexpensive and useful accessories that can save the day in a pinch. Best of all, you can sneak them past your better half without having to confess they're going to live in your camera bag.

Here are my top 10 favorite inexpensive accessories:

◆ **Plastic zipper bags:** I use these bags for everything from an impromptu rain cover for the camera to keeping lenses and other expensive gear clean and dry inside my bag or vest. Airline security can easily see what's in them, too. Buy several sizes from one quart to three gallon; they have a million uses. Cost: about $3-5.

◆ **Heavy-duty garbage bags:** I keep several garbage bags in my shooting vest and in my shoulder bag and if I get caught in a downpour, all the gear gets stashed immediately. Cost: about $7 for a box of 32.

◆ **Small flashlight:** Finding and reading all of those tiny dials and switches on your camera is tough once the sun sets (or if you're in a dark room). They're also great for reading maps in a dark car (dome lights are worthless) and just might save your life if you get lost in the wilderness. Buy and carry a few. Cost: under $5.

◆ **Disposable lighter:** I wouldn't go into the wilderness—even a local state park—without a lighter. You can use them to light an emergency fire, or even to signal for help. Cost: under $2.

◆ **Laminated maps:** Most grocery stores and gas stations have a pretty good selection of local and regional maps. Laminated maps last for years (I have a Manhattan map I've had for 10 years), they fold very flat, and you can mark them up with China markers and then wipe them clean. Cost: about $8 (overpriced but worthwhile).

◆ **Trail mix:** If you fly a lot, you know how hard it is to catch a snack between flights or when waiting for one. Also, whether you're hiking in the city or woods, a bag of trail mix can save your sanity and your mood. Cost: under $5 (much cheaper at home than in the airport).

◆ **Rain pocho:** I recently got caught in a horrific downpour while photographing the Statue of Liberty and a poncho kept me and my gear totally dry. Cost: under $8, and worth every cent. Buy better quality if you have a choice.

◆ **Duct tape:** A small roll of duct tape or electrical tape has a million uses, from patching tears in a camera bag to repairing a blown-out flip-flop. It's also good for quick-fixing a broken battery compartment door. Buy the bright neon colors; they're easier to find in your gear and you can use it to mark trails if you start to get disoriented in the woods. Cost: under $5.

◆ **Travel soap dish:** The unbreakable plastic variety are great for keeping small accessories like memory cards and batteries from floating around in your bag, or for stashing some extra cash. Cost: under $2.

◆ **Small bungee cords:** Absolutely indispensable for keeping tripod legs together or backing up your shoulder bag's zipper lid during the airport shuffle. Great for securing a water bottle to your tripod leg, too. A million uses. Cost: Under $5 for a pack of five.

Next time you're trying to think of a unique gift for the photographer in your life (or for yourself), think about making a survival kit with items from the list above—you can probably do it for under $50. You can carry these essentials with you in a large camera bag, backpack, or buy yourself a nice tote bag, like the one seen here from the Center for Creative Photography in Tucson, Arizona.

TECH SPECS: LENS: 18-70mm / FOCAL LENGTH: 62mm
EXPOSURE SETTING: Aperture Priority
EXPOSURE MODE: Auto / WHITE BALANCE: Cloudy
FILE FORMAT: JPEG / ISO: 200

Shooting Wildlife from Your Car

The toughest part of getting good wildlife shots is just getting close enough to your subjects so that they fill the frame nicely and are behaving naturally. Unfortunately, most birds and animals refuse to see us as anything but predators, and once they are frightened and start playing hide-and-seek, they become very elusive subjects.

One method of getting close to animals is to spend a lot of time squatting in a blind placed close to where your subjects hang out. If an animal gets used to seeing your blind in the same place, it will eventually ignore it. For many animals, however, you don't need to spend money on a blind because you probably already own a great one—your car. Animals rarely see cars as a threat, and unless you roll down the window and start whistling at them, they quickly adapt to its presence.

The key to using your car as a blind is to find an active area and then shut the car off while the wildlife becomes accustomed to its presence. I often park and sit still for a few minutes, then quietly get into the back seat and mount the camera in a rear window. Shore birds like egrets and herons tend to return over and over to a small feeding area where they can confine their food. If you park next to one of these areas you'll find the birds returning there over and over again. I shot the photo here, for example, on the Blackpoint Drive at the Merritt Island National Wildlife Refuge in Titusville, Florida, using a 70-300mm lens.

The main problem with shooting from a car window is keeping a long lens very steady. One way is to roll up a sweater or use an impromptu beanbag to keep the camera steady, but if you're using a very long lens— 300mm or longer—you're better off investing in a good "window pod" that mounts to your car door and window.

The best window pod that I've used is the Groofwin Pod (short for "ground-roof-window") that was designed by legendary wildlife shooter Leonard Lee Rue. This uniquely named and odd-looking camera support has multiple uses: it works as a low-level tripod for macro or wildlife work when it's used on the ground, it can be used on the roof of your car, or it can be used as a window pod. When used in a car window, the pod uses a 9 x 1-inch (23 x 2.5 cm) lip that can either be slipped into the window groove when the window is down, or catch onto the window itself if the window is partially raised. When used with my heavy-duty ballhead, I've used lenses up to 600mm and they held rock solid. The Groofwin sells for about $300 and if you're serious about shooting from a car window, it's a great investment that will help turn your car into a great wildlife shooting blind.

TECH SPECS: LENS: 70-300mm / FOCAL LENGTH: 375mm / EXPOSURE SETTING: 1/200 @ f/5.6 EXPOSURE MODE: MANUAL / WHITE BALANCE: Cloudy ISO: 200

Way back in the pre-Photoshop days, photographers who wanted to get experimental with color had to get somewhat inventive in their techniques. And since many of us grew up in the 1960s and were influenced by artists like Peter Max, we went to some pretty great extremes to intentionally scramble colors. The simplest method was to put colored filters over lenses, but some photographers got more extreme and tried methods like duplicating negatives and slides (often through many generations) and filtering them during duplication, cross-processing film (developing slide films in a chemistry solution meant for color negative films), or just messing around with colors in the darkroom.

One other option that a lot of us experimented with was a film called Kodak Ektachrome Infrared Film. This film was called a "false color" film because it included a layer that was sensitive to the infrared portion of the spectrum (which is invisible to humans), and the way that the film produced colors could never be predicted. By using filters over the lens, you could further mix up the already off-beat color palette.

TECH SPECS: LENS: Built-in zoom
FOCAL LENGTH: 35mm
EXPOSURE SETTING: 1/1050 @ f/3.2
EXPOSURE MODE: Aperture Priority
WHITE BALANCE: Auto / FILE FORMAT: JPEG / ISO: 100

The colors were wild, too: foliage often took on a magenta color, greens became bright yellow, and the skies would range from magenta to brilliant pink or yellow/green, depending on what filters you used and what the atmosphere was doing that day. It was a blast! Unfortunately, Kodak stopped making the film a few years ago and unless you have some stored in your freezer, it's a thing of the past.

There's a simple way to recreate the false-color look in Photoshop, however, and it's a lot of fun to play with. All that you have to do is open an image and then select the Hue/Saturation sliders (Image>Adjustments>Hue/Saturation). By sliding the Hue to extreme positions, you'll see the colors go through all sorts of wild combinations. That's exactly how I created this shot of St Patrick's Cathedral in New York City. Once I had a color shift that I liked, I used the Saturation slider to pump up the colors a bit more. I then used the Selective Color sliders (Image>Adjustments>Selective Color) and adjusted individual colors (in this case, I adjusted the magenta layer to add even more magenta to the sky). As a final step, I used the Noise filter (Filter>Noise>Add Noise) to add some noise to give the shot a slightly more realistic film look.

For some reason, the hue shifting that you can create in Photoshop resembles the Infrared look a great deal, and playing with it is kind of like a flashback to the basement darkroom I had during high school. If you'd like to see how pictures shot with the film really looked, take a look at the flickr.com Color Infrared pool. The great thing about experimenting with ideas like this is that there is no right or wrong, so you can't make any mistakes and the results are always unexpected and fun.

TECH SPECS: LENS: 24-120mm
FOCAL LENGTH: 36mm
EXPOSURE SETTING: 1/320 @ f/5
EXPOSURE MODE: Shutter Priority
WHITE BALANCE: Cloudy / FILE FORMAT: RAW / ISO: 200

Become a Peeping Tom

I must be a snoop by nature because it's very hard for me to see an interesting window and not press my face up against it to see what's inside. No, I'm not talking about roaming the neighborhood at night, but whenever I encounter a public building that might be hiding something of interest or an interesting storefront (antique stores often have great displays), I have to take a peek—and sometimes a few pictures.

Take, for example, the day I found a beautiful surprise inside a large, glassed-in building at a beach park in Connecticut. I'd seen the building from a distance several times before but I had no idea it held such a fine treasure. On this particular afternoon, however, I walked closer and saw that the late-afternoon sun was lighting up a beautiful old wooden carousel. Wow, what a visual treat to find—except that the building was closed and my only shooting access was through a bank of big windows. The lighting on the horses was gorgeous though, and it was bringing out a wonderful range of colors and textures. I couldn't resist at least trying to get a shot.

Shooting through glass isn't necessarily that tough of a problem, but on this day the setting sun was particularly brilliant and it was creating a ton of glare on the glass (which had a lot of nose smudges from other curious peepers).

Because the sun was going down very fast, I quickly explored several different sides of the building and settled on a side window that had a minimal amount of reflection. I also switched to a longer lens (a 70-300mm) so that I could get close-ups of the horse heads.

While there was still some glare in most of the shots (look carefully at the left side of the picture and you'll see some glass highlights), it was minimized by the combination of the longer lens and by finding a window that wasn't directly facing the sun. If I'd had more time, I might have found a rag and cleaned off a window, but the light was just melting away and I was losing the texture on the horses.

A polarizing filter (see tip 65) is also a great help in these situations and all you have to do is rotate the filter to eliminate most glass reflections. The only problem with using a polarizer is that they do suck up about 1 1/3 stop of lighting.

Shooting in through windows isn't a situation you will run into a lot, but when it does come up, it's nice to know there are tricks you can use to get the shot. The key is to find an oblique angle that hides the maximum amount of reflection and use a zoom lens to crop away everything but the key parts of the subject. And if you have a bottle of window cleaner and a rag with you, that won't hurt.

TECH SPECS: LENS: 70-300mm
FOCAL LENGTH: 360mm
EXPOSURE SETTING: 1/250 @ f/5
EXPOSURE MODE: Auto / WHITE BALANCE: Auto
FILE FORMAT: RAW / ISO: 200

Go on Safari in Your Own Backyard

While venturing off to Africa on safari is pretty much the fantasy of every wildlife photographer (me included), you really don't have to travel too far to find interesting animals to photograph. It's surprising, in fact, how much wildlife there is in a typical suburban neighborhood. In my little yard in Connecticut I've seen red fox, opossums (lots of them), raccoons, wild turkey, coyotes, a few kinds of snakes (all harmless, I think), woodchucks, skunks, turtles, and even the occasional hawk. And that's not to mention the dozens of different bird varieties that come to my feeders (or the stray cats that stalk them).

The great thing about photographing animals in your own backyard is that you don't have to go anywhere to find them. As with photographing any animals, African or suburban, the more you know about your quarry, the better your odds of getting good shots. If you've lived in a house for a year or two, you probably already know the animals' habits and when and where you're likely to see them. The raccoons in my neighborhood, for example, rattle the garbage cans almost every night in the summer at just about 2 a.m. I've surprised them a few times by showing up with my camera and flash just as they arrived.

The bunny in this shot has been my gardening pal for a few summers now. She comes within two or three feet (61-91 cm) of me when I'm weeding the veggie patch and I'm convinced that she likes human company. Even when I got up to run inside and get my camera the day I shot this photo, she didn't move at all, and while I was photographing her from about eight feet (2.4 m) away with a 70-300mm lens, she sat patiently munching the grass.

If you leave an old tripod next to a birdbath or a bird feeder for a few days before you plan to shoot, the birds will get used to it being there and it will help them ignore you. Also, shoot from a lawn chair if you can since the birds will probably ignore you if you're just sitting nearby. Inch the chair closer to the food or water every few minutes and you'll be able to get very close to them. You might also want to consider an inexpensive remote control (the one for my camera was only about $15) and then you can place the camera on the tripod and operate it from a greater distance—some remotes let you work up to 50 feet (15.2 m) away.

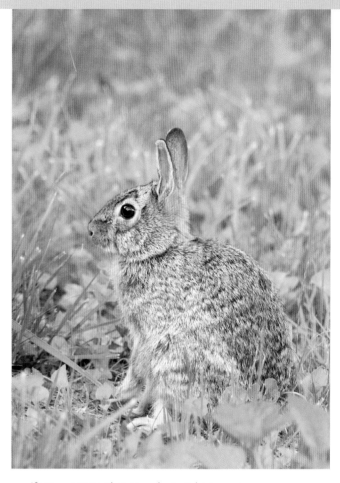

If you want to photograph at night, try using an accessory flash (as opposed to the built-in flash) because you'll get greater distance and more overall power. There are even devices available (like the Time Machine by Mumford: www.bmumford.com) that use infrared and/or sound triggers to fire the camera remotely so that the animals will take their own portraits. You can be watching reruns of Wild Kingdom and photographing animals in your backyard at the same time.

TECH SPECS: LENS: 70-300mm
FOCAL LENGTH: 232mm
EXPOSURE SETTING: 1/1250 @ f/5.6
EXPOSURE MODE: Auto / WHITE BALANCE: Cloudy
FILE FORMAT: RAW / ISO: 400

Consider the Strange Beauty of the Fisheye Lens

If you happen to be a D-SLR shooter, are completely bored with all of your lenses, and have an extra $700 or so burning a hole in your equipment pocket, a fisheye lens may be just the thing you need. That's exactly the situation I was in when I bought mine and I have to tell you, as unnecessary as owning a fisheye lens is, it's still a lot of fun—and actually, there are some practical uses (just in case you need to justify owning it to a nit-picking spouse), though you may have to stretch the word "practical" a bit to find them.

The fun part first: a fisheye lens is an ultra-wide-angle lens that provides a whopping 180-degree angle of view (measured diagonally from corner-to-corner) and that is far wider than even our own peripheral vision, which is about 120-degrees. The kind I recommend is a full-frame fisheye lens because it does not provide the cropped, circular angle-of-view that some fisheye lenses produce. The result is a wild and distorted view of the world that can't be obtained

TECH SPECS: LENS: 10.5mm fisheye
FOCAL LENGTH: 15mm
EXPOSURE SETTING: 1/100 @ f/8
EXPOSURE MODE: Program
WHITE BALANCE: Auto / FILE FORMAT: RAW / ISO: 200

with any other lens. Photos taken with fisheye lenses have a curved or bowed distortion that, combined with the super-wide view, produces some really interesting and creative images.

Another benefit of such a wide lens is that it has incredible depth of field—you barely have to focus this lens. and if you shoot at a mid-range aperture like f/8 or smaller, everything from your feet to the horizon will be in sharp focus. In fact, I shot the picture of the snowy beach seen here at f/6.3 and everything is in sharp focus from the bench that's about a foot (30cm) from my knee to the far horizon. And as you can

see here, when you include the horizon in a fisheye shot, you get a wickedly curved horizon line that looks like the edge of the earth.

Fine, so now that you have yourself convinced that you absolutely need one of these lenses, what are the practical applications? Because these lenses produce such a super-wide angle of view, and because they have enormous depth of field, you can use them in tight spaces to provide very inclusive and very sharp images (like when photographing your beautifully remodeled bathroom so that you can show it off to the relatives—you see, a perfect argument in favor of owning this lens). You can also photograph large groups of people without having to back up three blocks (like all of your wife's relatives gathered on your front steps—you can see where I'm going with this).

But won't these images be horribly distorted? Ah, there's the fun part (oops, this is supposed to be the practical part): there is software available that can correct the distortion and leave you with an optically correct image that still retains the wide-angle view and great depth of field. The Fisheye-Hemi

plug-in from Image Trends is one good option which sells for under $30 and works with both Photoshop and Apple Aperture. Once you've run the image through the software, the curved lines and image distortion are totally removed. Neat, eh?

To be honest, as much as I wanted this lens, it sat in my camera bag and was used infrequently for the first few months that I owned it. Since then, however, I've been carrying it with me everywhere, and though it doesn't fit into every situation, it's a ton of fun to have around. It's also a tiny lens physically and will easily fit into a jacket pocket. Now if only it took photos where subjects lost weight and sported a full head of hair—then you'd really have no problem selling the spouse on this great lens' wonders.

TECH SPECS: LENS: 10.5mm fisheye
FOCAL LENGTH: 15mm
EXPOSURE SETTING: 1/60 @ f/8
EXPOSURE MODE: Program
WHITE BALANCE: Auto / FILE FORMAT: RAW / ISO: 200

Draw Textures Out with Sidelighting

Whether it's the smooth, glossy surface of a bowling ball or the coarseness of a piece of sand paper, all objects have a texture. Finding ways to translate that texture in a photograph so people can "feel" the surfaces you're photographing is one of the things that makes the subjects seem more accessible. Remember, the world is a three-dimensional place (height, width, depth), but a photograph only has two of those dimensions. Your viewers can't reach in and scrunch someone's five-day beard in a portrait (not that they'd want to) or feel the softness of a baby's hair (everyone will want to touch that), so you have to provide the tactile sense for them.

The best way to accent textures in a photograph is by paying attention to the direction of the light as it strikes the surfaces of your subjects, and the best light for drawing out textures is sidelight. Light coming from the side casts myriad tiny shadows across the surface of an object and gives it a three-dimensional look. I photographed this old door handle with really extreme sidelight (look at how long the shadow on the left is), and the lighting really brought out the rough-hewn surfaces of the wood and the hand-hammered metal.

Sidelight also works to bring out the textures of things like a sandy beach or a gravel parking lot in a landscape. Backlighting will do the same thing, to some degree, especially if it's late in the day and the light is scraping off the landscape from a low angle. In some situations you won't see as much texture with backlighting because some of those tiny shadows (like the ones cast by side lighting) are hidden from the camera by other objects.

You can experiment with lighting direction and its effect on texture without much effort. Try photographing a rough-surfaced rock with the light falling on the front of it sometime and then move around the rock and shoot it so that the light is coming from the side—you'll see the difference immediately.

TECH SPECS: LENS: 18-70mm / FOCAL LENGTH: 105mm
EXPOSURE SETTING: 1/20 @ f/15
EXPOSURE MODE: Aperture Priority
WHITE BALANCE: Cloudy / FILE FORMAT: JPEG / ISO: 200

Stop Target Shooting: Use Off-Center Subject Placement

a feeling that all of those green boxes floating around in the viewfinder create their own brand of confusion, especially when you're used to a single focusing indicator, but they do provide a lot of framing flexibility.

Regardless of how you do it, taking your subjects away from the middle of the frame will improve about 90% of the photos you take.

Using off-center subject placement creates a sense of visual intrigue and, if done well, a sense of balance within the

Based on the sheer number of subjects that most of us seem to place smack dab in the center of the frame, you'd think most of our cameras had targets superimposed in the viewfinders and that there were extra points for hitting the bull's eye. And in a way we do have targets in the viewfinder—after all, in a lot of cameras that's where the focus indicators and metering targets are placed. Why wouldn't we put the subject there?

The problem with centering your subjects is that it tends to create very stagnant compositions—especially when it comes to portraits—but it's true of most other subjects, too. When you intentionally provide an imbalance of space around your subjects, it creates a more dynamic design, and a feeling of balance.

Thankfully, camera companies have gotten hip to our center addiction and they've started to expand and extend the focus indicators across the entire frame. Some cameras actually have dozens of focus indicators to help you focus on off-center and moving targets (there's that word again). I have

frame. In this shot of a Japanese garden, by placing the stone lantern to the extreme right and balancing it with a large open area, I used the open space to balance the "heavier" portion of the frame (the tree and lantern). The eye roams around the rest of the frame, curious about the vastness of the space surrounding the subject. I think that in this particular case, the design also reinforces some of the Zen feeling of the garden.

Knowing how to focus (or meter) off-center subjects will give you confidence in off-center framing, so if you haven't read it in a while, take out the camera manual and find out how to use the focusing indicators in different placements within the viewfinder.

TECH SPECS: LENS: 18-70mm
FOCAL LENGTH: 105mm
EXPOSURE SETTING: 1/125 @ f/5.6
EXPOSURE MODE: Auto / WHITE BALANCE: Cloudy
FILE FORMAT: JPEG / ISO: 200

Mind the Moods of Light and Weather

One of the interesting things about photographing autumn scenes (or almost any landscape scenes, for that matter) is that, depending on the lighting and weather, they can produce a whole range of emotional responses. Scenes shot on misty or overcast days where the colors are saturated but muted have a soulful but very pensive look to them. The same scenes shot on a sunny day with a bright blue sky are almost bursting with cheerfulness.

Of all the autumn photos I've shot recently, the ones that stand out the most to me are a few dozen that I shot of a small clump of Ginko trees (also called Maidenhair). I shot the pictures in a period of about 10 or 15 minutes and I get a happy feeling whenever I look at them. How can you look at the colors in this shot and not feel uplifted? The day after I shot this photo the clouds moved in for several days and I drove by those trees again; while their leaves were still intact and their colors were rich, the scene was greatly dimmed, as if someone had pulled the plug on the tree, shutting off the glow. Had I seen those muted colors and the gray sky before I had seen the electric colors of the shot here, I never could have imagined how luminescent the scene had been before.

Light and weather play profound roles in our emotional interpretation of a scene, as does the color of the sky. To get a wide range of emotional climates in your photos, it's worth exploring in all kinds of weather—especially when the autumn colors come to town.

TECH SPECS: LENS: 80-200mm f/2.8
FOCAL LENGTH: 300mm
EXPOSURE SETTING: 1/125 @ f/11
EXPOSURE MODE: Aperture Priority
WHITE BALANCE: Auto / FILE FORMAT: RAW / ISO: 200

The Many (Almost Magical) Uses of a Polarizing Filter

If someone told you that they could sell you a single lens filter that could darken blue skies, saturate colors, remove surface reflections (including window reflections), intensify rainbows, and reduce haze—would you buy it? You bet you would. And a polarizing filter can do all of those things and, at times, they seem like an almost magical accessory.

Polarizing filters are one of the most versatile and important photo accessories that you can own and, even though I use one less with digital cameras than I did with film cameras (I'll explain why in a minute), I still use one regularly. In the simplest of terms, polarizing filters work by blocking certain wavelengths of light from entering the lens and allowing others. They have a rotating mount that screws to the front of your D-SLR lens; as you rotate the filter, it blocks different wavelengths. Among the things that a polarizing filter does superbly well:

◆ **Darkens blue skies:** Polarizing filters block extraneous scattered light reflections in the atmosphere and can be used to darken blue skies. I use them less for this than I used to with film cameras because I can create the same effect in editing and have somewhat more control. I also feel that polarizing filters tend to over darken skies with digital cameras if you're not careful about exposure and the exact rotation position. Sky darkening works best when the sun is to the right or left of your shooting position, and not at all when the sun is behind or in front of you. You can see the effect in the viewfinder as you turn the filter and as you alter your position to the light.

◆ **Saturates colors:** When you turn the filter, the colors of things like leaves and grass or people's clothing becomes more (or less) saturated. This is the main thing that I used to use polarizing filters for, but again, I can saturate colors more selectively in editing. Still, I will sometimes use a polarizing filter with landscapes where I want to control the color saturation at the time I'm shooting.

◆ **Eliminates reflections:** This is something you can't do very easily in editing! You can remove reflections from any nonmetallic surfaces just by rotating the filter. If you're shooting a store window display, for example, you can penetrate the reflections to reveal what's behind the glass.

◆ **Reduces atmospheric haze:** Polarizing filters are much more efficient at reducing haze (not fog) than so-called

"UV" (ultra-violet) filters, and they're essential in landscape photography for that reason.

◆ **Intensifies rainbows:** No joke! By reducing the atmospheric haze and by blocking certain wavelengths of light, you can strengthen the colors of a rainbow substantially.

Polarizing filters are not inexpensive and you will probably spend between $40-$100 on a good one. If you're using autofocus lenses, be sure to buy a "circular" filter, but check your lens or camera manual to be sure of the type you need.

TECH SPECS: LENS: 18-70mm / FOCAL LENGTH: 51mm
EXPOSURE SETTING: 1/60 @ f/16
EXPOSURE MODE: Aperture Priority
WHITE BALANCE: Auto / FILE FORMAT: RAW / ISO: 200

Bring Ancestors Back to Life (Photographically Speaking)

The family albums that most of us have tucked away on a bookcase or stuffed in a trunk provide an amazing visual history of our family trees. Most of us can look back through several generations of family photos and stare our ancestors straight in the face. In the office where I write, I have a collection of family photos that date back almost to the beginnings of photography. For example, I find it amazing that I am able to look at the face of my mother's mother, a woman I never met, in her youth. It's just amazing to see that face so clearly captured and know that I am related to her.

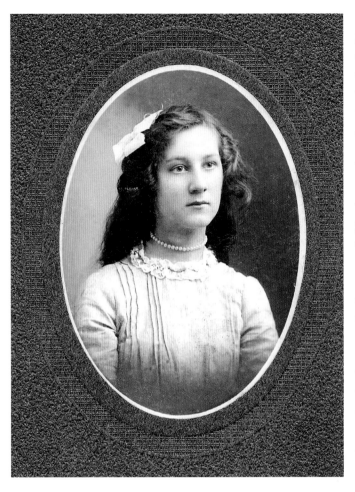

The problem with many of these early family photos, however, is that whether they are in our photo albums or framed on living room walls, they are often one-of-a-kind treasures. The negatives—if there ever were negatives—are long since lost and the prints we have are often badly faded and often physically damaged. Tears, stains, spots, and scratches are common.

The great news is that you can halt the decline of your family photos and, in fact, preserve and even restore them nicely with very little effort. If you have a flatbed scanner, it takes only a few seconds to scan a photographic print; in a few hours of free time you can probably scan most of your family albums. As an anniversary present for her parents, my girlfriend scanned 50 years of photos over a period of several weekends and then had them printed in large-format books. A great idea!

Be sure to scan them at a good resolution (300dpi or higher) so that you can make quality prints from them later. As you scan the images, try to title them as accurately as possible with name, date, location, etc. Then, when you finish a night's session, burn those files to a backup CD so that you have digital copies outside of your computer. If you don't own a scanner (and you should, they're under $100—a good holiday gift!), then take your family photos to a local camera shop that will scan them for you while you wait. That way your photos are never out of your sight. Don't mail your family photos to a mail-order lab or you may never see them again.

Restoring damaged photos is not really as difficult as it seems if you have some basic editing skills. Just making simple tonal and color adjustments, for example, can often erase years of fading. And a few minutes using the healing brush or the cloning tools in Photoshop or Photoshop Elements can eliminate dust, scratches, and even small tears. As your skills grow you'll be able to do much more in-depth restorations.

The key thing, however, is just to stop the aging process and bring your photos into the digital realm where, hopefully, they'll survive for many more generations to enjoy.

TECH SPECS: CAMERA: Flatbed scanner
RESOLUTION: 300dpi

Compare Sizes to Show Scale

Imagine if someone showed you a photograph of an elephant and you'd never seen or heard of one before. And imagine that the elephant was photographed in front of a plain white background with no hint of its size. You might like the looks of the elephant and, thinking it would make a nice backyard pet, call up the elephant store and order a pair. Now imagine your embarrassment when you try to put them in the back seat of your SUV to bring them home. If only someone had placed something familiar, like a mouse, on the elephant's trunk to provide a sense of scale, you would have been spared that awkward scene. And you wouldn't be stuck with two very annoyed elephants waiting for a ride.

Elephants and mice aside, scale is an important issue in many types of photography. Including objects of known (or approximately known) sizes provides an instant measuring stick for judging the true proportions of an object or scene. And even when we know the approximate true size of something, having other objects for comparison is very useful in revealing the true scale of the sizes involved.

In this shot of a cruise ship that I shot near Fort Lauderdale, Florida, for example, I used the two smaller boats to help reveal the size of the ship. You don't have to know the precise size of the smaller boats to appreciate just how big the cruise ship is because we're all fairly familiar with the ballpark size of a fishing boat or small yacht. If I had included a rowboat or kayak in the shot, however, you would have had an even better idea of all the sizes of all the boats. Still, just seeing the two smaller boats helps to give you a handle on the scale of the scene.

The funny thing is that this is a relatively small cruise ship, and if you saw it next to a much larger ship, its size would seem greatly diminished. All sizes are relative and that's the point of including objects of familiar size—they help you to make quick visual comparisons.

TECH SPECS: LENS: 70-210mm
FOCAL LENGTH: 105mm
EXPOSURE SETTING: 1/30 @ f/16
EXPOSURE MODE: Aperture Priority
WHITE BALANCE: Cloudy / FILE FORMAT: JPEG / ISO: 200

Follow the Clouds to Great Sunsets

Over the years I think that I've developed a nose for great sunsets (I can also smell a fresh-baked chocolate chip cookie a block away) and whenever I think one is about to happen, I make tracks for the beach. The best sign I have that a great sunset is on its way is a really interesting or intense cloud formation. I shot these clouds a few days after Halloween and the skies had been pretty much overcast all day. Toward the end of the day, I was taking a walk by the local seawall and noticed the cloud cover was starting to break up into interesting shapes. I particularly liked the dark bluish clouds mixing in with the lighter clouds. Often this is the perfect combination for a dynamite sunset, so I cut the walk short and drove over to a beach that has a better western view.

I got to the beach about a half hour before the sun hit the horizon and got to watch as these amazing clouds morphed from one shape to another and shifted from this white/blue combination to a more yellow/gold, and then finally, as the sun hit the horizon, a beautiful crimson sunset spread across the sky. The sunset was so spectacular that steady streams of people were hopping out of their cars with their cell phone cameras to photograph it. In the next tip I'll show you what the sunset looked like...it was quite amazing. So when you see great clouds, expect a great sunset.

TECH SPECS: LENS: 18-70mm
FOCAL LENGTH: 84mm
EXPOSURE SETTING: 1/250 @ f/10
EXPOSURE MODE: Aperture Priority
WHITE BALANCE: Auto / FILE FORMAT: RAW / ISO: 200

Expose Sunsets for Maximum Drama

One of the things that I like about shooting sunsets (and I shoot a lot of them) is that you can tweak the drama scale just by changing the exposure a few stops. And because there is no right or wrong exposure for sunsets (or sunrises, if you're one of those nutty morning people), you have a wide latitude of what constitutes a "correct" exposure. In fact, with sunsets, the only perfect exposure is the one that you like the most.

Most of the time, the safest way to get a technically acceptable sunset exposure (one where you can see some foreground detail and also get good color in the sky) is to meter without the sun in the frame. Just point the lens away from the sun itself, use your camera's exposure-lock feature to hold that exposure, and then refocus. However, you might find that this somewhat middle-of-the-road safe exposure is too bland for your tastes. One way that you can intensify the drama is by taking your exposure reading from a brighter area

of the sky; again, you still don't want the sun itself, but if you expose for a brighter area, you'll get darker, more saturated colors.

In this shot, for example, I did take some shots with the lens pointing at the darker clouds in the upper right, but the sky was too washed out (because I was metering a dark area, the camera tried to expose for a darker subject). But then I took some frames, including this one, where I metered for that bright area along the horizon. These exposures were about 2 1/2 stops less than the ones where I metered with the sky and it really enhanced the drama.

TECH SPECS: LENS: 18-70mm
FOCAL LENGTH: 105mm
EXPOSURE SETTING: 1/200 @ f/4.5
EXPOSURE MODE: Program / WHITE BALANCE: Auto
FILE FORMAT: RAW / ISO: 200

A lot of times when I'm shooting sunsets at the beach, I'll see people hop out of their cars, snap a few frames as the sun hits the horizon, and then leave. Those are probably nice shots, but the real show often begins about five or ten minutes after the sun has hit the horizon; it's a time I like to call the afterglow. It's during this brief period when color flares up into the sky and the clouds really catch fire.

The reason that the afterglow is so intense is because the angle of the sun is causing direct light rays to bounce around in the cloud cover and scatter on the layers of dust, moisture, and pollution. Believe it or not, the more pollution there is, the better the sunsets. After a forest fire or a volcano eruption, the sunsets are often spectacular for weeks and weeks as the dust lingers in the atmosphere. Even more amazing, these clouds of volcanic dust travel around the globe in jet streams and, in fact, when Krakatoa exploded in August of 1883 the sunsets were so intense as far away as New Haven, Connecticut (nearly half the circumference of the Earth away) that

people thought the sky was on fire. There are reports of the fire companies responding to fires in the sky!

Next time you're photographing a sunset, especially if there are interesting clouds, hang out and wait for the real show to begin. And incidentally, not only did I not saturate the colors in this shot (same clouds and sunset as the last two tips), but I actually had to tone them down because the yellows, pinks, and reds were bleeding together too much. The only area that I saturated a tiny bit is the reflection in the smooth water at the bottom of the frame to the left of center—I just wanted that spot of color to brighten the foreground a bit.

TECH SPECS: LENS: 18-70mm / FOCAL LENGTH: 46mm
EXPOSURE SETTING: 1/25 @ f/6.3
EXPOSURE MODE: Auto / WHITE BALANCE: Auto
FILE FORMAT: RAW / ISO: 200

Save Camera Batteries: Use the Peephole

Since the invention of digital cameras, the most popular feature has been the LCD viewfinder. And why not? Instead of smooshing your face up against the back of the camera and squinting into the peephole (optical) viewfinder like you did with film cameras, the LCD lets you compose images while holding the camera at a comfortable distance from your face. It's easier to see, you can hold the camera at weird angles (particularly if you have an articulated LCD) and, if your arms are long enough, no one will know you need reading glasses.

The problem with LCDs (other than that they are hard to see in bright daylight) is that they drain batteries very fast. The more you use your LCD to compose and review photos, the sooner you'll have to recharge your batteries. So when using the LCD isn't critical, or when you're shooting in bright daylight and the LCD view is hard to see anyway, try going back to using the peephole viewfinder. Some manufacturers have started doing away with optical viewfinders, which in my mind is a mistake bordering on an abomination—so that's one thing to consider when buying a new camera. If you shoot a lot and take your camera on trips, charging batteries is not always that convenient and that old-fashioned peephole can save you a lot of otherwise wasted battery power.

TECH SPECS: LENS: 18-70mm
FOCAL LENGTH: 40mm / EXPOSURE: 1/80 @ f/5.6
EXPOSURE MODE: Aperture Priority
WHITE BALANCE: Auto / FORMAT: RAW
ISO: 200

Whenever I teach a class in photography, the first assignment I give students is to photograph a piece of architecture. The practical reason for doing this is that everyone can find a building easily, while not everyone can find a great sunset or a pretty farm scene at will. Also, buildings don't run away from you the way your pets or other people might. Once you spot an interesting building, you're pretty much free to explore it from as many angles as you can think of and in all kinds of different lighting and weather.

Part of each assignment is also to photograph details within the building. And that's the secondary reason for the assignment: to help students see fine points within a larger subject. Whether it's the sign that says "Spike" over the doghouse door or the ornate embellishments of a cathedral, buildings are rife with photogenic detail. To get the shots here, I spent an entire afternoon photographing just some of the thousands of tiny details on the facade of Notre Dame Cathedral in Paris. I only used one zoom lens and slowly explored each façade of the building looking for interesting shots.

Next time you're walking through your hometown or you're visiting a new city, pick an interesting building and see how many different details you can photograph—I think you'll be surprised at the number of photos you'll find.

TECH SPECS: TOP LEFT: LENS: 70-300mm
FOCAL LENGTH: 135mm
EXPOSURE SETTING: 1/800 @ f/7.1
EXPOSURE MODE: Program / WHITE BALANCE: Sunny
FILE FORMAT: JPEG / ISO: 200

Practice Your Macro Skills on Houseplants

Living where I do in New England, taking macro photos of flowers (at least outdoors) is pretty much limited to those months when the ground isn't a frozen, barren wasteland. (If you've been reading these tips sequentially, you already know I'm not a big fan of winter.) But just because it's bleak, bleary, and bitterly cold outside doesn't mean that your macro floral skills have to get rusty until spring. One way that I manage to produce flower photos year round is to keep a lot of winter-flowering houseplants inside. As long as I get to them before the cats do, I almost always have something colorful to photograph that keeps my macro skills honed.

The key issues with indoor macro photography are lighting and keeping the camera steady. While I sometimes resort to using the built-in flash (as I did for the shot of the Clivia Miniata shown here), I much prefer the soft light of a north-facing window. The plants may prefer to live in a window that gets more direct sunlight, but you can easily move them to whatever window works best for ambient light. You can also use a table lamp equipped with one of those squiggly-shaped fluorescent bulbs (just remove the shade) because they provide a soft light that is relatively neutral if you set your white balance to fluorescent (or better yet, shoot in RAW and tweak the white balance in editing).

Because you'll often be working at small apertures (and therefore slow shutter speeds) if you're trying to get substantial depth of field, I strongly suggest using a tripod. If you don't own a tripod, use the arm of a chair or rest your elbows on a table to keep the camera steady.

Steadiness is less of a problem with flash since the flash duration is extremely short and prevents camera jiggle. If your camera has an anti-shake feature, that's great, too. (And when they start making humans with an anti-shake feature, photographic quality will soar.)

Most indoor flower blossoms last a short time, but your prints can keep the flowers alive all winter long!

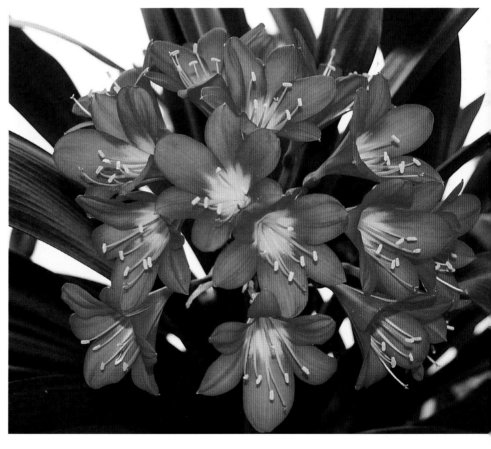

TECH SPECS: LENS: Built-in zoom
FOCAL LENGTH: 33mm
EXPOSURE SETTING: 1/60 @ f/4.5, with built-in flash
EXPOSURE MODE: Auto / WHITE BALANCE: Auto
FILE FORMAT: JPEG / ISO: 100

Immortalize Hometown Icons

"I don't know what to photograph!" I heard that complaint from almost every student I've ever had in a photo class. It kind of reminds me of when my brother and I were kids and would stare into a full refrigerator and say, "There's been bulldozed. I posted this photo on flickr.com and my website and have gotten many nice notes from people—now scattered to the four corners of the country—that remember their parents taking them there for hotdogs.

nothing to eat." (To which my parents would reply in shock, "The refrigerator is full of things to eat!")

Life is full of interesting subjects to photograph and one of the things I often tell restless students (and often remind myself) is that you don't need to travel to exotic places to find fun subjects. Think about the town where you live. What are the places that make that town unique? Where are your favorite places? Where do you eat lunch? Play with the kids?

What might seem mundane to some—the pizza joints, the old factory mills, the local baseball park—are really icons of a passing way of life and they make great subjects. The Cricket Car Hop was a legendary hot dog stand in the town where I grew up and, like a lot of hometown icons, it's since

Look around your hometown—especially at those vener-ated institutions (like the hot dog stands) that your kids might never get to see. Take a few hours some Sunday afternoon and start an album of them; when they're gone they're gone, but if you've captured them with a camera, they'll live forever.

TECH SPECS: LENS: 24-120mm
FOCAL LENGTH: 36mm
EXPOSURE SETTING: 1/125 @ f/14
EXPOSURE MODE: Aperture Priority
WHITE BALANCE: Cloudy / FILE FORMAT: JPEG / ISO: 200

Start Your Own Alphabet

Here's a fun little assignment: see if you can collect photos of all the letters of the alphabet. I've seen other photographers do this and I have always thought it was a fun idea since I seem to spot letters in some really curious places and have always liked collecting them. Your photos don't have to be great works of art, just clear shots of individual letters. I collect them in a separate folder and label them with keywords for where they were shot. This G, for example, was shot in a marine park in Lewes, Delaware. The letter was painted in bold script on a giant harbor float of some kind. (I've included a wide view so you can see what the overall scene looked like.) Finding letters like this is a good exercise in seeing because it forces you to look for details—and it's also downright addictive.

TECH SPECS: LENS: 18-70mm / FOCAL LENGTH: 78mm
EXPOSURE SETTING: 1/500 @ f/11
EXPOSURE MODE: Aperture Priority / WHITE BALANCE: Auto
FILE FORMAT: RAW / ISO: 200

Expect the Unexpected in Nature

Great nature photos are often the result of brief surprise happenings that no one could predict, and capturing them with your camera is one of photography's biggest challenges. As with most things in life, luck favors those who are prepared and those who are in the right place at the right time. For nature photographers, this means two things: be ready to shoot all the time, and spend a lot of time observing nature. I was thrilled enough to be getting very close shots of alligators while photographing from a boardwalk in a refuge in Florida, but when a small dragonfly landed just over the alligator's eye, I knew I'd have a unique photo. Fortunately, I was already focused on the gator's eye when the dragonfly landed and all I had to do was press the shutter button. (And lucky for me the dragonfly flew away and came back several dozen times, so I got many shots of the unlikely pair.) But the reality is that I was in the refuge with my camera on a nice day and I was prepared for this surprise moment. Be prepared: have your cameras out and your shutter finger waiting. And keep your toes away from the alligators.

TECH SPECS: LENS: 70-300mm / FOCAL LENGTH: 450mm
EXPOSURE SETTING: 1/640 @ f/8
EXPOSURE MODE: Program / WHITE BALANCE: Auto
FILE FORMAT: JPEG / ISO: 200

Photograph Everyday Stuff

Weeding the garden might not seem to be a particularly photogenic activity, but if you're a gardener it's an important (and all too real) part of life and we often ignore documenting mundane chores in favor of photographing more glamorous subjects—like picture-perfect, weed-free gardens. But in terms of building a well-rounded family album, it's those everyday moments that probably create some of the nicest memories. After all, you probably spend more time with your family doing chores around the house and yard than doing fun things in amazing surroundings.

A few years after my father passed away I was going through some boxes of old photos and was just thrilled when I found one of him cooking dinner. There he was, just living life and cooking for the family as he so often did. You can't go back in time and photograph those moments because once they're gone, they're gone. But when you unexpectedly discover a picture like that, it's akin to finding a rare old gold coin that you didn't know you had. Considering the fact that he was also a professional photographer, there was a surprising dearth of snapshots taken around the house. It's those little moments that fade fastest into history, and photos of them really bring the past back sweetly.

These days I keep a camera with me around the house and in the yard almost all of the time. In fact, one of my point-and-shoot cameras lives on the kitchen counter (and thankfully the cats haven't turned it into a toy yet) and I shoot pictures of the silliest things: the veggies I've just picked in the garden, that cats sitting on the porch watching the birds, fading flowers in vases on the kitchen counter, and even just the mess of books that clutter up my desk all of the time. In time, oddly enough, I know that these are the photos I'll treasure most.

TECH SPECS: LENS: 24-120mm
FOCAL LENGTH: 105mm
EXPOSURE SETTING: 1/160 @ f/6.3
EXPOSURE MODE: Auto / WHITE BALANCE: Shade
FILE FORMAT: JPEG / ISO: 200

Include Dark Foregrounds in Landscapes

I like landscape photos that really pop off the page, that have some element of drama that forces you take notice of them. One simple way to do that is to frame your scenes, when possible, with a dark foreground. Because the eye naturally seeks lighter areas or areas with more color, using a dark foreground helps to point the viewer to your main subject. It's easy to find dark foregrounds just by exploring a scene a bit until you find an area that is not as brilliantly lit as your main subject. In this scene, I used an area of marsh grass along the riverbank that was in shadow and contrasted it with the brightly lit boats. By exposing for the brighter areas, the foreground went even darker and made the frame a much bolder element. Also, I was careful to include the dark pilings on the left side of the frame to tie the foreground and middleground areas together.

TECH SPECS: LENS: 24-120mm
FOCAL LENGTH: 180mm
EXPOSURE SETTING: 1/125 @ f/5.6
EXPOSURE MODE: Auto / WHITE BALANCE: Cloudy
FILE FORMAT: JPEG / ISO: 200

Consider Wearing a Photographer's Vest

Unless you're wealthy and can afford to hire a Sherpa, probably the worst thing about traveling with camera equipment is having to haul it around with you. Shoulder bags are great for carrying your gear on and off planes and trains (never check gear in a camera bag, always carry it on), but when it comes to actually going out for the day shooting, forget it. Camera bags are a giant clumsy albatross and trust me, if you go walking through Grand Central Terminal at rush hour with a shoulder bag, some poor old lady is going down.

While I transport my gear in a shoulder bag or backpack, I always bring along a photographer's vest, and when I arrive at my destination I transfer the gear I think I'll need into it. (If I'm flying somewhere, I don't have to pack the vest since I wear it on the plane.) My primary vest (I own several) has about 20 different pockets and I can easily carry two extra lenses, a pocket full of memory cards, extra batteries, lens cleaning cloths, filters, and a dozen other small accessories. It also has a big rear pocket that's plenty big enough to carry a rain poncho and a few big black garbage bags to cover my gear quickly if a storm hits while I'm out walking.

Most good vests have a number of inside pockets, too, and I carry my passport and wallet there. There should be plenty of room for maps, airline tickets, and train schedules. I can also carry a sandwich and a bottle of water with me anywhere, and if I buy a few postcards or a small souvenir, I can toss them in an extra pocket and keep my hands free.

Because you're wearing the vest, you'll never really notice the weight—especially if you're careful to distribute larger items carefully. I can literally spend 12 hours in my vest, and while I'm thrilled to get if off when I get back to the hotel, it's completely comfortable. Yes, it might make you stand out as a photographer and I guess that could make you a target of thieves, but you're a far bigger target if you're carrying around an expensive-looking shoulder bag with an expensive-sounding brand name.

When choosing a vest, look at several different brands and designs. It's tough to judge one vest from another if you're shopping mail order, so if possible, go to a professional camera store or a big sports store that stocks several vests.

You might also consider going to a hunting or fishing supply store since hunting and photography vests are essentially the same thing.

Be prepared for being at the receiving end of jokes when you're out wearing your vest. I took a cruise to Bermuda years ago and without really realizing it, I was looking a bit military in my shooting vest and brown fatigue shorts. As I was getting off the cruise ship in Hamilton, one of the crew looked at me carefully and in his utterly British dry-humored voice said, "Visiting or invading?"

TECH SPECS: LENS: 70-300mm
FOCAL LENGTH: 168mm
EXPOSURE MODE: Aperture Priority
EXPOSURE SETTING: 1/60 @ f/7.1, with accessory flash
WHITE BALANCE: Auto / FORMAT: RAW / ISO: 200

Protect Your Images with a Copyright Notice

You've probably noticed that most of the photos you see on professional websites and blogs have a copyright symbol and their name or web address—and so should yours if you post your images online. It only takes a second to add a copyright notice and, while it certainly won't stop someone from ripping off your images, it might slow them down. Also, if someone intentionally deletes or hides your copyright notice, it shows intention to steal your images.

I'm definitely not an expert on copyright, but I do know that the moment you create a photograph (under United States law, anyway), you automatically own the copyright for that image. However, that copyright won't be of much use unless you register it with the United States Copyright Office. If someone infringes on your unregistered copyright, you can only demand that the infringed image be taken down or removed from circulation. But if you've registered that copyright, then you can file a lawsuit, collect lawyer fees, and get paid either compensatory or statutory damages. You don't have to register each individual photo; you can group your images together and register them for one fee. For example, you can put 100 images on a disc and call it the Collected Works of Jeff Wignall, Volume I. The Copyright Office recently created a quick and easy online service to make the registration process even easier—just check out www.copyright. gov/eco and follow the instructions.

Legalities aside, however, there are multiple benefits to putting your copyright notice on your images. For one, it discourages people (some people, anyway) from casually downloading and using your images for their own purposes. Personally, it's OK with me if

a college kid uses one of my sunset shots as their wallpaper, but if someone uses one of my sunsets on their website, they'll have to negotiate it with me first. Also, putting your name on your photos shows that you have a certain pride in your work. You see names on everything these days—including the company name on the side of the sea plane in the shot here—so why shouldn't your photos carry your name?

I try to be discrete about placing the copyright notice at the outer edges of my pictures, and I know that makes it easier for someone to erase it if they have larceny in mind, but again, removing a copyright notice with intent to avoid paying for an image is a crime. On some images that I know might be in high demand (like some of the popular musicians I photograph, for instance), I put the symbol in a place where it's more difficult to alter—even putting it across the face if I think it's needed.

©www.jeffwignall.com

TECH SPECS: LENS: 24-120mm / **FOCAL LENGTH:** 82mm
EXPOSURE SETTING: 1/320 @ f/8 (- 0.67EV)
EXPOSURE MODE: Aperture Priority
WHITE BALANCE: Cloudy / **FILE FORMAT:** JPEG
ISO: 200

Sports Photography: Off with Their Heads!

It probably goes without having to state it as a rule, but generally it's not a good idea to chop peoples' heads off in pictures. That said, I run hot and cold when looking at this photo: sometimes I like the action being aimed at the feet (it is soccer, after all), but other times I wish I'd twisted the zoom back faster (I was shooting very tight with a 70-300mm zoom) and included the entire players—heads and all.

The risk you run in composing off-beat images like this is that people will think you made a mistake and that you didn't mean to shoot it that way. And, of course, in this case they'd be exactly right: it wasn't a planned shot, it was just a matter of the action happening faster than my hands could react. But still, in looking at the 100 or so photos I shot during the first half of this game, this is one of the ones I like the best. I like the feet in motion, I like the ball being right on the sideline, and I like the shadows behind the players. I'm not sure that including their heads would have added anything to the shot. I'm sure the parents would love to see their little darlings' faces, but since I don't know the players, it's not a main concern for me.

So is cutting off the heads always a mistake? You decide next time you're out shooting sports—shoot a couple of shots without heads (it's probably tougher than you think when you're actually trying to do it) and see if you like the results. Does it put the emphasis on the action in a unique way? I'm not sure I'd go out looking for headless soccer players in the future, but I would still keep firing if a shot like this ran into my viewfinder again. And by the way, you're seeing the shot exactly as it was taken—this isn't a fake crop, though I'm sure someone will think it is. See, you can't even confess to mistakes without people calling you on it!

TECH SPECS: LENS: 70-300mm
FOCAL LENGTH: 120mm
EXPOSURE SETTING: 1/500 @ f/5
EXPOSURE MODE: Shutter Priority
WHITE BALANCE: Auto / FILE FORMAT: RAW / ISO: 200

Get Serious: Use a Tripod (Part I)

When I was about 20 years old, I was going through an intense period of frustration about the lack of progress my photography was making, both technically and creatively. My poor parents had to listen to me vent this frustration as I would sort slides on a light table and fling the rejects (somewhat violently) around my bedroom. One morning my father, who was also a photographer, said to me, "You'd like your photographs a lot more if you learned to use a tripod every time you shoot."

He was right. I had nothing to lose and so I gradually started hauling a tripod around with me. The pictures got better, but still I would go through periods of laziness where rather than slow down and set up the tripod, I'd take the easy way out. When I did get ambitious, however, and used a tripod, there was a quantum leap in the quality of my photographs. Today I wouldn't think of going out to shoot photographs without a tripod, and even if I'm traveling I always take a substantial tripod along. In fact, I'd rather leave a lens or two (or most of my clothes) behind to save weight than leave my tripod.

To be honest, I don't think you can be a serious photographer unless you use a tripod most (OK, not all) of the time. I would guess that I use a tripod for 90% of my photographs, and when the shot is very important, I use one 100% of the time. In fact, if I'm not using a tripod I feel downright lazy and I know I'm not giving the subject the full attention it deserves. Those times when I find myself starting to get lazy, I remember the hundreds of nights in front of the light table cursing myself for the photographs that were "almost" good enough—but not quite.

"But," you may object, "tripods slow you down!" Or, "You can't photograph a birthday party indoors with a tripod!" Or, "I have image stabilization, I don't need a tripod!" Yes, most tripods are a pain to carry; all but the most expensive graphite tripods are awkward and heavy. You're also right, photographing a family party with a tripod would probably be more of an inconvenience than it's worth (though I'd bet you'd get better quality photos if you did). And image stabilization is a wonderful thing (where was it when I was photographing rock concerts six nights a week at 1/30 of a second?). But image stabilization is no panacea, it's only designed to give you sharper images at marginally slow shutter speeds, and that's all. It won't let you make a 10-second exposure of traffic flowing through city streets at night, and it won't let you create multiple images to stitch a panorama perfectly. More to come about tripods in the next tip (in case you thought my tirade was over).

TECH SPECS: LENS: Built-in zoom
FOCAL LENGTH: 60mm
EXPOSURE SETTING: 1/400 @ f/6.3
EXPOSURE MODE: Aperture Priority
WHITE BALANCE: Auto / FILE FORMAT: JPEG / ISO: 64

Get Serious: Use a Tripod (Part II)

Now that I've got you convinced that it's time to buy a tripod, let me give you some of my specific reasons why you need one:

◆ **Sharper pictures:** Obviously, this is one of the primary reasons for owning a tripod. No matter how good your image-stabilization system is, a tripod is better because it lets you shoot sharply at any shutter speed. (By the way, in most cases you should shut stabilization off when you're using a tripod; otherwise, the camera actually makes pictures less sharp.)

◆ **More Shutter Speed Options:** Using a tripod makes all shutter speeds (even time exposures) available to you. You could never take a shot like this 28-second exposure of a Ferris wheel without a tripod—it just can't be done. Similarly, if you want to create the "ribbons of water" effect in a shot of a waterfall, you can't do it without a tripod. City skylines at night without a tripod? No way.

◆ **Depth of Field Control:** Getting extensive depth of field (near-to-far sharpness) should be a primary consideration in most types of photography (like landscapes), and unless you're shooting in bright sunlight or raise the ISO to a noisy level, you can't shoot at f/16 or f/22 without a tripod— especially as the light grows dimmer (twilight, cloudy days, misty mornings). I can't count the number of nice landscapes that I've ruined by not having enough depth of field before I

dedicated myself to using a tripod.

◆ **Exposure bracketing:** Exposure bracketing allows you to shoot three (or more) rapid exposures of the same scene with one press of the shutter button (in continuous shooting mode). But you will never get the exact same framing in all three shots unless you have your camera on a tripod.

◆ **High Dynamic Range:** And speaking of making bracketed exposures, that's a required part of HDR, a popular technique that consists of taking multiple identical compositions, each at a different exposure setting. There's no way to align those frames exactly without using a tripod.

◆ **Panoramic Stitching:** While I've done some panoramic stitches shooting handheld, that's a very experimental (and unreliable) way to shoot. If you really want a high-quality pan shot, the camera must be mounted on a tripod.

◆ **Slower Pace:** This is, to me, one of the most important reasons for using a tripod: it slows you down and makes you think. Very often photographers put quantity ahead of quality—thinking that more pictures of a subject means better results. I'd rather get one great, carefully executed shot of a landscape than 20 "almost" great shots.

Using a tripod forces you to consider all the elements of a shot: exposure, depth of field, sharpness, creative shutter speed, and it lets you use special techniques like HDR. It also takes the burden off of your shoulders when it comes to holding equipment all day. Personally, I'd prefer to haul a tripod into the field for 10 minutes rather than try to shoot with a 400mm lens handheld for hours on end without one.

There, I've given you my tripod lecture!

TECH SPECS: LENS: 24-120mm / FOCAL LENGTH: 36mm
EXPOSURE SETTING: 5 seconds @ f/25
EXPOSURE MODE: Shutter Priority / WHITE BALANCE:
Cloudy / FILE FORMAT: JPEG / ISO: 200

For a Little Romance, Try the Gaussian Blur

Back in the 1970s, when the SLR craze was exploding and photographers were all exploring the creative potential of photography, one of the odd things that you were likely to find in almost every photographer's bag was a jar of petroleum jelly. It wasn't for soothing the scrapes and scratches encountered while climbing around in nature, but rather for softening focus to give subjects like landscapes and portraits a more romantic look. Perfectly rational photographers (well, maybe not perfectly rational) would smear an otherwise perfectly good UV or skylight filter with a liberal coating of

the jelly to give their photos a soft or blurred look—and art directors were eating it up. Using petroleum jelly was so prevalent back then, in fact, that if you looked at the photo cards on the greeting card racks, it must have seemed the entire profession was suffering from some sort of communal glaucoma disease.

Still, the romantic look was popular and I sold a lot of photos thanks to that little jar of petroleum jelly—and I ruined a lot of good filters. You can create the same look in

editing and you'll waste a lot fewer filters and your fingers won't be slimy the whole time you're shooting. In Photoshop (and in most other photo editing programs) there are a number of blur filters available, but the one that I use most often is the Gaussian blur (Filters>Blur>Gaussian Blur). Once you open the dialog box for the tool, all you have to do is adjust the intensity of the blur using a slider.

The real trick to controlling the degree of the Gaussian blur, however, is not to apply it to the Background layer itself (which is the name of the default layer in Photoshop's Layer's palette), but rather to make a copy of the Background layer and apply the blur there. The keystroke command for creating a duplicate of the Background layer is Command J for Macs and Alt J for Windows. This creates an exact duplicate of the Background layer named Layer 1. Any changes you make to this copy layer will not permanently affect or appear in the Background image layer. There is a caveat, however. If you are following along in Photoshop, you'll notice that Layer 1 was placed above the Background layer in the Layers palette. We want Layer 1 to be below the Background layer to achieve our eventual goal. To do this, we have to first double click on the words "Background layer" so that we can rename the layer. (Renaming the layer unlocks it and allows us move it around in the Layers

palette.) Let's now call the Background layer the Original layer, since it is the original image that we won't be changing. While we're at it, let's change the name of Layer 1 as well—we'll call it the Blur layer since that's what effect we are applying. You should now still have two layers in the Layers palette: Original and Blur. Click on the Original layer so it is highlighted (this means it is the active layer) and then drag it above the Blur layer.

Now click on the Blur layer so it is active and apply the Gaussian blur (Filters>Blur>Gaussian Blur) to a degree you find appealing. I usually apply a much heavier degree of effect than I'm going to use in the final image because I will finalize the look of the picture by lowering the opacity of the Original layer. This will allow the effect in the Blur layer to show through the Original layer. To do this, make the Original layer active and use the Opacity slider, which is in the upper right corner of the Layers palette.

I used a 33% opacity for this image with the actual blur set to 9 in the Gaussian dialog box. The blur is probably somewhat difficult to see, which is a good thing; you always want to go easy on the filter or you just end up with an out-of-focus image (a lesson we had to learn many times back in the petroleum jelly days when we equated more jelly with more creativity).

Just to recap, the process is very simple: duplicate the Background layer, rename the Background and copied layers, apply the Gaussian blur (fairly heavily) to that copy layer, and then use the Opacity control on the original layer to adjust the blur intensity. It's a much more precise way of adding a bit of romance to your images, and you can also apply it selectively in specific areas of an image (applying it to just a window box full of flowers in an image of a house, perhaps). Thinking of all the money you'll save on petroleum jelly is just one reason to be glad it's not the 1970s anymore!

TECH SPECS: LENS: 18-70mm / FOCAL LENGTH: 57mm
EXPOSURE SETTING: 0.6 @ f/20
EXPOSURE MODE: Aperture Priority
WHITE BALANCE: Auto / FILE FORMAT: RAW
ISO: 200

Turn the Camera Vertical

Have you ever noticed that most of the photos that people shoot are taken horizontally? Even when the subjects themselves are vertical—things like trees and other people and tall buildings—photographers try to squeeze them into a horizontal format. In fact, one of the biggest groans that I hear from photo editors at magazines is that even though virtually all magazines are essentially vertical, photographers still shoot more horizontal images.

I think the real reason that most of us shoot so many photos horizontally is because that's how cameras are designed to be held and used. The viewfinder is on the top and in the middle, the camera controls are (mostly) on the top of the camera, and the LCD on digital cameras is horizontal. But that doesn't mean it's the best orientation in creative terms. Lots of subjects cry out to be framed vertically and they'll seem a lot more balanced and powerful if you let them proudly express their height.

I shot the photo here of a couple viewing an outdoor photo exhibit at the lovely Château de la Bourdaisière in the Loire Valley in France using a vertical format because I wanted to include them in the foreground and have the Château emerge above them in the background. I could have shot a horizontal that took in more of the photo exhibit and more of the park grounds, but the vertical seemed to me a more natural choice.

So next time you spot a subject that's taller than it is wide, turn the camera 90 degrees and see if things don't look more natural—someday you may make a photo editor very happy.

TECH SPECS: LENS: 18-70mm / FOCAL LENGTH: 93mm
EXPOSURE SETTING: 1/320 @ f/9
EXPOSURE MODE: Aperture Priority
WHITE BALANCE: Cloudy / FILE FORMAT: JPEG / ISO: 200

Pet Portraits: Focus on the Eyes

When it comes to taking interesting photos of your pets, one great piece of advice is to focus on the eyes—both figuratively and literally. Anyone who has ever owned a cat or dog (or a hamster, for that matter) knows that animals have very expressive eyes. You don't have to live with an animal long to know when they're apologizing with their eyes for knocking over your favorite lamp. Personally, I think animals are well aware of the power of their eyes and alternately use sad, loving, and adoring looks to mooch extra snacks.

Using the eyes as a focus point in more physical terms is also a good idea because, as with humans, eyes are the most interesting part of their faces. Since most portraits are shot with medium-telephoto lenses or zoom settings where depth of field is minimal, focusing carefully on the eyes also gives you one certain point of sharp focus. People looking at your portraits won't even notice if the ears (or whiskers) are slightly out of focus as long as the eyes are sharp and bright.

TECH SPECS: LENS: 70-300mm / FOCAL LENGTH: 220mm
EXPOSURE SETTING: 1/60 @ f/5.6, with built-in flash
EXPOSURE MODE: Auto
WHITE BALANCE: Cloudy
FILE FORMAT: JPEG / ISO: 200

Beware Specular Highlights

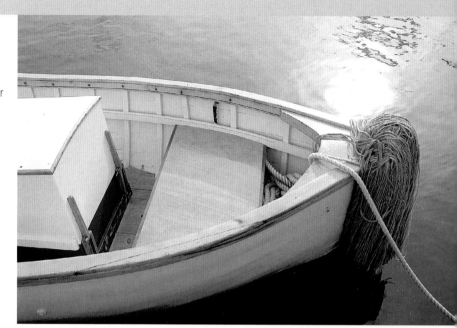

Taking accurate light readings is very important in getting good exposures, whether you're metering in a manual mode or your automatic meter is doing the work for you. Metering scenes of average brightness, where nothing is radically darker or brighter than the majority of the tones in a scene, is fairly simple and most built-in meters do a very good job.

Problems arise when there is excessive contrast in a scene, because the dynamic range (the dark-to-light contrast range) extends beyond the camera's ability to record those tones. One type of contrast situation that all cameras have a tough time with is called a specular highlight. These are extremely bright spots in a scene, created by a direct reflection of the sun or some other light source (like flash reflecting in a mirror), that cause the meter to grossly underexpose an image (give too little exposure) because they make the meter think that the entire scene is brighter than it is.

There's really no safe way to meter with a specular highlight other than to exclude it from your composition during the metering phase. In the shot here, for example, I wanted the reflection of the sun in the water, but I knew that if I metered with that spot in the frame, the whole scene would have been drastically underexposed. Instead, I took a reading from the boat and the water (which already constituted a fairly contrasty scene) while carefully excluding the bright spot. I also added +.67 stops of exposure compensation. Then I exposure lock by holding the shutter-release button halfway down and recomposed the scene.

The other alternative, of course, is to shift your shooting angle a bit to exclude the specular highlight entirely—which is what I did for the second shot (though I still prefer the shot with the reflection).

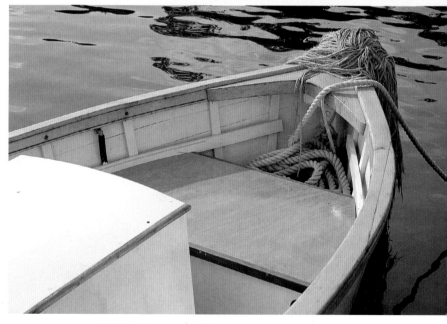

TECH SPECS: TOP: LENS: 18-70mm / FOCAL LENGTH: 37mm / EXPOSURE SETTING: 1/250 @ f/8 (+ 0.66EV) EXPOSURE MODE: Aperture Priority
WHITE BALANCE: Cloudy / FILE FORMAT: JPEG / ISO: 200
BOTTOM: LENS: 18-70mm / FOCAL LENGTH: 75mm / EXPOSURE SETTING: 1/250 @ f/9 (+ 0.66EV)
EXPOSURE MODE: Aperture Priority
WHITE BALANCE: Cloudy / FILE FORMAT: JPEG / ISO: 200

Use Patterns to Create Visual Rhythm

Whenever a shape, color, or texture repeats itself, it creates a pattern. Spiders know this (at least on some level) because their home is one big, interesting set of repeating lines. And Navajo weavers know it because their beautiful blankets are based on centuries-old patterns.

Patterns make great photo subjects because they delight the eye and spark the imagination; our curiosity gets the best of us and we have to examine them. Ever look at a honeycomb close-up and not marvel at the intricate architecture?

Patterns work best when photographed against a dark or simple background, and when the pattern itself becomes the dominant element of the frame. In other words, get close and crop out anything that doesn't scream pattern.

TECH SPECS: LENS: Built-in zoom
FOCAL LENGTH: 28mm
EXPOSURE SETTING: .5 seconds @ f/7.1 (- 0.33EV)
EXPOSURE MODE: Manual
WHITE BALANCE: Cloudy / FILE FORMAT: JPEG / ISO: 100

Eliminate the Subject...and Just Shoot the Reflection

Whenever I'm photographing near any kind of reflective surface, whether it's the surface of a pond, a store window, or a shiny car fender, I try to find ways to use the reflections in the composition. I think that including reflections as a component of a larger composition adds an element of color and depth that brings an extra level of visual interest.

There are some interesting benefits to photographing reflections, particularly when you're shooting them in water. For one, if the surface of a pond is dark (especially a very stagnant pond like this one), the colors will be more saturated. Also, if you have a breeze or some ripples (just toss a rock in the pond if you want ripples), you get an added level of abstraction. It's important to use a relatively small aperture (I shot this at f/9 but wish I had shot at f/11 or smaller) when photographing a broad reflection to be sure that the surface will all be in focus. Remember that you can use a polarizing filter (see tip 65) to enhance the saturation even further by eliminating glare on the reflective surface (as long as the surface isn't metal).

Also keep an eye open for unusual reflective surfaces. While hanging out near the Eiffel Tower one day, I noticed some interesting reflections in a dark-tinted tour bus window and spent about 15 minutes photographing them from various angles. I think I had more tourists looking at me and wondering what I could possibly be shooting than looking at the tower.

But reflections can also make interesting photographs when the subject itself is cropped entirely out of the frame. Isolated reflections have a very romantic, impressionistic feel, often bordering on abstraction. I shot the photo here while photographing a landscape scene of the trees that included a small bit of this reflection in the foreground. As I was shooting that larger scene, however, I began to notice some interesting possibilities using just the reflection. Within a few minutes I was so engrossed in shooting isolated views of the reflection that I completely forgot about the landscape scene. Sometimes you just have to go with the creative flow (which I guess is what creativity is all about).

Next time you're out by a pond or walking past a large picture window, see if you can't find a shot of just the reflection. You may find out you don't need the actual subjects at all.

TECH SPECS: LENS: 80-200mm f/2.8
FOCAL LENGTH: 245mm
EXPOSURE SETTING: 1/15 @ f/9
EXPOSURE MODE: Aperture Priority
WHITE BALANCE: Auto / FILE FORMAT: RAW / ISO: 200

Journey to Another Reality with Cool Black Light Pictures

I don't know how teenagers decorate their bedrooms these days, but back in the 1960s we had a pretty universal style: cover the walls with as many black-light posters as you could afford and beg your parents to buy you a black light for your birthday. Most of us just had little screw-in incandescent black light bulbs, but a few of my friends had huge four-foot (1.2 m) fluorescent fixtures and they enjoyed a very elite social status because of it. Recently, black lights have been enjoying a rebirth in popularity and I couldn't be happier—if only I'd kept all of those cool posters!

Black lights work by filtering most visible light and emitting only long-wave Ultraviolet light. Things that glow under black light are called black light reactive and there are a lot of things that react brilliantly, including certain minerals (fluorite, calcite, wernerite, and many more), petroleum jelly, quinine (tonic water), Mr. Clean, and even live scorpions. (Yes, if you lose a live scorpion in your house, a black light is the way to find it.)

You can also buy things that are made to react under black lights, like paints, balloons, soap bubbles, and jewelry (to list just a few), as well as lipstick and body paint in case you want to do some very haunting portraits. Places like Spencer gifts (in almost every mall) and online sites like blacklight.com sell tons of fun things to photograph. Look around hardware and toy stores for likely subjects, too—anything that is labeled 'fluorescent' (spray paints, highlighters, sticky notes, etc.) is likely to glow. But you'll probably get the most brilliant results from shooting close-ups of very reactive objects. The butterflies and dragonflies here, for example, were just unfinished wooden objects that I found in the local crafts store and then painted with a combination of both spray and brush-on black light reactive paints.

To take photos under black light, all that you'll need are an inexpensive black light fixture, some objects that react, and preferably a tripod since exposures tend to be very long. I've found that the fluorescent tubes are brightest and you can buy an 18-inch (45.7 cm) or 24-inch (61 cm) fixture with a bulb for under $25 (I used an 18-inch model for these shots). Making the exposures is just a matter of shutting off all room lights and placing your subjects close enough to the light so that they glow intensely. Surprisingly, most digital cameras meter black light quite well (remove the UV filter over your lens). My exposures were generally around 1/8 second at ISO 200 with the lens wide open. Without a tripod you could boost up the ISO and probably shoot handheld.

Black-light photography is very experimental and tremendous fun—and just think how excited and proud your parents will be when you ask them if they have any old Jimi Hendrix posters stashed away in the attic.

TECH SPECS: LENS: 18-70mm / FOCAL LENGTH: 82mm
EXPOSURE SETTING: 0.4 seconds @ f/9 (- 0.33EV)
EXPOSURE MODE: Manual / WHITE BALANCE: Auto
FILE FORMAT: RAW / ISO: 400
LIGHT SOURCE: Long-wave UV black light

Silhouette the Landscape

Creating silhouettes of isolated subjects (see tip 2) is a fun and relatively easy technique, but there's no reason that you can't take that idea to a larger scene—namely the landscape. Essentially, the process is exactly the same: find a dark subject against a light background and expose for the lighter area. Finding landscape subjects for this kind of treatment is a bit tricky and the best place to look (did you guess already?) is along the edges of hilltops.

Because hilltop landscapes (a row of barren trees, windmills, a lighthouse) are situated against the open sky, they're easy to silhouette. I found this farm scene in a rural corner of Iowa and I envisioned it as a silhouette from the moment I spotted it. I worked the scene from a lot of different angles and with several focal length lenses, but I knew that I wanted three main elements in the scene: the tree, the edge of the barn, and a cow. The cow was the tricky bit because every time I fine-tuned the composition, she went for a walk. I had to wait almost a half an hour for her to walk into the frame

where I wanted her (I was starting to wish I had a cardboard cow to substitute for her). The line of the fence tied the whole scene together.

The only editing that I did to this image was to enhance the contrast a bit using the Curves tool in Photoshop (but the Brightness/Contrast adjustment would have worked, too. I also used the Selective Color tool to clean up the white sky a bit. One last tweak that I made was to use the Midtone slider in the Levels control to bring up just a hint of green in the foreground grass. But to be honest, the silhouette straight out of the camera would have been very close to what I wanted.

Don't be afraid to tackle more complex scenes as silhouettes because the results are usually very interesting, and it's easy to tweak scenes like this in editing.

TECH SPECS: LENS: 180mm / FOCAL LENGTH: 270mm
EXPOSURE SETTING: 1/160 @ f/18 (+ 0.33EV)
EXPOSURE MODE: Aperture Priority
WHITE BALANCE: Cloudy / FILE FORMAT: JPEG / ISO: 200

Cropping Is As Cropping Does (with Apologies to Forrest Gump)

When I was I high school I had a student art teacher that I really liked because she was so passionate about making us more creative. Whenever she caught one of us obsessing over some insignificant detail of a painting with a tiny brush and a cautious attitude she would grab our hand and wave it through the air yelling, "Bold Strokes! Bold Strokes!" We all thought she was a bit nuts, but she made her point that no great creative advances are made by being afraid to take chances.

That's as true for photography as it is for painting: take cropping, for example. Most of us are so used to creating photos in traditional sizes that we are somewhat fearful of doing something as creatively innocent as cropping images in more radical ways. Much of our fear, of course, is that we imagine other people will think we were just trying to save a bad photograph by giving it an extreme haircut or perhaps cropping to an odd shape just to be different. But so what?

The fact is that cropping is as cropping does: if it works to get extreme with cropping, get extreme. It doesn't matter if you're cleaning up a cluttered composition or just flirting with a momentary burst of inspiration, if you can turn a mediocre photograph into a dynamic one by cropping it, then crop on. Besides, other people only notice what's good about a photo; they're not usually even aware of what you did to make it work.

I shot this photo of a friend's cat while we were all lying in the grass and enjoying the warm summer sun. But when I looked at the photo in full frame, his lithe, flowing curves and stealthy pose seemed somewhat diluted in the rectangular shape of the image. So instead of sticking with traditional proportions, I chose a long rectangular crop. Nothing that I cropped out of the photo will ever be missed and the image is much stronger without the excess baggage.

By the way, most editing programs have sizing boxes that pop up when you open the cropping tool and you have to leave these boxes blank if you want to do free-form cropping; otherwise, the tool will force you to crop to a certain size or proportion. Also, poke around in your software to find the shape tools (circles, ovals, polygons) because you can use them to crop to any type of standard graphic shape. And if you can't find the shape you want in your software, there are always scissors. If you want to cut out a picture of your main squeeze to fit a heart-shaped frame, don't let software stand in the way of love.

TECH SPECS: LENS: 70-300mm
FOCAL LENGTH: 247mm
EXPOSURE SETTING: 1/40 @ f/8 (+ 0.33EV)
EXPOSURE MODE: Program
WHITE BALANCE: Cloudy / FILE FORMAT: JPEG / ISO: 200

When it comes to image quality, I probably spend more time and effort on getting pictures sharp than any other technical consideration besides exposure. I use a tripod religiously, always check my shutter speeds and, with action subjects, I wait for the peak of action to shoot. But not every subject calls for a perfectly sharp picture; in fact, some call for just the opposite.

I shoot a lot of concerts, and while I always try to get nice, sharply focused shots of the performers, if they have a really active stage presence, I often slow the shutter speed down and try to intentionally blur some frames. I've photographed Professor Louie (shown here) many times and I've got hundreds of sharp photos of him, but during this particular show the light was kind of low and I knew that once he started

rocking out, getting sharp pictures was going to be tough. Instead of fighting the situation, I decided to slow the shutter speed to 1/2 second and just let the motion become the picture. I also intentionally shook the camera a bit during the exposures. I love the way the light is streaking off of the keyboard and the Professor has become an impressionistic blur.

Don't become a slave to sharpness. When the situation calls for it, instead of stopping the motion, exaggerate it.

TECH SPECS: LENS: 80-200mm f/2.8
FOCAL LENGTH: 232mm
EXPOSURE SETTING: 0.5 seconds @ f/22
EXPOSURE MODE: Shutter Priority
WHITE BALANCE: Cloudy / FILE FORMAT: JPEG / ISO: 800

Understanding the Three Types of Light Meters

Many digital cameras (including virtually all D-SLRs) offer a choice of three light-metering options, typically including: multi-segment (also called evaluative or matrix metering), center-weighted, and spot metering. Understanding how these metering types differ from one another and knowing when to use each is an important part of getting a good exposure. In this tip, I'll discuss multi-segment metering which is, by far, the most frequently used metering method (and with good reason).

Multi-segment meters work by dividing the entire frame up into a complex grid pattern. The camera then uses a series of algorithms to compare the various brightness regions of the frame and arrive at a good exposure. The way that these algorithms are programmed is nothing less than astonishing in their sophistication and complexity. The cameras have been programmed with the results of hundreds of thousands of potential exposure situations and when you point your camera at a scene, the camera's computer compares the scene you're shooting to all of those exposures to find the one that most closely matches your subject. Sounds like science fiction, I know, but it's all true—and it happens in the blink of an eye. Many multi-segment meters also take into account the colors of your subject and, using information from the lens and focusing system, determine which parts of the scene are closest to the camera and are likely the main subject. Whew!

What the camera is looking for as it analyzes a scene are familiar landmarks of shape, color, and tonality (brightness). In a really simple scene, for example, if it sees a tall vertical subject of average tone in front of a bright background in the upper half of the frame and a slightly darker foreground below the subject, it makes an educated guess that what you're shooting is a person standing on a green lawn in front of a bright blue sky (and wearing a red shirt). The camera no doubt also knows that your subject just got back from a week in Miami and has a nice tan. And in most cases, it would be correct. It then rummages around in its memory banks to find what it "thinks" is the best exposure for that subject.

The amazing thing about multi-segment metering though, is that it can handle far more complex scenes than that. In my shot of Notre Dame scene here, for example, the meter determined that what I'm shooting is a bright yellow subject (it probably even knows it's a piece of architecture based on the shape pattern of the subject) against a blue sky.

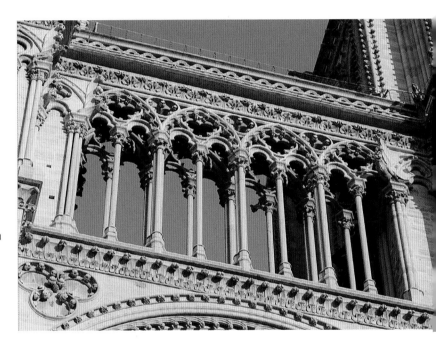

But even that is a mild challenge for a multi-segment meter. I commonly trust multi-segment metering when shooting subjects like a bright blue dragonfly sitting on a dark green leaf in front of a black pond with sunlight reflecting off of the water. And the exposures are (as the Brits say), spot on.

Multi-segment meters are extraordinarily accurate in a huge range of lighting situations, both complex and simple, and that's why they are the default metering systems of most cameras. In the next few tips, I'll talk about the other types of metering methods and why you might choose them over the genius of multi-segment metering.

TECH SPECS: LENS: 70-300mm / FOCAL LENGTH: 105mm
EXPOSURE SETTING: 1/200 @ f/7.1
EXPOSURE MODE: Auto / WHITE BALANCE: Auto
FILE FORMAT: JPEG / ISO: 200

Meter in the Middle of the Frame with Center-Weighted Meters

As I said in the previous tip, the multi-segment meters that are in virtually all cameras these days are very accurate, even with scenes that would have many seasoned photographers scratching their heads. However, there are some situations when metering only a specific region of the frame will provide more reliable results. One of the options for those situations is center-weighted metering.

As their name implies, these meters concentrate their readings on a small central region in the viewfinder. That area is typically about 8-10cm (.31-.4 inches) across, though on some cameras you can select from three different sized areas—8mm (the default), as well as 6mm (.24 inches) and 10mm. The meter doesn't meter exclusively from that area alone, but typically gives it about 75% of the metering ratio and about 25% to the remainder of the frame.

The advantage of center-weighted reading is that you can tell the camera to give more importance to one specific subject or area within the frame. In this shot of a water lily surrounded by black (artificially dyed) water, for example, I knew that the flower would provide a good exposure and that the black water might otherwise fool the meter into thinking there was less light than there really was and overexpose the entire shot. The meter read the entire scene, but put most of its emphasis on the flower, which was far closer to a middle tone. The

meter reading was perfect. The multi-segment meter might have provided just as good a reading, but why risk it if there is a more accurate method?

Center-weighted metering works best when there is a mid-toned subject of small, but not tiny, size within the frame. By reading off that subject and then using your exposure-lock function (usually just holding the shutter-release button down halfway), you can lock that reading and recompose the shot to get an accurate exposure for the entire scene.

In the next tip we'll talk about metering when the subject you want to read is especially small.

TECH SPECS: LENS: 60mm / FOCAL LENGTH: 90mm
EXPOSURE SETTING: 1/320 @ f/9 (+ 0.33EV)
METERING MODE: Center-weighted
EXPOSURE MODE: Aperture Priority
WHITE BALANCE: Sunny / FILE FORMAT: JPEG / ISO: 200

Take Spot-on Readings with Spot Metering Mode

I probably could have used the center-weighted meter for this shot because the bird is relatively large in the frame, but I chose the spot meter so that I could be sure the reading was only coming from the bird. Because the bird was white, however, I did have to add +1.3 stops of exposure compensation to keep it white. (I based the amount of compensation on experience and looking at the histogram, by the way.) Had it been a medium-toned subject (a blue heron, for example, which is gray), I could have just gone with the straight spot reading. Still, knowing exactly what I was metering helped me determine the correct amount of compensation.

You probably won't use the spot metering mode very often, but when you are confronted with a very small yet important subject area against a very bright or very dark background—a small flower blossom against a black shadowed area, for example—it can be a real life saver. Read your manual for more info on using specialty metering modes.

Spot metering is the ultimate refinement in metering small, selective areas, because it reads only one tiny area of the viewfinder, typically just a few centimeters in diameter. In my current D-SLR, for example, the spot metering is done in an area that's just .14 inches (3.5cm) across, which represents just 2% of the overall frame. The purpose of this mode is to let you take meter readings from very exacting and specific areas of the frame.

These days I use the spot meter less and less because, I have to admit, the multi-segment metering is amazingly accurate. Before the days of such dependable multi-segment metering, I did use spot meters much more frequently. Still, there are circumstances when a spot meter is the best (and sometimes the only) way to get an accurate reading. While photographing this white ibis in Florida, for example, the bird was completely surrounded by very dark—almost black—water. A multi-segment reading of this scene would have given me medium gray water and probably a very overexposed (washed out) bird.

TECH SPECS: LENS: 300mm / FOCAL LENGTH: 450mm
EXPOSURE SETTING: 1/640 @ f/9 (+ 1.3EV)
EXPOSURE MODE: Aperture Priority
WHITE BALANCE: Cloudy / FILE FORMAT: JPEG
ISO: 200

Get Close to Wild Animals (in the Wild, Naturally)

Getting a great close-up shot of a wild animal is one of the most exciting (and often frightening) moments that you'll have as a photographer. Few subjects (three-year-old kids aside) are as difficult, unpredictable, and potentially dangerous (this part doesn't necessarily apply to the kids) as an animal in its own environment—and few animals (and this does apply to the kids) could care less about you getting a good photograph. Animals in the wild are living their own lives and whenever you are close to one, you're the intruder and it takes a great deal of patience and skill to see or get near them, let alone come home with some good photos. I spoke in tip 57 about using your car as a wildlife blind, and here are some more things I've learned over the years that will help you get better photos of animals in the wild:

◆ **Take a wildlife tour:** Organizations like the National Audubon Society offer wonderful group tours that provide unprecedented opportunities to get close to birds and other wild animals. Some of these tours are simple afternoon hikes while others offer extended trips to seek out particular types of animals. The longer trips are not inexpensive, but they are often life-changing experiences (and if you need a personal Sherpa, let me know).

◆ **Hire a local guide:** It's funny that this never occurred to me as an option until I was on a camping trip in northern Maine and started seeing "moose guide" signs along remote stretches of road. For a fairly reasonable fee, these guides will take you one-on-one into prime wilderness areas, and their ability to deliver the goods is extremely high. They can't guarantee you'll get close to a moose or a bear, but they'll multiply your odds astronomically.

◆ **Study State Park Sites Online:** Every state in the U.S. and each Canadian province have a state bureaus devoted to wildlife protection and observation; they also maintain online sites with great information and maps that can provide some basic information about a particular animal or region.

◆ **Take a wildlife photo workshop:** Again, these are usually not particularly cheap, but they're a terrific way to get close to animals and hang out with other serious photographers. The best wildlife workshops are run by master photographers like Arthur Morris, who is perhaps the best bird photographer and one of the best photography teachers on the planet. Again, a good workshop is a potentially life-changing experience.

◆ **Read, read, read:** You've heard this many times (from me, probably), but the more you know about your subject, the better your odds of getting great photos. It's an absolute publishing crime, but Leonard Lee Rue's *How I Photograph Wildlife and Nature* is out of print, but it's the best book ever written on the subject and you can get used copies on Amazon for under a buck. Buy it.

Life is short (and some animals are disappearing fast), so if you dream about photographing wildlife, start making plans to do it today!

TECH SPECS: LENS: 70-300mm / FOCAL LENGTH: 315mm
EXPOSURE SETTING: 1/125 @ f/5.0
EXPOSURE MODE: Program
WHITE BALANCE: Cloudy / FILE FORMAT: JPEG / ISO: 200

Return to Familiar Haunts

I was surprised a while back when I was talking to a travel photographer friend and he told me that he never returns to the same destination to shoot unless he's on a paid assignment. His feeling is that there are just too many new places to shoot—at home or on the road—for him to spend time returning to old haunts.

I have to say that I both agree and disagree with his philosophy. On one hand I love to see new places and I always shoot more—and usually better—photos when I'm in a brand new locale. And returning to a place does sometimes feel like you're trying to recapture a past experience—not particularly conducive to creative ideas.

On the other hand though, the more you get to know a place the more you get in touch with its moods and its deeper rhythm. Also, the more you know the geographic and physical features of a locale, the more time you can spend thinking about lighting and weather and mood, and less about finding the good vantage points. I live about 30 minutes from the harbor shown here, and I've been there dozens and dozens of times. The boats may change places or swing a bit with the tide, but the islands and the shoreline remain the same.

Knowing what I'm going to encounter physically means that I can find compositions faster and pay much more attention to what the light and weather and seasons are doing. I shot this photo about 30 minutes after sunset, for example, because I knew that once the sun had set that the harbor would smooth over and the mist would start to settle around the islands. Had I not known the place so well, I might have left after the colors of the sunset had faded and missed this pretty deep-twilight shot.

I think the key to deciding if old haunts are worth revisiting is not so much that you've been there before (for better or worse) but does the place inspire you—do you enjoy being there and looking for photos? If you do like being there, then the creative possibilities are continually reborn because your imagination is open. And then, of course, when you do find yourself getting bored, you'll know it's time to wander further on down the road.

TECH SPECS: LENS: 80-200mm f/2.8 / FOCAL LENGTH: 330mm / EXPOSURE SETTING: 1/13 @ f/5.6
EXPOSURE MODE: Shutter Priority
WHITE BALANCE: Auto / FILE FORMAT: RAW / ISO: 800

Add Noise to Create a Film Look

Digital cameras have come a long way in a very fast time, and while photographers once wondered whether digital would ever equal the quality of film, now it's clear that digital cameras and images are far superior in almost all ways. Let's face it, you could never walk into a dimly lit concert setting and "push" your film to ISO 6400 and get the same quality you can get from some professional digital cameras at that ISO speed.

Whenever you pushed your film to a higher ISO speed you paid a price with much more obvious film grain—that sandy looking surface pattern that speckled the image. (When that grain appears in digital images it is called "noise.")

But interestingly, the lack of that grain or noise in some digital images tends to occasionally make them look very fake and "too good." Fortunately, you can easily add noise back into your images to recreate a film look, which is something I do only rarely, but it's still a useful option with certain kinds of images. Low light and twilight scenes, I think, look more real when you add a touch of grain. I'm sure that's partly because my lifelong visual reference point for such images is film, but still, on the rare occasion when I do add noise to simulate grain, I like the look. When I shot this scene of a lighthouse on the Connecticut shore, I was shooting at ISO 1600. Once downloaded, I was surprised to see that there was virtually no noise and the image looked too clean. Where was the grain I was used to seeing in twilight scenes? Though the image was technically better than a film image, it seemed like it was missing something.

Photoshop to the rescue! By selecting the "Add Noise" filter from the Filter menu (Filters>Noise>Add Noise) I was able to add noise back into the shot. The tool is incredibly easy to use—you simply push the slider until you see the degree of grain that you want. Remember that noise gets bigger in prints as you blow things up, so always add grain with the image open at 100% on your monitor and make a test print before you finalize the image. And like adding salt to a meal, it's best if you add a little and then increase it if you need more; if you add too much noise (or too much salt), that's all you'll notice.

By the way, adding grain can also be a useful tool if you're copying old family photos and you improve them too much, which has happened to me. By adding a smidgen of noise back, you retain the authenticity of the original photos. Who would have thought we'd have to add flaws back into digital images to make them look real?

TECH SPECS: LENS: 70-300mm
FOCAL LENGTH: 450mm
EXPOSURE SETTING: 1/50 @ f/5.6
EXPOSURE MODE: Manual
WHITE BALANCE: Cloudy / ISO: 1600

Lay Down and Look Up!

Most of the time when we're out shooting pictures we look at the world that's in front of us from eye level. We look straight ahead, occasionally turning to see what's off to the side. For some reason though, most of us rarely look up— perhaps it's a primal fear of showing our eyes to a low-flying predator (or maybe we just take the sky for granted). But there are a lot of great photos directly overhead and the only way to find them is to occasionally look up—straight up.

That's exactly how I found this shot of a beautiful old live oak tree draped in Spanish moss on the grounds of the Marjorie Kinnan Rawlings Historic State Park near Ocala, Florida. Rawlings wrote *The Yearling* and the house she wrote it in is preserved at the park—a great Florida side trip. Nearby the Rawlings' homestead, there's a small picnic area at the edge of a lake with lots of beautiful old live oak trees.

I had spent an hour or so (between bites of lunch) looking for a good shot of Spanish moss because it's always been a frustration to me that, despite having spent a lot of time traveling in the south, I didn't have a good Spanish moss shot. At some point during lunch I laid down on the grass next to a particularly big oak tree just to enjoy the Florida warmth and finally saw the shot I'd been waiting for. Here was a perfect silhouette of this rugged live oak completely decorated with Spanish moss with the bright Florida sun making the moss glow like backlit hair.

I spent another half an hour or so shooting various compositions, looking almost straight up. And while it was a pain in the neck (literally) to get my tripod to point up that steeply, I really had a good time taking the pictures. I used multi-segment metering to meter the shot and added 1.3 stops of exposure compensation to keep the highlights in the moss bright and clean. Next time you're stumped for an original angle, trying taking a break and laying in the grass—you never know what great shots you might find.

TECH SPECS: LENS: 18-70mm / FOCAL LENGTH: 27mm
EXPOSURE SETTING: 1/125 @ f/6.3 (+ 1.3EV)
EXPOSURE MODE: Program
WHITE BALANCE: Cloudy / FILE FORMAT: JPEG
ISO: 200

Editing Quick Tip: Fade Photoshop Filters for Artistic Control

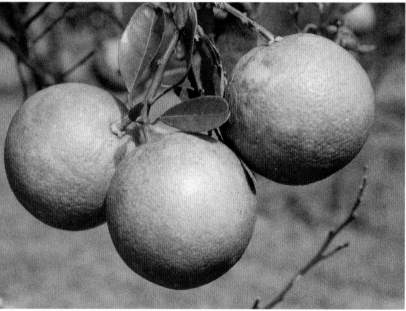

TECH SPECS: LENS: 18-70mm / FOCAL LENGTH: 105mm
EXPOSURE SETTING: 1/250 @ f/8 (+ 1.3EV)
EXPOSURE MODE: Program / WHITE BALANCE: Cloudy
FILE FORMAT: JPEG / ISO: 200
PHOTOSHOP FILTER: Add Noise

Here's a really quick and easy tip that provides a simple way to control the intensity of Photoshop filters. Any time that you apply a Photoshop filter to an image and you think it's too strong (or just want to see how it would look if you had used less of the filter), simply go to the edit menu and you'll see an option to fade that filter (it will say "Fade...." with the name of the filter next to it). If you click on that option, you'll get a slider that lets you adjust the strength of the filter from 100% (maximum) to 0% (no effect).

In the first version of these oranges, I applied some noise just to give the shot a rougher, old photo look. The noise is obviously way too heavy, so I used the Fade tool and reduced the effect by 50%.

The option is only available after you apply the filter, however, so you must go immediately to the Edit menu after the filter is made active. If you do anything else after you apply the filter, the Fade option won't appear. This technique is a great way to tweak filter strength without having to start over again.

Editing Quick Tip: Create a Blue Flamingo

Imagine—a blue flamingo! Everyone loves fantasy, I think, and nothing conjures more romance or imagination than the idea of a totally new species of animal. Unfortunately, this bird is pure fantasy and I created it (from a shot of a pink flamingo, of course) in Photoshop. The first time I put a version of this shot on flickr.com, however, two interesting things happened: for one, it got the highest number of views of any image I had on the site. The photo also got ripped off faster than you can possibly believe—I found it on blogs, websites, e-zines, and even on the cover of an online menu for a restaurant. (I didn't have to sue anyone, by the way, but I did go after every single abuse.)

Creating this wonderful bird was a lot easier than you might think, and it was all done with the Hue/Saturation tool in Photoshop (Elements has the same tool). Here's how to do it:

1. First, choose a subject with a bold overall color. The flamingo worked well because it was just various shades of pink and white.

2. At the top of the Hue/Saturation window, look for the Master pull down menu. There you'll find a list of all the colors. Choose the color that matches your subject (in this case, red). If you were doing this with a lemon, for example, you would choose yellow.

3. At the bottom of the Hue/Saturation window, you'll notice there is an Eyedropper tool with three boxes: the Eyedroper, the Eyedropper with a plus (+) symbol, and the Eyedropper with a minus (-) symbol.

4. Select just the eyedropper and click anywhere in your subject. That tells the tool what color you want to change. Now select the eyedropper (+) box and then click as many times as you like to pick up more shades of the main color in your subject (I probably made about 12 different clicks within the flamingo to pick up various shades of red and pink).

5. Now adjust the Hue slider and watch what happens. The color of your main subject (a flamingo, a lemon, etc.) will begin to shift colors radically. Interestingly, because you chose a specific color from the drop down menu, only that color will shift. The remaining portions of your photo will remain the same.

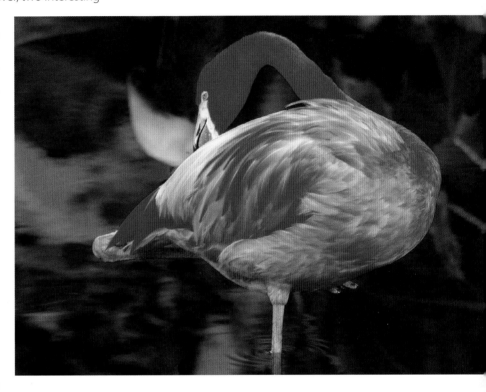

After I changed the flamingo from pink to blue, I did some touching up (darkening selected areas of the background, healing some tiny flaws in the water, etc.) and then did an overall Curves adjustment. You'll notice there is still a tinge of pink in the flamingo and I could have gotten rid of that by going more extreme with the hue shift, but I kind of liked the pinkish color coming through a bit. This is a really simple Photoshop trick that can be a lot fun (unless people steal your crazy new image, of course!).

TECH SPECS: LENS: 80-200mm / FOCAL LENGTH: 180mm
EXPOSURE SETTING: 1/400 @ f/6.3
EXPOSURE MODE: Aperture Priority
WHITE BALANCE: Cloudy / FILE FORMAT: JPEG / ISO: 200

Create an Organization System for Your Digital Files

It's amazing how fast a library of digital images can grow. What starts out as a few dozen shots here and a few dozen there suddenly becomes hundreds and then thousands of images. It's as if they're breeding on their own while you're sleeping. Not only can all of these images clog up your hard drive, but just keeping track of where they are can become a logistical nightmare unless you keep a tight grip on organization.

It's essential that you find some means of knowing where your digital images are and that you set up a method of finding them quickly—and the sooner you start, the sooner you'll tame the beast. I've tried several organizational programs (I used to love iPhoto, but recent versions are just not reliable and create more problems than they solve) and over time I've developed a very simple two-step method.

The first thing I do when I download a new set of images from the camera is to put them into a folder that describes the primary subject and date. For the photo here, for example, I created a folder called "Paris, September 2008." Because I use Photoshop and an excellent stand-alone Adobe program called the Bridge (I couldn't live without it), all of these folders are alphabetically organized within Bridge. To find Paris, I simply scroll down through the folders alphabetically.

Very simple. Because Bridge and Photoshop are integrated, all I have to do is double-click on the image and it opens in Photoshop.

But within any given folder, of course, there may be several different topics. The "Paris, September 2008" folder might contain images of the Eiffel Tower, Notre Dame, Paris Cafés, etc. If there are enough files that require different subheadings, I divide the various subjects and create a new folder for each one.

But a quicker way (for me, at least) is to assign each individual file specific keywords. Within the Paris folder, for example, I would assign the keywords "Paris" to all the files, and then more specific words for different subjects. I can then click on "Notre Dame" and only the images of Notre Dame will show up. If I want to see Notre Dame and the Eiffel Tower, I can search both keywords at once. Better still, I can do a global search on my computer to find all the files with those keywords.

There are a lot of free and inexpensive organizational programs available and it really doesn't matter which one you use if it seems logical to you and it lets you navigate your files efficiently. The important thing is to create a system early and stick with it. I now have upwards of 75,000 images in my library and as good as my memory usually is, if I didn't organize my files by both folder and keyword names, I'd spend half my life looking for images. And nothing is worse than having a client on the phone that wants to buy an image today and you find yourself sitting at the computer 12 hours later still looking for it.

TECH SPECS: LENS: 18-70mm / FOCAL LENGTH: 28mm
EXPOSURE SETTING: 1/10 @ f/3.5
EXPOSURE MODE: Program / WHITE BALANCE: Auto
FILE FORMAT: JPEG / ISO: 800

Enhance Depth by Raising Your Subject Higher

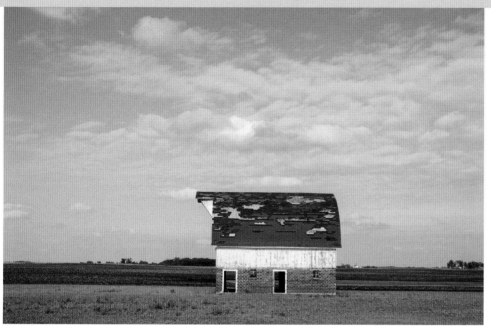

If you're trying to create a sense of depth in a photograph, one really simple way is to place your main subject closer to the top of the frame. By placing the subject higher (or placing the horizon higher), you exaggerate the foreground, reinforcing the sense of distance from the camera's position to the subject and/or the horizon. It gives the viewer the sensation that they would have to walk farther into the scene to get to the subject.

These two shots of an Iowa barn were photographed from exactly the same spot and all that changed was the position of the horizon and the barn. By placing the barn lower in the frame, it seems much closer and more immediate; by tilting the camera down a bit and taking in more of the meadow, the horizon rises higher in the frame and the barn seems more distant. A simple trick, but it's a great way to show depth.

TECH SPECS: LENS: 24-120mm / FOCAL LENGTH: 45mm
EXPOSURE SETTING: 1/125 @ f/20
EXPOSURE MODE: Aperture Priority
WHITE BALANCE: Sunny / FILE FORMAT: JPEG / ISO: 200

Get the Maximum Blast from Built-in Flash

I'm not a big fan of using built-in flash because in most situations, not only are these units not very powerful, but let's face it, it's like aiming an interrogation lamp at your subject—all the romance of the conversation is dead.

There are times, however, when it comes down to a simple decision: it's either resort to the built-in flash or put the camera away. Here in New England, for example, autumn is agricultural fair time and shooting close-ups of farm animals is always a lot of fun. The problem is that as sunny and bright as it is outdoors, the minute you step into any of the animal-display barns, it's like entering a cave—there's just no light at all.

Carrying a big accessory flash around a state fair is no way to enjoy yourself, and that much light used that close would probably frighten the dickens out of most farm animals. The only solution is to pop up the built-in flash and try to find shots where the flash isn't terribly intrusive or obvious—and where your subjects are close enough to be lit by the mild-mannered blast of the tiny flash unit.

TECH SPECS: LENS: 18-70mm / FOCAL LENGTH: 46mm
EXPOSURE SETTING: 1/60 @ f/4, with built-in flash
EXPOSURE MODE: Auto
WHITE BALANCE: Auto / FILE FORMAT: RAW / ISO: 200

There are numerous problems with built-in flash, the most obvious being that the flash is harsh, very directional, and rarely flattering. Also, the power of the flash is modest at best, so you are limited in how large a subject you can light and how far you can be from that subject. But in watching several other people (most with point-and-shoot cameras) shooting flash photos in the same barns, I noticed several simple things people could have done to improve their flash photos. So here are some quick tips for improving your built-in flash images:

◆ Stay within the flash distance range. Most built-in units have a range of roughly 3-12 feet (.9-3.7 m). Your manual will provide the exact range. If you work closer than that (unless you're specifically working in a close-up mode that allows a reduced distance range), you will blast your subject with too much light and overexpose it. Conversely, if you're too far away, you won't have enough light on your main subject and your photos will be dark.

◆ Use flash compensation if your subject is very light. Many D-SLRS and compact zoom cameras have a flash exposure compensation setting that lets you add or subtract light from the flash exposure (without affecting the main exposure of the camera). If you photograph a very light subject in the foreground (like the sheep shown here) without compensation, the flash will read the light reflecting back from the white subject and shut down the flash prematurely (thinking there's plenty of light) so that the overall scene is too dark. In this case, I only used +2/3 stop of compensation because I really didn't care if the background went dark (in fact, I wanted it to be darker so the sheep would stand out), but I added that extra 2/3 stop because I thought it would lighten the sheep's wool coat a bit. Read your manual for more about flash compensation.

◆ Consider buying a Soft Screen diffuser from Lumiquest. Lumiquest sells this great little gadget for under $15 that mounts quickly to your built-in flash and softens the light nicely without absorbing it too much.

◆ Keep your batteries fresh. Flash is one of the biggest drains on your camera's batteries, so it's important if you're going to be using flash to keep your camera batteries freshly charged. Weakened batteries will delay flash-recharging times significantly, and they will also reduce the maximum flash-to-subject range.

◆ Allow your camera time to recharge the flash. You can't shoot flash photos as rapidly as you can shoot outdoors in sunlight because the batteries need time to charge the flash unit. Give the camera an extra few seconds between flash exposures and you'll be sure you're getting a maximum blast each time.

◆ Don't put your fingers in front of the flash. I see this all of the time—people putting their fingers or their camera straps in front of the flash unit and blocking the light (or creating unwanted shadows on the subjects). Find a comfortable grip that avoids blocking the flash unit.

◆ Take chances and hope for the best. There have been a lot of times when I didn't think the built-in flash was worth turning on but I shot the photos anyway. I'm sometimes amazed by the difference just a tiny bit of flash can make—often providing me enough light so that I can save the shot completely in editing. What the heck, if you're deciding between not shooting or taking a chance on the flash, take the chance, you might get a happy surprise.

◆ Consider buying an accessory flash. If you've been frustrated by the limits of your built-in flash, perhaps it's time to consider buying an accessory flash unit (or dropping lots of hints around birthday time) if your camera has a hot shoe that accepts an accessory unit. A good accessory flash can provide you with a flash range several times longer than a built-in flash unit and offers tons of other flash options, like bounce flash for softer light.

Built-in flash isn't the greatest lighting option in the world, but it sure beats not taking pictures—and it's a whole lot better than carrying flash bulbs in your pocket the way I did when I was starting out!

Beware the Six-Legged Horse

another angle. But it was just a snapshot at a country fair, so I let it slide. But do be aware of backgrounds when you're shooting—especially people and animals. How many times have you seen trees or light posts that look like they are growing out of a subject's head? And it's not just the big stuff you've got to look out for. Whenever you're composing shots, look for little things that can become distractions. Things like pieces of trash, bright cars in the distance, or complicated details in buildings; really, anything that takes the focus off your subject. If you can't move the background

If you look closely at this photo, you'll notice that the horse appears to have four front legs. This is a beautiful (and huge) draft horse, so I'm not sure if that would make him stronger or not, but it sure makes it look a bit like a circus freak. The problem, of course, is that another horse is standing right behind this one, and all that you're seeing of the second horse are its front legs.

Unfortunately, the horses had just finished working when I snapped this shot and were eating furiously, so I wasn't going to ask the owner to pose them better for me. I only shot the photo because it was such a beautiful and big horse; I simply wanted a way to remember it. The point is, though, you really have to keep an eye on backgrounds. Had this been an important shot, I would have waited or worked harder to find

distraction (unless you're strong and can pick up cars), move to a different spot and recompose to lessen the distraction. Make it a point to always consider the background and make it as clean as possible. Otherwise, you may end up with six-legged horses or two-headed people, and viewers may think you've been shooting pictures at the sideshow portion of the country fair.

TECH SPECS: LENS: 18-70mm
FOCAL LENGTH: 43mm
EXPOSURE SETTING: 1/500 @ f/11
EXPOSURE MODE: Aperture Priority
WHITE BALANCE: Auto / FILE FORMAT: RAW / ISO: 640

Visit Maine During Lupine Season

One of the most spectacular wildflower displays any-where in the world happens each June all over the state of Maine, when the beautiful lupines come into bloom. If you've never seen the lupines in bloom, it's an amazing sight: you come around a corner on a country road and suddenly dozens of acres are filled with purple, blue, and pink stalks reaching upwards of five feet (1.5 m) tall.

I have to confess to having spent a lot of frustrating hours over the years trying to get a good photo of the lupines, and it's tougher than it looks. I was in a spectacular field in Rangeley, Maine, one summer and got so frustrated at not being able to find a shot that I came close to tossing a camera into the woods. It can really make you nuts to have what looks like millions of flowers in front of you and not be able to find a single good shot.

Getting a good shot is actually a true test of your ability to see creatively—and this is true of all fields full of flowers, so if you can't make it to Maine to shoot lupines, apply this tip to your own nearby flowers. One of the first decisions you'll have to make is whether to shoot just a few blossoms or try to take in an entire meadow.

Remember that you don't have to include every flower stalk that you see in order to impart the feeling of endless blossoms. Often, it's better to find a small group of flowers and contrast them against a plain background (try to use a dark background like the pine trees in the shot here). Experiment with different lenses or zoom settings, too. I find that a medium telephoto setting is a good way to isolate a small grove of plants, but a wide-angle lens will let you exaggerate the depth of a long field full of flowers.

If you're really serious about getting a good shot of a broad field, consider bringing a small stepladder with you. Just getting an extra three feet (1 m) of height above the field is enough to get a really unique and interesting perspective. The great landscape master Ansel Adams had special shooting platforms built on top of his vans for that very reason.

Lighting is also very important in shooting the lupines: early morning and late afternoon, when the light is soft and less contrasty, is ideal. I actually like working on cloudy days because the flower colors are more saturated and there are no glaring highlights. One other slight problem I run into when shooting lupines is wind—on windy days you either have to include some motion (intentionally using a show shutter speed) or just wait for a calmer part of the day.

TECH SPECS: LENS: Built-in zoom
FOCAL LENGTH: 48mm
EXPOSURE SETTING: 1/190 @ f/5.1
EXPOSURE MODE: Aperture Priority
WHITE BALANCE: Auto / FILE FORMAT: TIFF / ISO: 100

Informal Group Portraits: Get Them to Smile!

Not everyone likes to get their picture taken (I'm emphatically included in that group), but the trick to shooting happy portraits is to make your subjects look like they're having a grand time. And the secret to that is getting them to smile—and not just a fake smile for the camera, but a genuine happy smile. The best way I've found for doing that is to have someone else doing the dirty work for you—preferably someone that your subjects like and have fun being around. In this case, it was the grandfather who was kidding with the three women just off camera. By having someone else interacting with them, you get the chance to watch for nice moments and keep your face pressed up against the viewfinder (or looking at the LCD) and paying attention to camera controls. Also, it helps if you're shooting from a slight side angle because then your subjects are interacting naturally with someone off camera and looking directly at them rather than into the lens. By the way, all outdoor portraits work best when they're shot in open shade with just a touch of fill flash to open up shadows on the face. If you set the white balance to Cloudy, it will warm the flash up nicely, too.

TECH SPECS: LENS: 18-70mm / FOCAL LENGTH: 62mm
EXPOSURE SETTING: 1/400 @ f/4.5 (+ 0.33EV), with
built-in flash / EXPOSURE MODE: Program
WHITE BALANCE: Cloudy / FILE FORMAT: JPEG
ISO: 200

Make Hay (or Autumn Pictures) While the Sun Shines

Autumn is probably my favorite time of year. I just love the smell of wood smoke in the air, seeing pumpkins on everyone's front steps, the sweet taste of fresh-made cider—and getting another chance to photograph those amazing autumn leaves. Of all the surprises that Mother Nature has to offer photographers, few are more fascinating to watch than seeing thousands of trees and millions of leaves burst into intense shades of yellow, orange, and red. If you've never seen the height of autumn's glory in New England, it's a sight to behold.

In New England, everyone talks about the "peak" of color as if it were some type of mystical moment—and in some ways, it is. While some autumns are better than others, in each season there seems to be a short window of a few days (some Vermonters will tell you it's a few hours) when the leaves are so intensely colored you'd think they were going to just burst and start squirting colorful pigments all over the landscape. The colors are so outlandish that they seem to shine even on the darkest nights.

When the colors get to this state, however, you have to have your camera ready and be prepared to drop what you're doing and start shooting. I saw the tree here while on my way

to a dentist appointment and the afternoon light was just starting to illuminate the leaves. I actually thought of ditching the appointment to photograph the tree, but decided I had some time before the light would be perfect.

Thankfully, it was a short appointment and so I was able to run home afterwards, grab my camera, and get back to the tree just as the last rays of late afternoon light were igniting the treetop. I shot for about 15 minutes, taking a variety of views of this tree and some others nearby before then the sun faded and the magic was gone. The tree was still beautiful to look at, but the illumination was over for the day.

Whether it's the true peak or not, when you see a spectacular tree like this, you have to make an effort to photograph it because, as so often happens in life, the beauty fades quickly. The day after I shot this photo there was a driving rain that lasted for days and I'm sure that most of the leaves were soon lying on the ground. The moment when I saw the tree ignited with autumn color, with every leaf in place, was almost certainly over until next year. How glad I am that I made the effort to shoot it!

We tend to think that beautiful natural scenes are just sitting there waiting for us to take advantage of them but, of course, they're not. It's up to you to capture the beauty the moment when you see it.

TECH SPECS: LENS: 18-70mm
FOCAL LENGTH: 52mm
EXPOSURE SETTING: 1/200 @ f/9
EXPOSURE MODE: Aperture Priority
WHITE BALANCE: Auto / FILE FORMAT: RAW / ISO: 200

Cultivate Flower Photos: Visit a Botanical Garden

If you like to photograph flowers and plants but don't have the time or room for a garden at home, consider making a trip to a local botanical garden. Even if you do garden a lot at home, you'll get to see things at a botanical garden that most home gardeners could simply never grow in quantities that are extraordinary. Wherever I travel in the world, in fact, one of the things that I seek out are the local gardens and botanical collections.

Most gardens have two types of displays: formal outdoor gardens and indoor conservatories. Longwood Gardens, just south of Philadelphia, for example, has around 1,000 acres of outdoor gardens and more than four acres of indoor gardens! In fact, the conservatory contains more than 5,500 different types of plants growing in 20 different gardens. Another favorite haunt of mine is the New York Botanical Garden in the Bronx, which features 250 landscaped acres, 50 curated display gardens, a 50-acre native forest, and more than a million different plants—all waiting to be photographed. I photographed the water lilies shown in one of their several nice reflecting pools behind the main conservatory (I also photographed a family of 11 baby ducks here).

Those are some of the big guns, of course, but I've found wonderful small gardens in places like Corpus Christi, Texas, and Tucson, Arizona, and there's even a small but terrific rose garden in a park just up the street from where I live. Do an online search for local gardens and odds are you'll find one that's within a short drive. Don't forget to check YouTube, also, because you're sure to find lots of videos of formal gardens and botanical parks.

One other thing that I like about photographing in a botanical garden, by the way, is that they usually have a staff of gardeners who work continually to deadhead old blooms and weed the gardens so that you don't have to worry about a great shot being ruined by a few raggedy blossoms. Even better, you can ask the gardeners lots of questions about how they keep the gardens looking so nice.

TECH SPECS: LENS: 18-70mm / FOCAL LENGTH: 40mm
EXPOSURE SETTING: 1/60 @ f/3.8
EXPOSURE MODE: Program
WHITE BALANCE: Cloudy / FILE FORMAT: RAW / ISO: 800

Look for Holiday Still Life Pictures at Home

I am one of those people that actually likes to decorate for holidays. Whether it's Christmas, Thanksgiving, Halloween, or almost any other holiday, give me the slightest excuse to hang some fairy lights or make an arrangement from pinecones and candles and I'm there. I'm sure this is a gift (or a burden) handed down to me from my mother, who decorated the house so overwhelmingly at the holidays that we used to joke that Christmas had exploded in our living room. There wasn't a candlestick or banister or picture frame (or cat) that wasn't adorned with at least one red bow—and often several. What was the purpose of a holiday if not to turn the house into a greeting card?

I don't go as nuts as my mother did, but during Christmas you would be hard put to find a corner in my house that doesn't have some little splash of red or gold. One of the nice things about having all of these little thematic nooks around the house is that they give me a chance to make some impromptu still life photos. The day I shot this scene, for example, I was sitting at the dining room table reading mail and noticed the pretty morning light coming through the blinds and illuminating this little candle dish. Much as I would love to ignore such moments and keep doing what I'm doing, it's nearly impossible: when a photo calls, I have to get the camera and respond.

Shooting still life subjects around the house is actually a lot of fun and it's good photo practice. Turning your home into a studio teaches you to pay attention to the lighting and to appreciate the beauty of the shapes, colors, and textures of the objects that you live with every day. I don't make a big production out of these found shots and I try to shoot them exactly as I first notice them. For this shot, I moved a few little sparkly plastic snowflakes out of the way and warmed up the colors in post-processing, but otherwise the scene appears just as I found it.

With shots like this, you'll typically be working either with existing daylight or a combination of daylight and artificial light from lamps. I shot a few frames of this scene with flash, even experimenting with lowering the flash compensation (so it wouldn't overwhelm the daylight that was coming from a window to my right), but the shots made exclusively with window light were the best.

Taking photos of holiday still life scenes has a few practical benefits beyond photography, too. For one, even if you're a sentimental fool (or especially if you're a sentimental fool), it's easier to put the decorations away if you know you'll always have the photos to recall how your house looked. Also, you can turn these holiday photos into greeting cards next year. Most importantly, if you're the primary decorator, it's nice just to spend a few moments appreciating the beauty and creativity of your decor—even if the rest of the family teases you for turning the house into a holiday cliché.

TECH SPECS: LENS: 70-300mm
FOCAL LENGTH: 195mm
EXPOSURE SETTING: 1/200 @ f/11
EXPOSURE MODE: Program
WHITE BALANCE: Auto / FILE FORMAT: RAW / ISO: 400

Be Golden, Shoot in the Gold Zone

Although I am on the prowl almost constantly for pictures, especially when I'm traveling, like many photographers I would guess that I do 80% or more of my real shooting during the first hour or so after sunrise and the last hour before sunset. Photographers refer to these times as the golden hours because of the warm color of the light.

Personally, I think a lot of pros call these the golden hours for purely mercenary reasons—they know that they can sell more photos shot during these hours than at any other time of day. Photo buyers are human, too, and they are just as susceptible to the romantic glow of a warmly lit scene as the rest of us. Let's face it, if you can shoot the parking lot at Home Depot with enough golden light on it people will "ooh" and "aah" at the photos. There is just something about that amber veil that puts people in a warm and cozy place, emotionally speaking.

Light quality is another nice benefit of the golden hours. There is a softer quality to the light, which means that contrast is gentler, shadows are more open, and highlights are less likely to be burned out. Also, because the light is raking across the land at such an oblique angle, there are a lot more textures brought out in landscapes. And if you're doing a portrait, you can place the low sun behind your subject and get a nice, warm glow around the hair.

Try an experiment sometime: shoot a shot of a local strip mall or some other place at high noon (on your lunch break, perhaps) and then go back there an hour or so before sunset and shoot it again. You'll be stunned at the difference.

TECH SPECS: LENS: 18-70mm / FOCAL LENGTH: 90mm
EXPOSURE SETTING: 1/100 @ f/14
EXPOSURE MODE: Aperture Priority
WHITE BALANCE: Cloudy / FILE FORMAT: RAW
ISO: 200

Photoshop Filter Fun: Flood Your Photos

I'm not a big collector or user of offbeat Photoshop filters, but there are a few that I have had a lot of fun with. One of those is the Flood filter from Flaming Pear Software. This filter, which installs into your plug-ins folder and shows up in the Photoshop filter menu, does just what the name implies: it floods your photos with water and lets you turn dry landscapes into waterfront property and create surreal reflections as if by magic. It's a blast to play with and the download is very affordable.

The filter is very easy to use and I don't believe I've ever looked at the PDF manual that came with it; I simply opened a photo and started playing. The interface is purely graphical (in other words, you just click on little icons and see what happens) and there are controls for manipulating where the flood horizon goes, how smooth or rippled the water looks, how bright the reflections will be, and more. Or you can click the randomizer and let the program choose the options for you; you'll get some very surprising results that way.

In this pair of comparison shots of the Cathedral in the Rocks in Sedona, Arizona, you can see how the shot looks with and without the filter. The cathedral is, of course, high on a rocky

perch and the closest water is probably in Oak Creek about a mile away. With the help of the Flood filter, I was able to set the building at the edge of a desert pond. You have to love this stuff!

You can download a trial version of the software for free (Windows or Mac) at www.flamingpear.com; if you decide you can't live without it, you just pay the licensing fee. I have to say it's probably the most fun software I've ever bought for under $30 and, for commercial photographers, it can have a lot of practical applications in still life work. I've seen my good friend and master food photographer Jon Van Gorder use it to great effect in food shots (reflecting a bottle of vodka in an ad shot, for example).

TECH SPECS:
LENS: 24-120mm
FOCAL LENGTH: 70mm
EXPOSURE SETTING: 1/60 @ f/11
EXPOSURE MODE: Aperture Priority
WHITE BALANCE: Auto
FILE FORMAT: JPEG
ISO: 200

Give Your Sunsets a Powerful Foreground

It's easy to look at a pretty sunset or sunrise and think that nature will do all of the work for you when it comes to photographs. With all that color and drama, what's not to like? But you can improve any sunset or sunrise by simply finding a dynamic foreground to place in front of it. Because you want the colors and cloud patterns (or sky reflections, if you're near the water) to dominate the shot, you want your foreground subject to be simple, yet interesting. Also, because it's likely that your foreground will end up entirely in silhouette, you also want a subject that's bold enough to be reduced to lines and shapes and still add interest to the photograph.

I took this shot of the rigging on a commercial fishing boat in Galilee, Rhode Island, and I really like the way the complex web of stays and ropes creates such interesting patterns. It took me a while to find the shot—even though I had been scouting around the harbor an hour or so before sunset. I was really hoping to get a shot of a boat pulling into or out of the harbor, but all the boats were tied up for the night. After walking around the marina in a slight state of panic for what seemed like an eternity (it was probably only about 10 minutes), afraid that I might miss this great sunset and not get a good shot, I looked up into the rigging of this boat and knew it would make an interesting composition. I planted my tripod on the dock and fired off a few dozen shots as the sky grew more intense and then started to fade; I also shifted my shooting position slightly every few frames for variety's sake.

By the way, in terms of exposure, I just took a multi-segment reading from the sky since the foreground was going to be in silhouette, but I did add +2/3 stops of exposure compensation to keep the sky brighter. I shot this photo in JPEG format, but had I shot in RAW, I would not have used the compensation but would have made the adjustment in the RAW converter.

Scouting ahead of time is the real key to finding a good sunset foreground. I've always found it's better to sacrifice an hour of late-afternoon shooting to do more scouting if I think there's going to be a great sunset, because I know that the combination of an interesting foreground and a great sunset make really pretty photos. Better yet, scout earlier in the day, at midday perhaps; just be sure you get back to your sunset location in time to catch the show.

TECH SPECS: LENS: 105mm / FOCAL LENGTH: 157mm
EXPOSURE SETTING: 1/80 @ f/9 (+ 0.66EV)
EXPOSURE MODE: Aperture Priority
WHITE BALANCE: Cloudy / FILE FORMAT: JPEG
ISO: 200

Photoshop Tip: Create an Old-Fashioned Postcard Look

I love the look of old travel photos, especially those old sepia postcards that you find at flea markets and yard sales. It's amazing how those images bring back the feeling of another era and a more adventurous vision of travel. But you don't have to visit antique sales to find those kinds of images; you can create them in Photoshop from new photos with only a few quick clicks. I shot the photo here a few winters ago in Florida and you can see that just adding a slight sepia tint gave it that antique postcard look.

Creating the effect only takes a few minutes. Here's how I did it:

◆ First, choose a photo that has a sort of old-fashioned look to it. In this case, by selecting a scene of a dirt road and palm trees, the picture really captures the feeling of "old" Florida.

◆ Next, do a quick Curves (or Levels) adjustment, just to get the exposure right, but keep the contrast somewhat flat. I didn't do any other editing to this image—it's not even cropped. In particular, I didn't sharpen the image because I wanted it to have that soft, aged look.

◆ In either the Adjustments menu (Image> Adjustments) or at the bottom of the Layers palette (I always choose the latter because you can turn off adjustments made as a layer), select the Photo Filter option. Then select a warming filter and crank up the warmth and use a high density. In this case, I chose the #85 warming filter and ran the density up to 97. The higher the density number, the more filtering you get.

◆ Finally, I opened the Hue/Saturation tool (also in the Layers palette) and, using the Master setting, I desaturated the image until the setting was about -67.

That's it! There are probably a few dozen other ways to create a good sepia tone from a color image, but this one is really quick and easy. If you know how to use the Photo Filter and Hue/Saturation tools, you can make these adjustments in about 20 seconds.

TECH SPECS: LENS: 80-200mm f/2.8
FOCAL LENGTH: 183mm
EXPOSURE SETTING: 1/125 @ f/9
EXPOSURE MODE: Aperture Priority
WHITE BALANCE: Cloudy / FILE FORMAT: JPEG
ISO: 200

The RAW Deal: Why I Now Always Shoot RAW

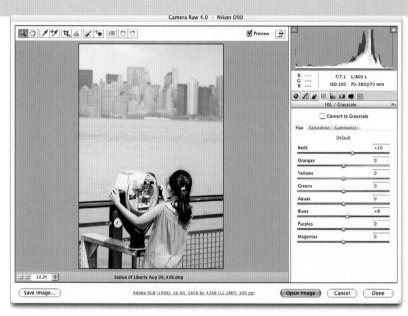

If there was such a thing as a photographers' bar (and maybe there is and no one's told me about it yet), I'm sure that one of the most heated topics of happy hour debate would be the perpetual row over RAW vs. JPEG camera formats. Other than the classic Canon vs. Nikon holy war, nothing incenses the opposing factions in photo circles like the discussion over which recording format is better. And if you think that I'm going to stick my foot in the middle of that dogfight, well...maybe just a bit.

The truth is, of course, that neither format is inherently superior to the other; it's all a matter of how you work and how involved you are with image editing (and if someone insists that one is intrinsically best, beware that bulging vein in their neck—it's about to start throbbing). It actually took me years to arrive at the decision that RAW was a better format for me and, in professional circles at least, I was very late to the game. Now, however, I shoot RAW almost exclusively—and I'll tell you why.

First, let me briefly explain the differences. Whenever you take a photograph in the JPEG format, regardless of how you have the camera set up or what mode you're working in, the camera processes your image before you see it. The camera's software automatically enhances things like color saturation and sharpness, for example, to make your images look as good as possible right out of the camera. And for a lot of photographers (and photographic situations), that's a good thing. If all that you do is drop your card off at the local CVS to be printed, for instance, this will vastly improve the quality and "prettiness" factor of your images. So what's wrong with that? Nothing.

The price you pay for that quality and convenience, however, is that you surrender a certain amount of technical and creative control to the camera. You can choose to set the white balance to Cloudy, for instance, to warm up shots on a cloudy day—but you are stuck with that white balance once

you take the picture. You are also stuck, to a degree, with the exposure that was set when you shot the photo. Another problem is that, in order to keep files as small and manageable as possible and to keep your camera cranking out images as quickly as it can, the camera also compresses JPEG images. That's what JPEG is in fact, a compression scenario that shrinks images by tossing out similar pixels before you've even seen them. Once tossed, those pixels are gone forever—it's as if the resolution of your camera has been degraded and,

balance in any way you like. If, for example, you weren't sure if you wanted the image to be warm or cool, or if the dominant light source was tungsten or daylight, no problem—you can make that decision after the fact. You can also adjust the hue/saturation/luminosity of each individual color before you even begin to edit the image—quite amazing. And you can pre-adjust curves in the conversion process (though to be honest, I do all of my precise curves adjustments in Photoshop).

It was largely the ability to change the first two things—exposure and white balance—that ultimately won me over. That and the fact that my good friend and one of the world's premiere food photographers, Jon Van Gorder, convinced me that by not tossing away duplicate pixels and by editing in 16-bits instead of 8-bits (another RAW feature), the quality of my images would vastly improve. I tried it for a few weeks and he was right. Once I switched to RAW, my images were radically better. My editing also became more careful, more calculated, and I understood more about what I was doing and why.

Are there downsides to shooting RAW? Yes, but for me they are slight. For one, RAW files take up huge amounts of both card space and hard drive space. But memory prices have plummeted so much that cost is no longer a major concern. You can buy a one-terabyte hard drive now for a few hundred dollars—unimaginable when I started shooting digitally. Also, because the files are so large, they slow your shooting down; it simply takes the camera longer to transfer the images from the buffer to your memory card. And finally, there is that extra step in processing that you must go through.

So is RAW better? Ask me in the photographers' bar some night. In the meantime, look at the type of work you do, the level of quality you demand from your images, how much time you want to spend editing, and how many memory cards you're willing to own. Don't let anyone tell you you're wrong to shoot JPEG if the balance tips in that direction for you. But if shooting in-the-RAW sounds appealing to you, try it. I think once you do, you'll be evangelizing in no time.

of course, it has. JPEG is known as a lossy format—it loses information during compression.

RAW images, on the other hand, are recorded with virtually no behind-the-scenes enhancement or degradation. The image that comes out of the camera is almost exactly as you shot it. The most common analogy for this is that a RAW image is like a camera negative—all of the information is there for you to alter as you like in editing, just as you would interpret a negative in the traditional darkroom. Even more importantly, nothing is lost in translation. Every pixel that was exposed is maintained and nothing is compressed; thus, RAW is referred to as a lossless format.

Where RAW really gets interesting, however, is during the pre-editing process. Whenever you download and then open a RAW file, you must first go through a conversion step that enables you to change some fundamental things like exposure, white balance, tint, contrast, and saturation. To do this, you need to use a RAW converter program like Adobe Camera RAW (also, most manufacturer's supply RAW conversion software with their RAW-capable cameras). These programs give you a lot of leeway. In terms of changing exposure, for example, you can be off by several stops in-camera and correct the exposure during editing. You're not just making a curves or levels adjustment, as you can do with a JPEG file; you're actually changing the exposure. You can also change the white

Tracing the history of color theory is one of those roads that once you start meandering down, you find yourself feeling a bit like Alice who, after eating a strange piece of cake and growing so enormously tall that she could no longer see her own feet, uttered the famous words, "Curiouser and curiouser." Indeed.

Depending on which books you read and how far in history you're willing to go back, the story of color theory includes, among other notable characters, Leone Battista Alberti, Leonardo da Vinci, and even Johann Wolfgang von Goethe who, in 1810, published a 1,400-page treatise on color (an abridged version of which is still in print, by the way). If you want to go back even further, of course, you would have to drag in the ancient Egyptians whose color theories were so strictly tied to religion that artists were told which colors they could use for certain subjects—and any variations from those options were severely frowned upon. And we all know just how severely the ancient Egyptians could frown upon things they didn't like.

For photographers, however, perhaps the most significant study of color began with Sir Isaac Newton who, in the late 1660s, used a prism to divide light into the color spectrum we are all so familiar with. Newton, not being one to let a good thing lie half done, then joined the ends of that linear spectrum into a circle, thus creating the prototype for the color wheel that artists and photographers use today. The color wheel is essentially a visual representation of the colors in the spectrum and it has many interesting uses. The primary use for photographers is to help us study the visual and psychological impact of various color combinations. It's a fascinating topic and one you could spend a lifetime studying, but being aware of just a few of the potential combinations of colors will enable you to choose palettes to enhance and manipulate the mood of your photos.

Here (very basically) are the main color schemes:

◆ **Monochromatic Color** is the use of a single color (or very closely related colors) in various intensities and levels of saturation. If you were photographing ferns on the forest floor, for example, you might tighten the composition to limit your palette to a variety of shades of green. Monochrome color schemes are often interpreted as very soothing or calm, though they are probably the least attention getting.

◆ **Analogous or Harmonious Colors** are colors that are adjacent to one another on the color wheel. In the photo of petunias here, for example, the pinks and violets are very close to each other on the color wheel and, in fact, gradually merge into one another on blended color wheels. As with monochromatic colors, adjacent colors tend to create a feeling of harmony and peacefulness. Because these color pairs are often found occurring naturally in nature, landscape designers and florists are big on analogous color combinations.

◆ **Complementary Color** is made up of two colors that are opposite each other on the color wheel and that typically compete with one another. You might photograph a warm-toned subject like a yellow ball of yarn contrasting with a cool-toned blue yarn ball, for instance. Complementary colors draw attention because of their inherent visual contrast.

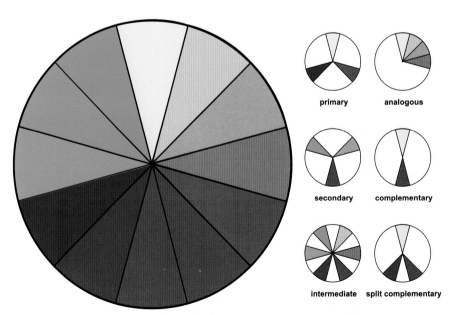

primary analogous

secondary complementary

intermediate split complementary

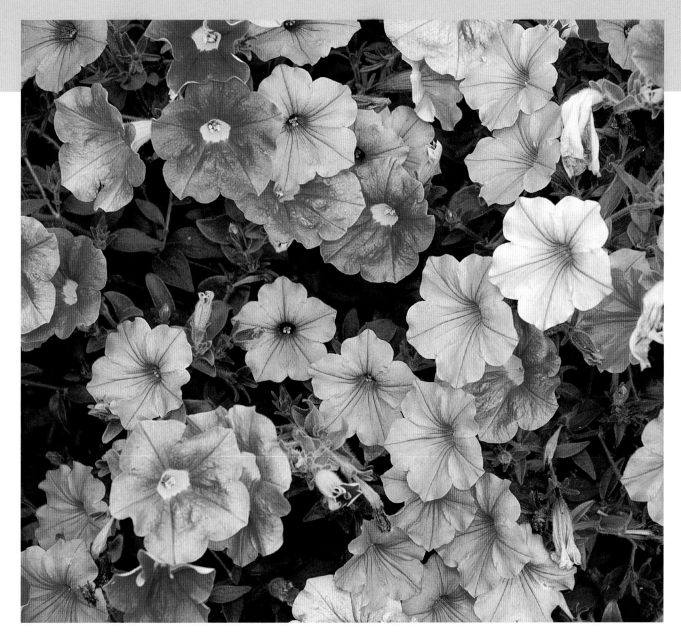

◆ **Split Complementary Color** uses a particular color and the two colors adjacent to its complement. If green was your main color, then red would be its complement. The two colors on either side of red would be the adjacent colors. A split-complementary color scheme provides good contrast without being as brash as a straight two-color contrast.

◆ **Triadic Colors** consist of three colors that are found equally spaced around the color wheel—red, yellow, and blue, for instance. The combination of these three colors tends to create an interesting feeling of both contrast and harmony, tending to make compositions look more balanced. Still life and product photographers often use a triadic color scheme for that reason—it's both vibrant and attractive.

There are actually a few more color combinations that you can read about online or in a good color theory book, but like I said, the farther in you go, the more your head may begin to spin. But not to worry; like Alice, eventually your thoughts will shrink back to normal size and the world will start to make sense once again.

TECH SPECS: LENS: 18-70mm
FOCAL LENGTH: 84mm
EXPOSURE MODE: Program
EXPOSURE: 1/60 @ f/6.3, with built-in flash
WHITE BALANCE: Auto / FORMAT: RAW / ISO: 200

Zoom the Lens

I'm guessing that about five minutes after the first zoom lenses were introduced, some clever photographer discovered the "zooming" technique. They showed a friend, who then showed another friend, and pretty soon the whole world was zooming (if you were around photography much in the 1970s, you probably remember the zooming fad quite well). And while it was probably overdone to some degree back then, it's still a fun and creative technique.

Using the technique with an accessory lens on a D-SLR is very simple: you just rack the zoom lens from one focal length extreme to another during a long exposure—typically within the range of about 1/4 second to a full second. The technique works best with D-SLR cameras because there is a physical lens barrel to twist during the exposure, but I have done it with point-and-shoot cameras by pressing the zoom switch during a long exposure. I think you could mimic the technique with some (or even all) point-and-shoot cameras that have Shutter Priority—it's certainly worth a try.

To get somewhat predictable and controllable images (though everything is an experiment when you're playing with techniques like this), it's best to use a tripod to steady the camera. Then select your framing and, with the zoom lens either at its shortest or longest focal length, use Manual mode (or Shutter Priority mode) to select a long shutter speed. Then push the shutter release button and rack the zoom to the opposite end of its focal length range. Experiment with faster/slower zooms and using a limited range to see the different effects you get.

I used the zooming technique for this shot of a church in Loches, France, because when I got to the church it was nearly dark and the lighting was horrible. I had this feeling that if I zoomed the shot during a full-second exposure I might recreate something of the medieval aura of the town. Look at the shot carefully and you'll see two sharp images of the church, one at either end of the zoom, because I paused very briefly at both extremes. I like the shot and I'm glad I shot a few dozen frames with this technique. I'm sure if I had just shot a "straight" shot in that dim light, it would have been a dull and forgettable image.

TECH SPECS: LENS: 18-70mm
FOCAL LENGTH: 105mm
EXPOSURE SETTING: 0.3 @ f/22
EXPOSURE MODE: Aperture Priority
WHITE BALANCE: Cloudy / FILE FORMAT: JPEG
ISO: 200

Need a Challenge? Illustrate an Emotional Concept

Sometimes the best way to push your creative envelope is to give yourself a challenge. One way that many art teachers encourage this is to have students illustrate a single word or concept, or a particular emotion. The word quiet, for example, might be illustrated nicely by a person studying in the library, but it could also be illustrated by a harbor scene at sunrise. And while you can't see the wind, you can certainly illustrate the concept of wind—leaves blowing down the street, salt spray blowing off the tops of waves, etc.

Emotions are a great source of photo ideas. Think of the range of emotions that most of us go through in a typical day: happy, sad, pensive, blue, exuberant, excited, victorious, defeated, loved, lonely, and more. If you have young kids around the house, you're likely to see this spectrum of emotions on an almost hourly basis, and taking pictures of those emotions and moods is a great way to add depth to your family album.

Even if you don't know your subject, you can often try to imagine the emotions they're feeling and then accent them using the tools of composition, exposure, and color theory. To me the photo here perfectly illustrates the concept of the word *alone* or *lonely*, though that is just my interpretation of the scene— there's every possibility that the person in the photo isn't feeling lonely at all. For the shot, I used a normal lens and very open framing so that the person standing on the jetty was engulfed in a huge area of sky and sea. I also shot on a somewhat overcast day late in the afternoon, and I think the color palette of the scene emphasized the solitary nature of the moment.

Challenges push you forward as an artist both visually and emotionally, and finding ways to illustrate ideas and concepts is a great way to hone in on your personal vision. And if you have ambitions to sell your photos or become a professional, you'll find that most photographs are assigned, or purchased through stock sources, based on your being able to illustrate concepts rather than come back with photos of specific subjects. The photo here, for instance, could be used to illustrate a financial ad ("When it comes to investing decisions, you're on your own"), or a Hallmark card ("When you're away, the world seems empty"). Merging visual and emotional concepts is precisely what the advertising world is all about.

TECH SPECS: LENS: 18-70mm / FOCAL LENGTH: 52mm
EXPOSURE SETTING: 1/100 @ f/7.1
EXPOSURE MODE: Aperture Priority
WHITE BALANCE: Auto / FILE FORMAT: RAW / ISO: 200

Be a Part of Art: In Memory of Jeanne-Claude

One of the most important ways to develop as an artist, whether art is your hobby, your passion, or your profession, is to look at what other artists have done. It's impossible, I think, to be successful in any artistic medium unless you know where other artists have taken it in the past. All art has a history and a progression and it's important to immerse yourself in that history whenever you get the chance. Most works of art are created to have a more or less permanent existence and there's hardly a town or a city where you won't find at least one museum where you can study great art. But there are also artists who believe that art is best experienced as just that—an experience—and they create artworks that are more temporary in nature. We can learn from (and photograph) these fleeting moments in art.

In the winter of 2005, a project called The Gates, created by the artists Christo and Jeanne-Claude, was put on display in Central Park in New York City. It was one of the most ambitious and important art installations in history and millions of people experienced the fun and excitement of walking through endless miles of brilliant orange metal and fabric gates. I was fortunate enough to see The Gates on one of the last days of the installation and it was one of the most

TECH SPECS: LENS: 17-35mm f/2.8
FOCAL LENGTH: 27mm
EXPOSURE SETTING: 1/320 @ f/9 (+ 0.66EV)
EXPOSURE MODE: Aperture Priority
WHITE BALANCE: Cloudy / **FILE FORMAT:** JPEG
ISO: 200mm

inspiring and enthralling art experiences of my life. It was also one of the most fun days I've ever had in New York City. Walking under the flapping bright-orange fabric flags, along with thousands of other art lovers, was a far more emotional and spiritually exuberant experience than I had expected. Some kind of magic descended on Central Park that I think was shared by almost everyone who went to see The Gates, and that magic changed the way we all thought about the park, art, and one another. Sadly, Jeanne-Claude passed away in New York on November 18, 2009. In her life, she and Christo changed the way the world looks at art with their compelling installations. And by keeping up with inspiring artists who are breaking new ground, you'll be in a better position to make creative leaps in your own work.

Whether you go to a museum to look at a paintings that are centuries old or take part in a live art happening, seeing art in person is a great way to awaken your imagination and to witness the power of creativity. Go be a part of art and I guarantee the inspiration will show in your own photos.

TECH SPECS: LENS: 18-70mm
FOCAL LENGTH: 56mm
EXPOSURE SETTING: 1/60 @ f/6.3
(+ 0.66EV)
EXPOSURE MODE: Aperture Priority
WHITE BALANCE: Cloudy
FILE FORMAT: JPEG
ISO: 200

Keep a Places Journal

For a travel photographer, one of the most frustrating things in the world is to find a great photo location and then lose it. I know, because I've done it—a lot. The problem is that I like to wander, especially when I'm exploring someplace new, and since I'm concentrating more on things like finding interesting shots, waiting for great lighting, and wondering where I'm going to stop and get a burger, I often forget to make notes about exactly where I was when I shot the pictures. A few weeks later I'm back home editing photos and scratching my head while looking at maps, trying to piece the trip back together again.

A far better option is, of course, to just keep a notebook handy in your shooting vest or on the dash of your car for keeping notes and directions for finding locations. I don't go back to the same places all that often, but there are certain pretty places, like this red barn in Iowa, that I would love to shoot again (perhaps in a different season) if I was back in that part of the state. I know roughly where I shot it and I can picture the road in my mind, but I'm not at all sure I could find

it on a map. Had I just written down the route number and the nearest cross street, finding it would be a breeze.

I'm sure that in the next few generations of digital cameras there will be geotagging/GPS data included in the EXIF data, and keeping a road journal will be a thing of the past, but for now, it's worth writing down where you were when you shot some of your favorite pictures. Besides, while GPS might be a cool techie thing to play with, it's not like you can stuff theme park brochures or diner menus into it the way you can with a notebook or journal. And if you're revisiting an area for more photographs, you'll definitely want to remember where the best burgers in town were...though to be honest, I rarely have trouble remembering that.

TECH SPECS: LENS: 70-300mm f/5.6
FOCAL LENGTH: 185mm
EXPOSURE SETTING: 1/50 @ f/8
EXPOSURE MODE: Aperture Priority
WHITE BALANCE: Cloudy / FILE FORMAT: JPEG / ISO: 200

Shoot What Interests You

When it comes to deciding if a subject is worth photographing or not, I think a lot of people—including most professionals—run the idea through a mental filter: is this subject interesting or good enough to spend time photographing? Don't filter yourself. The one criterion you should use in deciding whether or not to photograph something is if it interests you. If something calls to you and makes you want to photograph it, don't listen to the critics in your head, just listen to your imagination. These are, after all, your pictures and you get to decide what makes a good photograph. If you critique your ideas too much before you shoot them, you'll only stifle your imagination and give yourself another reason not to haul out the cameras and tripod to make the effort.

I grew up in a suburban part of Connecticut and because I didn't spend much time in the country as a kid, I have always fascinated by it. I'm sure if I had grown up on a farm I might not find cows and tractors and old barns quite so fascinating—or maybe I still would; who knows? But farms and farm machinery have always loomed large in my imagination, and when I visited Iowa for the first time a few years ago, I was totally intrigued. I spent several days just wandering down dirt roads, photographing things like corncribs, forgotten barns, ratty old farm fences, and just about every silo that I saw.

I shot the photo for this tip in the picture-perfect town of Prairie City, Iowa. In fact, this tractor is sitting in front of a few huge grain silos just a short walk from the town center. By the time I got to the silos, the light was beginning to fade (you can see the last splash of daylight on one of the big silos) and a deep shadow had fallen across the tractor. I shot several photos anyway, knowing that I could probably save the shot in Photoshop—which is exactly what I did. In fact, it took 30 or 40 steps to get a good finished file, but because I loved

the subject so much, spending time with the image was fun. I just put on some folk music by Iowa musician Greg Brown and tweaked to my heart's content.

The most important audience you'll ever have for your photography is you. If your photos don't excite you, if the subjects don't stir your imagination, you'll have a hard time inspiring someone else with them. I think the love you have for your subjects and your fascination with them ultimately becomes part of their power. I can't imagine anyone putting "industrial tractor" at the top of their list of favorite photo subjects, but I think there is a quietness and an intimacy to this shot that others can appreciate. And any time I can document a piece of fading America, I feel that's a worthwhile ambition to serve.

TECH SPECS: LENS: 24-120mm
FOCAL LENGTH: 66mm
EXPOSURE SETTING: 1/6 @ f/16
EXPOSURE MODE: Aperture Priority
WHITE BALANCE: Cloudy / FILE FORMAT: JPEG / ISO: 200

Compose with Odd Numbers (Don't Ask Me Why)

You probably wouldn't think it would matter how many of something you have in a particular photo, but whenever you're composing a group of subjects, whether it's pears, people, polar bears, or pretty much anything else, compositions seem to work best with odd-numbered quantities. None of the composition books I have read seem to offer a really solid reason why that's so (file it under "minor mysteries of the human brain"), but I think it's a good rule to follow. Whenever I'm arranging objects in a found still life or composing a landscape, I almost always seem to gather things in groups of three or five (three trees, five horses, etc.). There were about 50 sailboats in the harbor when I took this shot, clustered in little groups, some odd, some even, but the groups that looked best in the viewfinder always had odd numbers in them. Strange, isn't it? I think part of the problem with even-numbered groups is that the eye can easily divide the subjects into pairs and it starts to divide up the frame on some subconscious level. But whenever there are threes or fives, for example, they seem to adhere to one another in a way that unifies them. Try it sometime. Photograph groups of apples on your kitchen table and see if you like the odd groups better than the even ones. And if you figure out why the odds look better, let me know.

TECH SPECS: LENS: 70-300mm f/5.6
FOCAL LENGTH: 190mm
EXPOSURE SETTING: 1/200 @ f/9
EXPOSURE MODE: Program
WHITE BALANCE: Cloudy / FILE FORMAT: RAW / ISO: 200

Maximize Depth of Field for Ultimate Sharpness

There are really two kinds of sharpness in a photograph. One is the sharpness of your main subject; say, a person standing on the beach, and that sharpness depends on how steady you were at holding the camera, the shutter speed you used, how carefully you focused on your subject, and how still your subject was standing. If you are careful with your technique, your subject should be quite sharply focused.

The other type of sharpness is depth of field or "near-to-far" sharpness, and that describes how much of the beach in front of and behind your subject is also in sharp focus. Depth of field sharpness is not an absolute thing that has exact starting and stopping points; rather, it's a zone of what is called "acceptable" sharpness. Photographers can maximize this zone of acceptable sharpness if they know what factors affect it. Basically, three things used in conjunction with one another determine how much depth of field sharpness an image will have: lens focal length, your distance from the subject, and the aperture you're using. Here are some things to keep in mind when you're trying to maximize depth of field:

◆ Wider lenses have inherently more depth of field. That means that for a given f/stop at a fixed lens-to-subject distance, the shorter the focal length of the lens, the more your image will be in sharp focus from near to far. Wide-angle lenses provide the most depth of field and telephoto lenses the least.

◆ With any given lens, the smaller the aperture—f/16 as opposed to f/4, for example—the more depth of field you'll get. So use Aperture Priority and choose a small f/stop to increase depth of field.

◆ With any given lens at any given f/stop, the farther you are from your subject, the more depth of field you will have. If you were shooting a picture of a friend with a 28mm wide-angle lens at f/8, for example, your photo would have inherently more depth of field if you stood 10 feet (3 m) away than if you stood 5 feet (.9 m) away.

Remember, it's these three factors in combination that really determine depth of field. If you're photographing a landscape and want lots of near-to-far sharpness, choose a wide lens and a small aperture and you will increase depth of field. I shot this photo of Las Olas Boulevard in Fort Lauderdale, Florida, using a combination of a wide-angle lens and a very small (f/20) aperture. Because you're usually using small aperture to get a lot of depth of field, you'll also be using relatively slow shutter speeds. In order to be able to shoot this photo at such a small aperture, I had to reduce the shutter speed to 1/30 second. You can see the motion blur caused by the slow shutter speed in the pickup truck. Using a tripod helps to steady the camera, but you'll still get blur with any moving subjects.

TECH SPECS: LENS: 18-70mm / FOCAL LENGTH: 27mm
EXPOSURE SETTING: 1/30 @ f/20
EXPOSURE MODE: Aperture Priority
WHITE BALANCE: Cloudy / FILE FORMAT: JPEG / ISO: 200

Minimize Depth of Field for Selective Focus

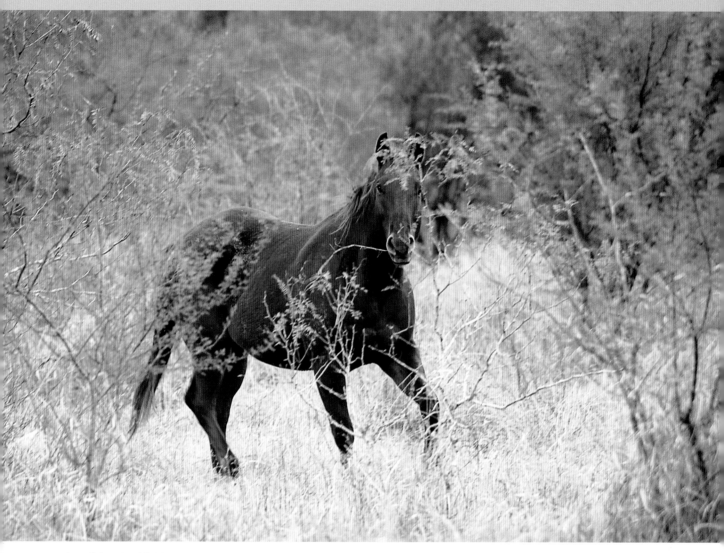

A lot of depth of field is a great thing if you want everything in your pictures to be in sharp focus. But there are times when you might want to limit or restrict depth of field so that only your main subject is sharply focused and the background and/or foreground is less sharp. The main reason for doing this is to accent your primary subject—in a head-and-shoulders portrait, for example—where you want your subject's face in sharp focus but want to toss the background into a soft blur.

You can reduce the amount of depth of field by simply reversing the things we talked about in the previous tip. Again, here are the primary factors:

◆ **Lens focal length:** The longer the focal length of the lens, the less depth of field you will have at any given aperture (f/stop) and at any given distance. As you zoom a lens from wide to telephoto, for example, you quickly lose depth of field (provided you are keeping the aperture the same). I used a 70-300mm lens at the 300mm position (450mm in 35mm terms) to shoot this horse on the King Ranch in

TECH SPECS: LENS: 70-300mm
FOCAL LENGTH: 450mm
EXPOSURE SETTING: 1/125 @ f/5.6
EXPOSURE MODE: Aperture Priority
WHITE BALANCE: Cloudy / FILE FORMAT: JPEG / ISO: 200

Kingsville, Texas, partly because I needed the long lens to bring the wild horse close, but also so that I could throw the foreground scrub and background out of focus.

◆ **Lens aperture:** The wider the aperture (again, assuming focal length and subject distance are constant), the less depth of field you'll see in the image. You will get significantly less depth of field at f/4 than at f/16, for example. Just remember: larger lens openings equal less depth of field. Of course, this does not affect how sharp your subject will be if you focus carefully; the larger aperture only reduces the near-to-far sharpness.

◆ **Subject distance:** The closer you are to your main subject, the less objects will be in sharp focus in front of and behind the subject. Want less depth of field? Move closer to your subject.

So, if you were shooting a portrait of a friend near a harbor and just wanted the person sharply focused with the boats in the background recorded as a soft impressionistic blur, you should choose a wide aperture and a long lens. You'll be able to see the results of your depth of field experiments on the LCD when reviewing the shot, but you won't see them if you're composing with live view on the LCD because the lens is not stopped down to its shooting aperture until you actually take the photo. (If you're using a D-SLR with a depth-of-field preview button, you can use that feature to check it, but the viewfinder gets so dark that it's often hard to tell the difference.)

If you're shooting with a point-and-shoot camera, keep in mind that you'll have less control when it comes to restricting depth of field because they tend to have inherently smaller apertures which creates more depth of field.

Finally, if you're shooting in bright light and the camera won't allow you to use a wide aperture, even at a high shutter speed, you can use a neutral-density filter in front of the lens to reduce the light. These filters won't affect color but do reduce the amount of light entering the lens.

TECH SPECS: LENS: 70-300mm
FOCAL LENGTH: 375mm
EXPOSURE SETTING: 1/200 @ f/5.6
EXPOSURE MODE: Manual / WHITE BALANCE: Cloudy
ISO: 200

Extend Your Telephoto Range with a Teleconverter

If there's one thing (optically speaking) that photographers always want more of, it's a longer telephoto range. Even with the long telephoto lenses available (300mm is common with zoom lenses) and the fact that these lenses are even more powerful on a camera with a cropping factor, there's always a desire to have longer and longer lenses. And for certain types of photography like wildlife and sports, big telephoto lenses are a huge help, no question. It's nice to be able to fill the frame with a songbird across the yard, or a third baseman across the field.

The problem is that once you get past the 300mm range in a zoom or straight telephoto lens, you're getting into some very expensive pieces of glass. A good quality 600mm lens can set you back around ten grand—yikes! I'd rather put a down payment on a condo in Florida than spend that kind of money on a lens. But there is a relatively inexpensive alternative: telephoto converters. A converter is a tube with glass elements that fits between your existing lens and magnifies the telephoto range. These converters typically come in either a 1.4x or 2x power; so, with a 300mm lens and a 1.4x converter, you have, in effect, a 420mm lens. Now we're rocking! But now add in the 1.5x cropping factor that is common on many D-SLR camera bodies and you're looking at (or through) a 630mm lens! Fantastic.

The great thing about converters, as I said, is that they only cost a fraction of the price of an equivalent lens. I shot the second of the two photos here with a Kenko Teleplus Pro

TECH SPECS: LENS: 70-300mm
FOCAL LENGTH: 232mm
EXPOSURE SETTING: 1/1250 @ f/4.5
EXPOSURE MODE: Shutter Priority
WHITE BALANCE: Auto / FILE FORMAT: RAW / ISO: 200

2x converter on a 70-300mm f/5.6 lens set at 230mm (in 35mm terms)—the equivalent of a 460mm lens. How cool to be able to double the focal length of the lens I was using by slipping a converter onto the camera—and it takes just a few seconds. The Kenko converter sells for around $220.

Are there any drawbacks to converters? Yes. One is that there is some potential degradation of sharpness and the degree really depends on the quality of the converter. To be honest, I didn't notice any measurable loss in sharpness with the Kenko—in fact, I found it to be supremely sharp if you lock the camera down on a good tripod. There is no way to get a sharp photo with a 460mm lens without a tripod. Some photographers complain about a lack of sharpness with converters but neglect to mention they're trying to handhold enormous lenses. Also, any time you use a longer lens you're going to lose depth of field (it's just an optical fact) and I think some photographers see that lack of depth of field as a lack of sharpness—and they're not the same thing.

Keep in mind, however, the longer the lens you're starting with and the more converter power you add, the more likely you are to see some loss of sharpness. Is the loss a deal breaker? No way. You can more than make up for any softness in editing, provided you used a good tripod and a fairly fast shutter speed. If it comes down to not getting the shot or getting the shot and having to sharpen it later, I prefer to get the shot.

There is a loss of about a stop of light with all 1.4x teleconverters (about two stops with a 2x converter) and that's just part of the price you pay to get a longer lens. It's simple to overcome the loss of a stop if you need it by just doubling the ISO—from 200 to 400, for example—and that buys you back the lost stop. You might notice some slowness of focus with any teleconverter, but if you find a good edge to focus on, it's not much of an issue.

TECH SPECS: LENS: 70-300mm (with 2x teleconverter) FOCAL LENGTH: 232mm (plus 2x with converter=464mm) / EXPOSURE SETTING: 1/250 @ f/6.3 EXPOSURE MODE: Shutter Priority WHITE BALANCE: Auto / FILE FORMAT: RAW / ISO: 200

Finally, one of the best things about a teleconverter is that it will fit in your pocket. If you're out hiking and carrying a 70-210mm or 80-300mm lens, you can double that range with something that won't weigh you down. Yes, you might lose a bit of sharpness and you will lose some light, but when you compare the weight, cost, and convenience factors, it's hard to ignore the beauty of a good-quality converter.

Pause to Photograph Sacred Spaces

No matter where you live—small town or big city—chances are that some of the greatest artwork in your community exists in the churches, mosques, and temples that you drive past every day. Unless you attend religious services on a regular basis, odds are that you pass by these places without ever seeing or thinking about what's inside them. We see the buildings and some are beautiful from the outside, but often even a very modest exterior hides some wonderful works of art—paintings, shrines, altars, stained-glass windows, and other very artful objects. Sadly, because of security concerns these buildings aren't as open to the public as they once were, but if you stop by the office and ask for permission to explore, chances are a secretary or someone in the clergy would be happy to let you in to wander around with your camera. If you have confidence in your skills, you might also offer them photos for their website or printed programs in exchange for the chance to shoot.

Famous churches and cathedrals, especially in tourist areas, are a lot more likely to be open to the public during regular hours, so before you go on a trip, do some research to find out exactly where they are and when they're open. Be sure to also see if there are any photo restrictions; most don't allow the use of tripods or flash, but it does vary by place. I photographed the St. Photios Greek shrine in St. Augustine, Florida, and there were many people taking pictures of the beautiful interior. St. Augustine is a very touristy town and the temple is on a tourist block, so I think photography is encouraged. The shrine is filled with some very pretty Byzantine-style frescoes of many apostles and saints and it's just full of colorful art and decoration. I used a bit of fill flash to shoot this photo and no one seemed to mind (still, I would always ask someone at the door for permission if you're going to use flash). I'm sure it would please my mother to know that I stop by churches and temples once in a while—even if it's mostly to take pictures.

TECH SPECS: LENS: Built-in zoom
FOCAL LENGTH: 35mm
EXPOSURE SETTING: 1/8 @ f/1.8
EXPOSURE MODE: Auto / WHITE BALANCE: Auto
FILE FORMAT: TIFF / ISO: 125

Keep an Eye on the Highlight Warning

One of the questions that I hear a lot from folks that are new to digital cameras is: "Why do parts of my images flash at me when I'm reviewing photos on the LCD?" The answer is that they have inadvertently turned on the highlight warning or "clipping" warning. Clipping is a term used in digital photography that essentially means the highlights are burned out and that there is no recognizable detail in those areas. Most digital cameras (at least most D-SLRs) have a feature that you can turn on or off that flashes to warn you that you have overexposed areas; typically, these clipped highlights flash as small dark patches wherever there is a total loss of highlight detail.

But isn't that what the histogram is for? Yes, you can also tell when you have burned out highlights by looking at your histogram for any given shot. On the histogram display you would see that part of the graph is butted up against the right side of the display (the right side is the highlight region), but what it won't tell you is where those areas are in the image. The highlight warning provides that information by flashing at you. This is an extremely useful feature because once highlights are blown out, there is very little chance to bring them back. In the photograph of the white ibis shown here, if you look at the top of the head (just above the eyes) you'll see that there is a patch of brilliant white that is missing all detail. I've tried bringing the detail back to that area with a combination of curves controls and highlight masking, but the detail is pretty much lost forever.

So what do you do if you get a clipping warning? The only thing you can do is to use your exposure compensation feature to reduce exposure. Or, if you're shooting in manual, reduce the exposure by using a smaller aperture or faster shutter speed. Yes, this will cause more of your image to shift to the shadow side of the histogram, making everything else proportionately darker, but it's far easier to open up shadow areas than it is to bring back lost highlights. I can bring shadow detail back in even the darkest parts of an image, but with highlights, once they're gone, they're gone.

The real question when you see the highlights flashing, however, is whether you really need detail in those areas. In this shot, I would say yes, I wanted detail and because I wasn't paying attention to the warnings, I lost a great shot. Had I paused for a moment to review the clipping, I would have seen the warning and cut my exposure (possibly even using an accessory flash to compensate, being careful not to overexpose with the flash).

The key thing about the highlight warning feature is that it puts you in control of making that decision rather than just reading the bad news from the histogram after you've made your shot. If you suspect some highlights might cause problems, just shoot a test frame and turn on the warning. If there are no warnings, or if the clipped areas are not important, keep shooting. If you're getting dazzled by flashing areas, reduce the exposure. While the histogram is a nice feature because it tells you if you have a lot of areas lost to shadow (left side) or highlights (right side), it takes the highlight warning to show you where those lost highlights are precisely.

TECH SPECS: LENS: 70-300mm / FOCAL LENGTH: 450mm EXPOSURE SETTING: 1/250 @ f/5.6 / EXPOSURE MODE: Shutter Priority / WHITE BALANCE: Cloudy FILE FORMAT: JPEG / ISO: 200

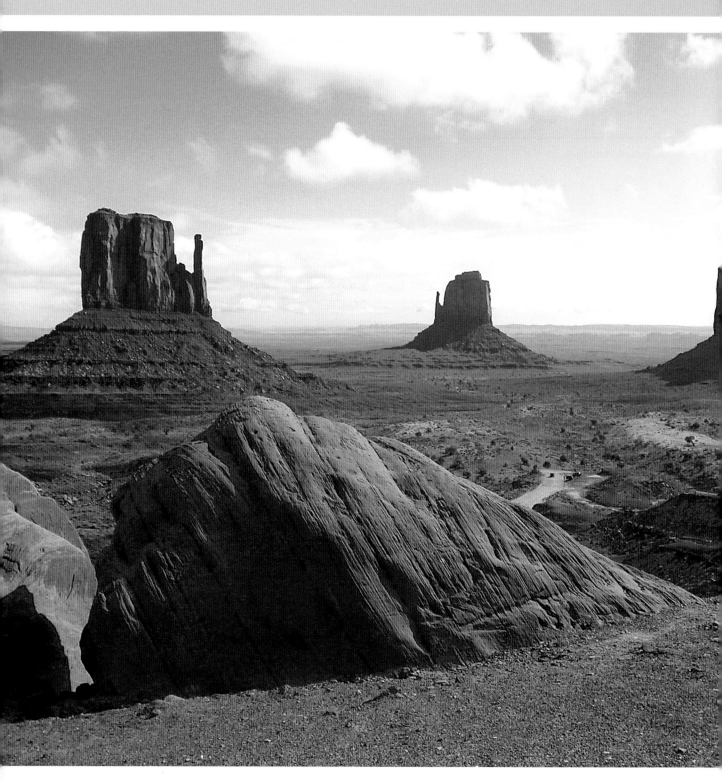

If you're a fan of Western movies and John Wayne and you'd like to see where some of his best films were shot, or if you'd just like to see and photograph the American Southwest, there is one place that should be at the top of your list: Monument Valley in southern Utah. There is no other place in America that symbolizes the beauty and mystery of the American West like this extraordinary place. Monument Valley is actually a Navajo Tribal Park and is administered (and lived in) by the Navajo Tribe.

Monument Valley presents some of the best landscape photo opportunities in the Southwest and features "monuments" or rock buttes that rise up between 400 and 1000 feet (122-305 m) high. The photo here was shot from the rim of the valley near the visitor's center, and while that's surely a beautiful viewpoint, there is a 17-mile driving tour through the valley floor that is simply spectacular. I spent five days on this scenic drive, and each day that I returned the light and weather dramatically repainted the landscape. If you prefer to focus only on images and let others do the driving, the Navajos also offer guided tours for both groups and individuals.

Quite a number of Navajo live in the Valley, and when you visit you're not just in a park, but in their living room, so you also get a sense of the history of the Navajo people. The Navajo are, with good cause, intensely proud of the Valley and every resident that I met went out of their way to tell us about the park, suggest great photo ops, and even invite us to their homes. Their warmth towards visitors is quite amazing.

Monument Valley has long been a favorite location for making films: *My Darling Clementine*, *The Searchers*, *How The West Was Won*, and the *Legend of the Lone Ranger*, are just some of the classics shot here. Among the highlights of the Valley drive, in fact, is a stop at John Ford Point—named by the Navajo in honor of the legendary Hollywood director who made so many films here (including all of those John Wayne westerns). Modern filmmakers have shot here, too, and some of the famous contemporary films include *National Lampoon's Vacation*, *Back to the Future* and, fittingly, it's here that Forrest Gump ends his "monumental" walk. There is a very nice micro-museum at Gouldings Lodge that tells the history of filmmaking in the Valley.

The Navajo recently built a hotel on the rim of the Valley that looks out at the same view that's in the photo here. I really hope this doesn't commercialize the park too much since its remote location has always kept it somewhat obscure as a tourist locale, but I understand the need for the tribe to profit from tourism and to make visiting the park a more convenient experience. Getting to the valley is a challenge, by the way—it's a four-hour drive from Flagstaff, Arizona, and it's 25 miles from the nearest town (Kayenta, Arizona). Still, it's a beautiful drive and worth every effort it takes to see this one-of-a-kind landscape.

TECH SPECS: LENS: Built-in zoom
FOCAL LENGTH: 35mm
EXPOSURE SETTING: 1/560 @ f/5
EXPOSURE MODE: Aperture Priority
WHITE BALANCE: Auto
FILE FORMAT: TIFF
ISO: 100

Step Up to Better Garden Photos

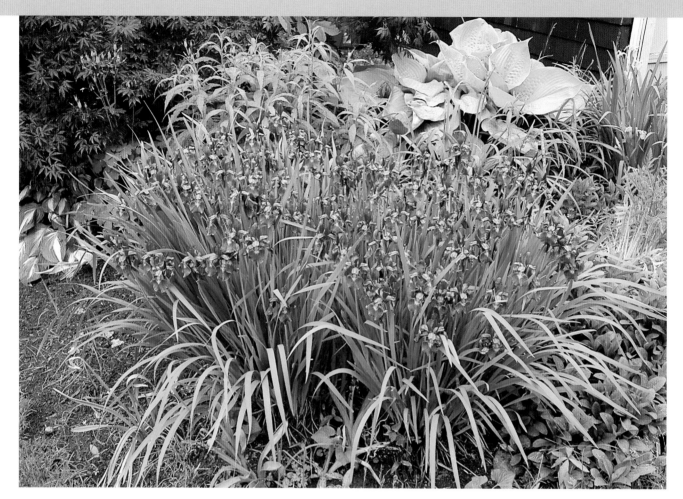

A few years ago, after realizing that I was shooting all of my garden photos from approximately the same height (coincidentally, my eye level), I decided that varying the angle more might add some variety to my shots. I tried some shots with a 6 foot (1.8 m) step ladder, and for some shots, particularly wide shots of entire garden beds, that worked fine, but the angle was too steep for closer shots of smaller areas. It looked like a giant had been shooting the photos (though I have shot some photos of my garden from a second-story bedroom window and they look kind of cool).

Next I tried a kitchen stool; just a small plastic step stool, and it was perfect. Even though it only bought me about another foot (30.5 cm) of shooting height, the difference in the angle was noticeable and it seemed higher, yet not extreme. Better still, because I was only a foot higher, I was able to use my smaller tripod. I have a much taller tripod, but it weighs a lot more and I'm less likely to haul it around the garden. The plastic stool is great and I can even throw it in the car for road trips. It makes an excellent platform to get a foot above the crowds at parades or fireworks, too. Of course, considering the stool only costs about $5, it's worth buying one just to keep in the car. Go ahead and put it on the next shopping list.

Height is a great thing in composing photos because it provides just enough of a tweak to the composition that people notice the difference without it being an obvious gimmick. Try it!

TECH SPECS: LENS: 18-70mm / FOCAL LENGTH: 33mm
EXPOSURE SETTING: 1/20 @ f/9 / EXPOSURE MODE:
Aperture Priority / WHITE BALANCE: Cloudy
FILE FORMAT: JPEG / ISO: 200

Architecture: Break Some Rules to Add Drama

Ask any architectural photographer and they'll tell you never to get too close to a tall building with a wide-angle lens because your photos will show an effect called keystoning, which causes the buildings to lean back in space. But ask them if they ever do exactly that to create drama and the answer will be, "Of course!" In most cases, you want to get architecturally-correct views (especially if you're shooting photos for the architect) which means either backing away a sufficient distance or, if you're well-heeled equipment-wise, using what's called a perspective-control lens (a lens with a shifting front element that corrects keystoning). This helps to keep the lines of the building square and parallel. But when it comes to creating dramatic photos of architecture, very often it comes down to abandoning technical rules and going with what looks most interesting.

I photographed this view of the Iowa State Capitol, for example, using a relatively wide 24-120mm zoom lens at its widest setting (which was equivalent to about 36mm in 35mm format) from right next to the building. Obviously, the building doesn't lean back like this and the columns don't converge, but again, the combination of the wide lens and the close vantage point created a shot that is technically "wrong" but also quite dramatic. I also shot a number of images with a longer lens from a distance so that the building would look architecturally correct, but they were complete yawners! The last thing you want people to do when they look at your photos of buildings is to get bored. Next time you find an interesting building, shoot some "straight" images if you have to get it out of your system, but then break some rules and see if you like those photos even more.

TECH SPECS: LENS: 24-120mm
FOCAL LENGTH: 36mm
EXPOSURE SETTING: 1/400 @ f/10
EXPOSURE MODE: Aperture Priority
WHITE BALANCE: Cloudy / FILE FORMAT: JPEG / ISO: 200

Take Dad's Advice: Spotlight Subjects with Frontlighting

It's amazing how much practical advice dads give us early on in life that we carry with us forever—even when it comes to photography. If you're dad ever let you use his camera, odds are that the first time he handed it over his words of advice were to "keep the sun coming over your shoulder" (or possibly, "Keep that strap around your neck!"). And for getting evenly lit and well-exposed photos (especially with the simple cameras like the Instamatics that I grew up with), it really was good technical and creative advice. Safe and practical—the dad's motto.

As our experience and creativity grows, however, most of us become lighting mavericks and leave the secure reliability of frontlighting behind and instead experiment with light coming from the sides, from above, or even from behind our subjects. Ah, the sweet elixir of rebellion. And for some reason photo writers and teachers tend to reinforce our flight from lighting safety by belittling the value of frontlighting as a creative tool.

The truth is that, in addition to its practical value, there was some good creative power in dad's advice. Frontlighting has a lot of underrated artistic qualities, including the ability to spotlight subjects with a broad, even light and to bring out a bright and cheerful palette of colors. And let's face it, sometimes you're stuck with the light that you're stuck with and unless you want to linger your vacation away waiting for the earth to spin a bit more, you play the cards you are dealt. In the case of this antique sign display in Greenville, Maine, frontlighting was my only option (unless I wanted to wait a few hours for the signs to fall into shade), but the spotlighting effect it created really ignited the colors and added a nice crisp sharpness to the scene. While I normally saturate most digital images at least a tiny bit (especially for the web), this shot appears exactly as it came out of my camera.

So if your dad always told you to keep the sun over your shoulder, he was actually giving you pretty good practical and artistic advice. Unless, of course, backlighting or sidelighting works better for a particular shot. In which case, listen to your mom who always told you that you were very special and a devout individualist.

TECH SPECS: LENS: 80-200mm f/2.8
FOCAL LENGTH: 195mm
EXPOSURE SETTING: 1/1000 @ f/8
EXPOSURE MODE: Aperture Priority
WHITE BALANCE: Cloudy / FILE FORMAT: JPEG / ISO: 200

Release Stress with a Bit of Abstract Sign Fun

I love to take pictures of signs at night because there is something very visually exciting about that pure and highly saturated color against the dark sky. Another fun thing about shooting signs is that they are one of the few subjects that really call out to be composed in a completely abstract way. Unless you're photographing a neon sign that makes more sense as a whole (it spells out a classic neon word like Diner, for example), there is really no reason to even include the entire sign. Instead, look for patterns of light and shapes and colors that have their own visual rhythm. I photographed the sign here at a carnival, and I don't even recall what the sign said—and I don't think I shot a single frame of the complete sign. But I did get fascinated by the interplay of shapes and colors and the flow of the swirling script.

Normally with night shots (as with any shot) I go to great lengths to get a plain background and to have the pieces of a composition seem organized, but in this shot the random shapes and colors of the carnival flags and rides in the background just push the scene even further into the abstract. All the various bits of the shot create a kind of organized clutter that really appeals to me—especially since I'm usually so controlling about the background and simplicity of most of my shots. To be honest, I think I often shoot photos like this to release the tension of keeping such a tight grip on "reality" in most of my photos; letting go and just playing with light and color is very relaxing. Interestingly, when I'm editing an evening shoot, if there are some abstract night signs in the take, I tend to go to those images first, probably because they have a fun and carefree feel to them. It's hard to look at a sign like this and not get a mood lift. In the case of carnival signs, at least, I think that is exactly the atmosphere the sign maker was trying to create.

Next time you see an interesting sign at night, try to intentionally avoid shooting the whole sign and instead see if you can find some interesting patterns of shape, line, and color. Try holding the camera at weird angles or just zoom in until you barely recognize the subject—you may find that letting go of reality for a few minutes is a welcome (and relaxing) change.

TECH SPECS: LENS: 18-70mm / FOCAL LENGTH: 57mm
EXPOSURE SETTING: 1/80 @ f/4.5
EXPOSURE MODE: Program / WHITE BALANCE: Auto
FILE FORMAT: RAW / ISO: 640

Meter from a Middle Tone

You've probably read this somewhere already (no doubt when you were up late at night studying your camera manual by flashlight under the covers), but all light meters are designed to give accurate readings only when metering a subject of average tone. This tone is often referred to as "middle gray" because an average tone sits in the middle

where they belong. They may still fall outside of your camera's dynamic range (see tip 136) if the scene is too contrasty, but at least the tones within that range will be accurately placed.

How do you know if any of the tones in your image are falling outside of the camera's dynamic contrast range? Look at your histogram. If you see a thick black area pressed up

against the left edge of the graph, some of your shadows are probably falling into pure black without any detail. Conversely, if you see an area of the graph huddled up against the right edge, you've probably blown out some highlights.

Life will be much simpler if your camera has a center-weighted metering mode because that lets you precisely meter from small and specific areas. In the center-weighted mode, your meter is concentrating almost all of its metering attention on a small area in the center of the frame (see tip 95). And once you've metered the best area, simply use your meter-lock feature (holding the shutter release button down half-

of the tonal gray scale, halfway between pure white and pure black. If you are not metering from a middle tone, your light readings can never be fully accurate—unless you make exposure adjustments (by using exposure compensation, for example) that are based on personal experience.

Fortunately for photographers, subjects of middle tone are quite prevalent: green foliage, green grass, blue sky, most gray objects—these are all close enough to middle gray to provide very accurate metering results. This is particularly useful when a scene contains a relatively small area of important subject matter (a person's face, for example) surrounded by a lot of very bright subject matter (like the snow behind her) or very dark areas (a large shadow, perhaps), because these dark or light areas would otherwise fool the meter. By metering from the average tonal area, the light or dark areas will fall exactly

way) to lock that reading, and your exposures will be perfect.

Exposure and metering are complex subjects, but you only have to learn the very basic concepts to get great exposures most of the time. And one of the most significant aspects of that concept is that if you meter from a middle tone, and if your subject and lighting fall within your camera's dynamic range, you will get perfect exposures. And isn't that what we all want out of life?

TECH SPECS: LENS: 24-120mm / FOCAL LENGTH: 97mm
EXPOSURE SETTING: 1/200 @ f/8
EXPOSURE MODE: Aperture Priority
WHITE BALANCE: Auto / FILE FORMAT: JPEG / ISO: 200

Consider the Suggestion (Not Rule) of Thirds

It must relate back to some intensely rebellious incident in my childhood (one of a trillion, no doubt), but I've never been very good at following rules. That's probably why I balk abruptly when I hear anything—even if it's a beneficial idea—labeled as a rule. Still, when it comes to photographic composition, there are some guidelines that can be very useful in speeding up and improving the image-design process; one of those is commonly known as the rule of thirds.

You've probably heard or read about the rule of thirds many times and, even if you haven't, you've almost certainly invoked it without even knowing it. For many visual artists it's such a natural concept that it's employed without any forethought. Essentially, what the rule suggests (not dictates) is that you divide the frame, both horizontally and vertically, using a set of invisible dividing lines. Using this design principle will help you establish a more harmonious sense of balance in your images.

If, for example, you divide the frame vertically by placing a strong horizontal line at either the lower or upper one-third division, you create a pleasing sense of proportions between the upper and lower halves of the scene. In the sunset here, for instance, by placing the horizon line approximately one third of the way down from the top of the frame, I've created a 2:1 ratio between the lower and upper halves of the scene and the brain perceives this as having stability and balance. The idea of thirds is further reinforced in this shot by placing the small clump of dark land in the foreground at approximately the lower one-third line.

You can also use the intersection of lines as a helpful guide in placing important subject elements. In this shot, I've put the heavy clump of land at the intersection of two lines and that sets up a nice feeling of balance with the open area of water to its right.

Would the image fail if I moved either the horizon or that clump of ground to a slightly different position in the frame? No, of course not. Dividing the frame is as much about personal taste and instinct as it is about rigid divisions of the frame. But artists have been using this simple technique for centuries and I think you'll find that when you're searching for just the right balance of objects, spaces, and lines, the suggestion (not the rule!) of thirds can be very useful.

TECH SPECS: LENS: 18-70mm / FOCAL LENGTH: 105mm
EXPOSURE SETTING: 1/20 @ f/18
EXPOSURE MODE: Aperture Priority
WHITE BALANCE: Cloudy / FILE FORMAT: JPEG
ISO: 200

Be Aware of Your Camera's Dynamic Range

There is a great deal written about the dynamic range of digital cameras and how this range differs from that of film cameras. I find it interesting and informative to read the varying (sometimes wildly varying) opinions about it, but I usually end up more confused by the end of an hour of reading than I was at the start—largely because the experts tend to disagree pretty emphatically about just how digital cameras stack up against film cameras in dynamic range.

No one argues about how dynamic range is actually defined. In very simple terms, it's the range between the darkest shadows and the brightest highlights in which the camera can record detail. And it's pretty much accepted that a digital camera's contrast range is narrower than film's (particularly color negative film); in other words, most experts agree that a good quality color negative film, properly exposed, can record a wider range of tones than a digital camera (also when properly exposed). The actual dynamic range of a particular digital camera depends on a lot of factors, including the size and design of the camera's digital sensor. Your camera's manual will provide some insight into those particulars. Generally, the larger the sensor your camera has, the wider its dynamic range; which is why a full-frame digital camera— which has a sensor that's the same size as a frame of 35mm film—usually has a broader dynamic range than a camera with a smaller sensor. (In fact, overall, all aspects of image quality get better with a larger sensor.)

The important thing to remember is that your camera does indeed have a limit to its ability to record contrast, and if you try to exceed that range, something is going to give. Not maybe, definitely. Either the highlights or the shadows (or both) are going to get lost. How your camera reacts to a very contrasty scene (and which end of the scale it dumps) depends almost entirely on how you expose things. If a scene has very bright highlights and very dark shadows, you can usually expose to capture one end of the range knowing that you are willingly sacrificing the other. In other words, if you really want to record detail in bright highlights (and normally you should, though there are exceptions), then you will have to cut the exposure to bring highlight detail into range. Doing this, however, will cause the shadows to lose all detail. On the other hand, if you set exposure for the shadows, you

will gain detail there, but lose most highlight detail. The contrast range never changes for a particular scene at a particular moment, but by altering the exposure, you shift which part of that range in which detail will be recorded.

There are times, of course, when the scene will wildly exceed your camera's contrast range and even your ability to record only a portion of that range. In the scene here, which I shot in the Chincoteague National Wildlife Refuge in Virginia, the presence of specular highlights made it impossible for me to hold the very bright highlights on the water. If I had exposed for them (and theoretically that might be possible), the rest of the scene simply would have gone black or near black. No thanks! Instead, I simply chose to expose the best I could for the grasses and the silhouette of the goose in the foreground and let those super-bright highlights just blow out. Yes, I could have shifted the exposure down a bit, perhaps underexposing by two or more stops from what I shot, but then the light, airy feeling of the brilliant morning sun would be lost. Detail or not, I liked the way the highlights turned to a wash of specular highlights. Also, since I shot this in RAW format, I could easily have corrected the exposure to a fair degree in editing but chose not to do that.

There are two things to keep in mind about dynamic range: one is that camera makers are improving it and stretching it all the time—in a few years, the range is probably going to be extraordinary. Two, in many situations you can use a technique called High Dynamic Range imaging, which I've mentioned in this book before, which vastly extends the dynamic range of digital images.

TECH SPECS: LENS: 70-300mm
FOCAL LENGTH: 165mm
EXPOSURE SETTING: 1/640 @ f/10 (+ 1EV)
EXPOSURE MODE: Aperture Priority
WHITE BALANCE: Auto / FILE FORMAT: RAW / ISO: 200

Include Hands in Interesting Ways

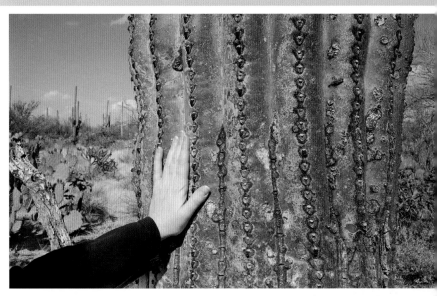

A friend's hands can be very useful things to have "handy" when you're out shooting—they can help you carry gear, point to interesting subjects that you might have overlooked and, if you're lucky, maybe even scratch your back occasionally. But having an extra hand or two nearby can also be a useful creative addition to your compositions. Hands can be used to show comparisons of scale and texture, they can hold unusual objects in your compositions for you (a plastic alligator dangling over Times Square, perhaps) or maybe just to point to a real alligator sunning in a nearby stream (hopefully not too nearby). Hands are interesting because they add a human element to any type of composition and again, in terms of both scale and texture, they can be extremely helpful. Using my friend's hand touching this giant saguaro, for example, provides a great sense of scale to the massive folds of the ancient cactus (which is probably at least 100 years old), and her delicate fingers provide a wonderful textural comparison to the rough, time-worn skin of the plant.

By the way, if you aren't lucky enough to have a cooperative friend with nice hands nearby, you can always use your own—just place your camera on a tripod, frame the scene, and then use the self timer to get your hands into position. Or, if you have long enough arms and a wide-angle lens, you can probably even just reach out into the scene and include your hand. I've photographed small stones and shells sitting in the palm of my hand this way and have even photographed a chipmunk feeding from my hand. But however you get a hand in the shot, just be sure to frame the scene carefully so that people know you meant to include it and didn't just take a nap while you were composing the picture. You've got to hand it to hands—creatively and logistically, they're quite handy.

TECH SPECS: TOP: LENS: 18-70mm / FOCAL LENGTH: 36mm / EXPOSURE SETTING: 1/500 @ f/11
EXPOSURE MODE: Aperture Priority
WHITE BALANCE: Auto / FILE FORMAT: RAW / ISO: 200

BOTTOM: LENS: 70-300mm / FOCAL LENGTH: 122mm
EXPOSURE SETTING: 1/60 @ f/10
EXPOSURE MODE: Cloudy
WHITE BALANCE: Auto / FILE FORMAT: RAW / ISO: 200

Get Positive Impact from Negative Space

I'm a firm believer that every bit of the frame should be working toward the benefit of the whole. If there is something in a frame that isn't working—try to get rid of it, either by cropping with your zoom lens or by changing your vantage point. But there are times when using empty areas, what artists call negative space, can be a useful and provocative part of your compositions.

There are actually three elements in any design: the positive space (the area where your subjects lives), the negative space (any substantial blank area in the frame), and the border. Your job is to create a pleasing interaction of these three elements. The border is easy enough; the camera creates it for you, and the positive area is obvious because this is your subject (trees, mountains, a person—whatever). Including the negative space is a bit trickier because you're trying to decide how much nothing to include—and to include it in such a way that it embellishes the rest of the image.

Negative space can be used in a number of ways to help build a powerful composition. One way that negative space works is to simply create emphasis for the positive space. By photographing a horse on a hill with lots of sky behind it, for example, the eye naturally lands on the horse because it's the most interesting thing in the frame. Very importantly, blank areas in the frame can also be used to create a sense of balance. If you're photographing a tall ship in silhouette at sunset, you can balance the dark mass of the ship with a large bright area of sunset sky.

Yet another way that negative space can be exploited is to create a sense of distance. In the shot of this oyster fishing boat, I've exaggerated the space between where I was standing and the boats by using the negative space of the blank water so strongly at the bottom of the frame. The eye can't help but travel up through the path of blank canvas and arrive at the boats. And by giving the eye such a long area to travel across, the brain has a better handle on the distances involved. You get a much better sense that I'm standing on the shore observing the boats.

Whenever you find an interesting object or subject to photograph, see if you can't find an area of relatively blank space—water, a lawn, a sandy beach, sky, a big shadow—to help create a more interesting composition. Nothing can be a very powerful creative tool.

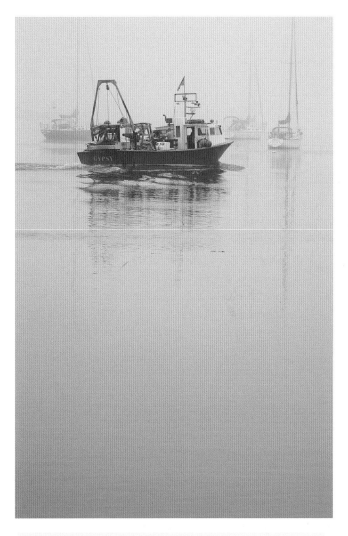

TECH SPECS: LENS: 80-200mm f/2.8
FOCAL LENGTH: 200mm
EXPOSURE SETTING: 1/60 @ f/5.6
EXPOSURE MODE: Manual
WHITE BALANCE: Cloudy / FILE FORMAT: RAW
ISO: 400

Turn Around and See What's Behind You

One of the flaws that I am most guilty of in photography is getting so obsessed with one subject or one area of a location that I overlook or ignore other interesting possibilities around me. I'll often get so intent on getting a good shot of a particular subject or detail that I forget to lift my head and look around and see what's to the left or right—or more often, behind me—and it's an oversight that has caused me to miss some great shots.

The day I took this photo, for example, I was photographing some old steam locomotives in Essex, Connecticut, trying to find an angle that would show the ruggedness of the hulking old engine. As usual, I was working at the end of the day and the evening light, which had just pierced through an overcast sky, was shifting and fading quickly. Rather than scout for additional pictures, I kept shooting and refining the shot in front of me until the light was no longer sculpting the edges of the engine. I was so intent on what was in the viewfinder that I worked one particular shot for about 10 or 15 minutes and barely lifted my head from the camera other than to check camera settings.

Finally, the light was a bit too dim and I'd run out of ideas and angles, so I turned to start walking back to my car. Wham! Right behind me was this extraordinary water tower up on a hill, silhouetted against an incredibly tumultuous sky. It was those same clouds that had been playing havoc with the lighting on the locomotive, but it never occurred to me that the sky itself might hold a great shot. And to be honest, I never even noticed the water tower until I turned around to leave.

I had just enough time to pop off exactly three shots before that nice edge of light slipped off the left side of the water tower. The moral of this tip is to remember to take the time to lift your head and look around even if you have to force yourself to look away from your main subject. Don't get so focused that you fail to see the big picture—especially when the light is changing fast, as it does at the beginning or end of the day.

TECH SPECS: LENS: 18-70mm / FOCAL LENGTH: 105mm
EXPOSURE SETTING: 1/1250 @ f/9
EXPOSURE MODE: Program
WHITE BALANCE: Auto / FILE FORMAT: RAW
ISO: 800

Run Away with the Carnival (for a Moment at Twilight, Anyway)

I spend a lot of summer and autumn weekends bumming around carnivals and state fairs with my cameras. I spend so much time doing it, in fact, that I sometimes begin to feel like one of the carnies (and at times I've had half a mind to ask how I can sign up to finally live my fantasy and join them on the road). The rides are one of my favorite things to shoot at carnivals. Maybe it's a longing for my lost youth (though it's hard to remember back that far, so I don't really know) or just the glitz of all that color and light and motion, but I have a hard time resisting the siren song of all those twirling, swirling, cheesy light displays.

Success in photographing carnival rides has a lot to do with when you shoot them. The lights on the rides usually start coming on before the sun even begins to set. As the daylight disappears, you'll usually find that the sky takes on a rich sapphire blue and the contrast between the artificial lights and the sky gets very intense.

That's exactly the time of day I chose to shoot the photo here, and the beautiful contrast between natural and artificial light only lasted about 15-20 minutes before the magic was gone. At one point, however, the twilight reached a peak of brilliance and there was an almost even balance in luminosity between the ride and the sky, and that's when the shots really started to pop. I kept on shooting after the sky had faded to gray and then black, but I knew that the best photos were the ones I had made right at the height of that twilight.

It's important that you be ready to shoot when the mix of light hits its peak, so scout out your shots during the last hour of daylight and be ready to shoot as the sun sets and the sky illuminates with that glowing blue color. You might even get some good shots with the last rays of daylight illuminating the rides as the sky grows darker.

Incidentally, this is one of the rare times that I didn't use a tripod, largely because the fair was so crowded I was afraid someone would trip on it. But by using a fence rail from a nearby ride, I was able to handhold this shot at 1/8 second; it's not the sharpest shot I've ever made, but it is sharp enough. I even managed to do some motion shots hand held, though the inherent movement of the rides turned the shots into abstracts, so sharpness wasn't a concern.

TECH SPECS: LENS: 18-70mm / FOCAL LENGTH: 33mm
EXPOSURE SETTING: 1/8 @ f/3.5
EXPOSURE MODE: Program
WHITE BALANCE: Auto / FILE FORMAT: RAW / ISO: 640

Now You See It, Now You Don't: The Magic of the Clone Stamp

If I was stranded on a desert island and had to choose just a few Photoshop tools to bring along with me (assuming this desert island had laptop computers and digital cameras), the Clone Stamp tool would definitely be on the short list. As mystical and magical as I find almost everything about digital-image editing, I am most enchanted by the ability to "clone" pixels from one part of an image (or an entirely different image) to another. The Clone Stamp essentially replicates the pixels you tell it to copy and then places them wherever you want them. Just how cool is that?

There are a lot of practical applications for using the Clone Stamp and the more you use the tool, the more uses you'll find and the more your admiration of this profoundly helpful tool will grow. One of the most common uses for cloning is to "erase" things that you don't want in a shot. If, for example, you've taken a great and very pristine shot of a saguaro cactus in Tucson, only to find on closer examination that you've

inadvertently included someone's discarded coffee cup, you can literally erase it from the photograph and no one will ever know it was there (don't you wish we could clean up the planet as easily?).

You can also use the Clone Stamp to erase larger things that you no longer want in your photos—like taking dear old Auntie Maude, who wrote you out of the big will at the last minute, out of your holiday photos. She never smiled anyway, so banish her. In the photo here, I was able to completely eliminate the treasure hunter from this Florida beach. Not that I have anything against my fellow treasure hunters, but

TECH SPECS: LENS: 18-70mm / FOCAL LENGTH: 66mm
EXPOSURE SETTING: 1/100 @ f/18
EXPOSURE MODE: Aperture Priority
WHITE BALANCE: Cloudy / FILE FORMAT: JPEG / ISO: 200

its printing size, you are far less likely to spot any minor flaws. Also, work slowly and with a small brush; this takes more patience and makes the work go slowly, but the results are usually more precise. To change the size of your brushes, use the bracket keys on your keyboard as a shortcut. Hold down the right bracket (]) to make the brush larger; the left bracket ([) will make it smaller.

There is more to the cloning technique, but most of it you will learn

it makes a good demonstration point. And just so you don't think that I waited until he left the scene and shot a second picture, I carefully left his shadow when I cloned him out. I repeat: How cool is that?

Using the Clone Stamp is a lot easier (and even more fun) than you might think. If you were sitting here next to me, I could have you erasing certain relatives from your photos in a matter of moments. First, decide which part of the image you want to hide and what you want to hide it with. Second, select the Clone Stamp tool from the toolbar. Then "sample" the replacement material—this is the area of pixels you want to copy—by clicking on that area (Option-click on a Mac, Alt-click on a PC), and then use the cursor to paint those pixels over the part of the photo you want to cover up.

The only real choices you'll have to make are what size brush to use when cloning and what level of hardness to use. It takes some experience to know which size brushes work best with certain subjects and what level of hardness makes the cloned areas most invisible, but you will quickly see what works and what doesn't. I suggest always working with the image at around 100% enlargement so that you can work in greater detail on a larger image; this way, when you shrink it back to

through trial and error. For example, when I erased the treasure hunter I continually re-sampled my source area and took that source material from immediately to his left or right. By doing this, you keep the same level of sharpness in the replacement material as you had there before. If your sourced material comes from a different lateral area, you might be in a different sharpness zone (in terms of depth of field, for example), so you'd be cloning material that was more or less sharp than the area you were replacing—and that would show. Once I had the man erased, I then looked carefully at where he'd been and cloned in some bicycle tire marks, stones, and footprints to make the beach look natural. I know, it really seems like magic—but it relies on your skills, too.

By the way, you can clone from one photo to another! Just have both images open, sample from one and deposit in the other. I've taken flowers from one garden scene and placed them in another and it takes just seconds. You could, quite easily (and gleefully), place old Auntie Maude's head on the body of a wild goat. OK, one last time, all together now: How cool is that?

Put Your Memory Eggs in Several Small Baskets

Two great things have happened with memory cards in recent years: prices have tumbled and capacity has soared. For example, today you can buy SD (Secure Digital) cards with a capacity of 32 gigabytes (GB)—that's enough to store more than 10,000 images from an 8-megapixel camera! And if you shop around, you can get some really great deals. I can remember the days of paying well over $100 for a 1GB CF (Compact Flash) card. Today you can buy 16 times that amount of storage capacity for less than half the price— pretty amazing! And from what I've read, capacity is going to grow even higher, especially now that HD video is becoming so common in digital cameras.

The question this brings up, however, is just how big a card (or cards) you should use. My personal philosophy is that you're far better off with two or three smaller cards than one giant card. Why? For one, while I've only had one card corrupt on me out of the 50 or so cards I've owned—it's still a relevant concern. How horrific would it be if your 32GB card suddenly corrupted on your way home from a long vacation? I'd sooner have four 8GB cards and have to change cards a few times during the trip (which takes what, all of 30 seconds?). But more important is the question of losing a card. If you go to Africa on safari and put all of your images on one or two 32GB cards and you lose one of those cards, you've potentially lost 10,000 pictures. Trust me, at that point you'll be feeding your-self to the lions voluntarily. You might still lose a lot of images if you misplaced a smaller-capacity card, but you probably wouldn't lose your entire vacation.

Knowing how much card capacity you need is really dependant on the megapixel count of your camera and what image-format you are using. If you shoot in JPEG you'll get a lot more images than if you shoot in RAW, which is very memory-hungry. You'll also need a lot more memory if you are shooting RAW and JPEG simultaneously (as I occasionally do). Also, do you shoot HD video with your D-SLR? Video uses a ton of memory. To know how many images you can expect to record based on card size and your camera's megapixel count, I suggest consulting the website of the specific brand of card you're using, because the capacity can vary slightly from brand to brand.

The bottom line is that what's true for eggs is also true for digital images: don't put them all in one basket and you'll feel a lot more secure about getting home with those digital eggs intact.

TECH SPECS: LENS: 80-200mm
FOCAL LENGTH: 240mm
EXPOSURE SETTING: 1/800 @ f/7.1
EXPOSURE MODE: Aperture Priority
WHITE BALANCE: Cloudy / **FILE FORMAT:** RAW / **ISO:** 200

Do (or Don't Do) These Things with Your New Camera

So maybe you've gotten to the end of this book and decided to upgrade from a point-and-shoot camera to a D-SLR, or from an old D-SLR to a shiny, more capable new model. Whenever I get a new camera, I have this odd tendency to leave it sealed in its box and eye it warily for several days—or even a few weeks—before I take it out to play. Even though I've owned dozens of cameras in my life, I still find myself somewhat intimidated whenever there's a new addition. As familiar as I am with what most camera features do and what new surprises I can expect to find, there's still that awkward "new gizmo" hump that I have to get over. Over the years, I've developed a list of tips for making the process go faster and this is the exact list I hand out to students when I teach adult continuing-education classes:

1. DO read your camera's manual. It's one of the few books that was written expressly for the camera that you own. Also, see if there is a Magic Lantern Guide published for your camera—they're much better written and illustrated than the guide that comes with your camera. Keep your camera handy and find each control or feature as you read about it.

2. DO read all of the menu screens. Granted, some menus are kind of obtuse, but the menus are the dashboard of your camera, and the more familiar you are with the menu choices—and sub-choices—the less likely you are to drive your new toy into a photographic ditch.

3. DO take your manual with you when you're out shooting. If you're out on a Sunday afternoon cruising for snaps and you encounter a question about camera controls, you don't want to wait until you get home to find the answers. Keep the manual in a plastic zipper bag so it doesn't ever get wet.

4. DO take lots of pictures. Photography, like any craft, is a learn-by-doing process and since you're shooting digitally, there's no film to buy. The more photos that you take, the more comfortable you'll feel with your new camera, and the more likely you are to experiment.

5. DON'T, however, shoot carelessly just because it's free. Take the time to think about each photograph that you take; think quality, not quantity.

6. DO feel free to leave the camera in the Program or Auto exposure mode while you're getting used to it. Better to shoot pictures right away than to avoid the camera because you're intimidated by its complexities. Lots of pros, including me, use the Program mode regularly (you need only look at the Tech Specs in this book to see that).

7. DON'T be afraid to experiment with all of the controls. Try out different exposure modes and see what happens. Search for and play with unusual modes like flash exposure compensation. Again, just read the manual and have fun. Short of dropping it on concrete (or sneezing on the sensor), you can't hurt the camera. There's a reset option (see your manual) that returns your camera to all of the default settings if you get hopelessly tangled.

8. DO print your pictures frequently so that you can see your mistakes and successes more clearly. There's nothing like seeing a large print of a great shot to boost your confidence.

9. DO look for a basic (or advanced, if you're past the beginner's stage) digital photo course at your local adult continuing education program. I've taught continuing-ed programs and I've taken many classes, too; they're a great way to learn and I've made a lot of good friends there.

10. DON'T live in a creative vacuum. Join a photo-sharing community like flickr.com or digitalimagecafe.com to see what others are doing creatively and get advice from others who own the same camera.

High Speed Subjects (Part I): File a Technical Flight Plan

Even if you know your camera very well, it's always a good idea to have a technical strategy in place when you're photographing an unusual subject—particularly a high-speed subject. This is a lesson I learned while photographing the U. S. Navy's Blue Angels at an air show in Rhode Island. Because getting to photograph a subject like this is such a rare occasion, I wanted to be sure that I did everything possible in advance to get sharp, well exposed photos of the jets. In fact, I spent more than an hour the night before studying my camera manual, the camera controls, and pre-visualizing what the shots might look like. I even stood in the parking lot of the hotel (in the dark, no less) and, with a 300mm lens mounted on my camera, practiced panning across the sky.

There were many issues to consider. I knew, for example, that photographing jets buzzing past at 400mph was going to be tricky and just getting my camera to expose and focus for a subject moving that fast was a real challenge. Let's face it, with subjects moving at that speed (and often showing

up from totally unexpected directions), you have no time to tweak exposure or wonder if you're using the right focusing mode. In the blink of an eye all of your options disappear in a trail of jet fumes—you either had the camera set right or you didn't.

Since I knew that exposure decisions would be impossible to make on the fly (bad pun), I decided that I would shoot the entire afternoon in the RAW format. That turned out to be a good decision in some respects, but not so in others. When you're using in RAW it means that you can be off in your exposures by several stops and correct the exposure in editing.

TECH SPECS: LENS: 70-300mm
FOCAL LENGTH: 315mm
EXPOSURE SETTING: 1/1250 @ f/4.8
EXPOSURE MODE: Shutter Priority
WHITE BALANCE: Auto / FILE FORMAT: RAW / ISO: 200

You can also adjust the white balance later, and that was very helpful in this case because the white balance was changing as the jets went in and out of cloudbanks.

I also knew that I wanted to be able to fire as fast as possible. My latest D-SLR has a maximum burst rate of 4.5 fps, so I switched the camera into the continuous shooting mode. But because I was shooting in RAW (and this is the downside of RAW), the camera had to pause periodically to process the huge files. I lost several shots because I had to wait for the camera to write images to the card. The camera would have responded faster had I been shooting in JPEG format—and I might next time.

I also wanted the camera to constantly re-focus and refine focus throughout the exposures and so I set the camera for continuous focus. In this mode, the shutter will fire whether the focus is perfect or not, because it's continuously trying to focus on the moving target. In the single-frame focus mode, the camera will only fire if perfect focus is achieved—but that would have meant losing a lot of frames because the camera simply would not have fired when I wanted it to.

Was I successful? Well, while the percentage of "keepers" was lower than I would like, I'm sure my pictures were much sharper and more consistently exposed because I took the time to plan my approach the night before. Probably more importantly, by just shooting the show, I learned a lot about shooting very fast subjects and how to manipulate camera controls to give me a fighting chance.

Give yourself a fighting chance next time you're shooting an unusual subject and create a flight plan. In the next tip we'll take a look at the more Zen side of preparing for very fast action subjects.

TECH SPECS: LENS: 70-300mm
FOCAL LENGTH: 450mm
EXPOSURE SETTING: 1/1000 @ f/5.6
EXPOSURE MODE: Shutter Priority
WHITE BALANCE: Auto / FILE FORMAT: RAW / ISO: 200

High Speed Subjects (Part II): Become the Moment, Grasshopper

In the previous tip, I talked about the importance of having a technical game plan ready to photograph unusually high-speed subjects, and that's a very important aspect of any kind of action or sports photography. But in addition, I think the best action photos are made when you deeply understand and appreciate the beauty and complexity of the moment at hand. Most action subjects have an element of grace and I think that capturing the essence of that grace goes beyond mere camera controls; it requires, dare I say it, a kind of "oneness" with the subjects.

Take, for example, this photo of three members of the Cortes Family of trapeze artists (part of the family troupe that travels with great high-wire artist Tino Wallenda, see tip 9) that I shot at an agricultural fair in Connecticut. I really like this photo and consider it one of the best I shot that summer (and it was a busy summer of shooting). The reason that I like it so much, I think, is not only that it captures a great moment and is technically flawless, but because it is exactly the moment I visualized before I even began to shoot.

You can't pre-visualize action the first time you see it, of course, which is why I attended the fair for two days in a row. On the second day you have experience with that subject you didn't have on the first. On the second day, for example, I sat and tried to replay the previous day's performance while looking at the rigging: How high is the trapeze arc? How fast does it swing? Where is the brief pause before it swings back? When do the performers reach for one another? How often do they shake off a jump? What are the signals that they're going to shake it off instead of completing it?

Studying the rigging was very important and it became an almost Zen-like exercise because I felt that the more I knew

TECH SPECS: LENS: 70-300mm
FOCAL LENGTH: 105mm
EXPOSURE SETTING: 1/800 @ f/9
EXPOSURE MODE: Manual / WHITE BALANCE: Auto
FILE FORMAT: RAW / ISO: 200

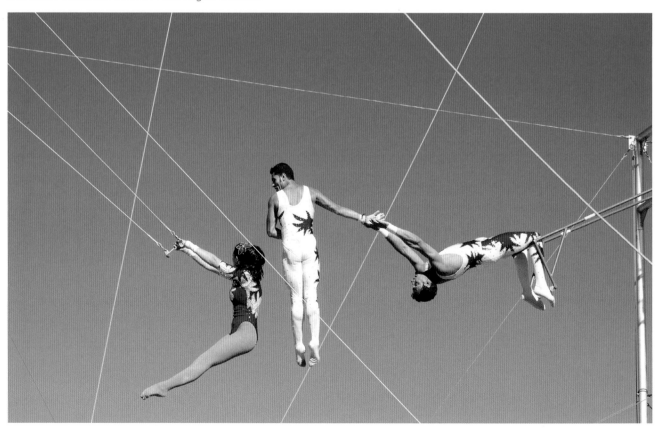

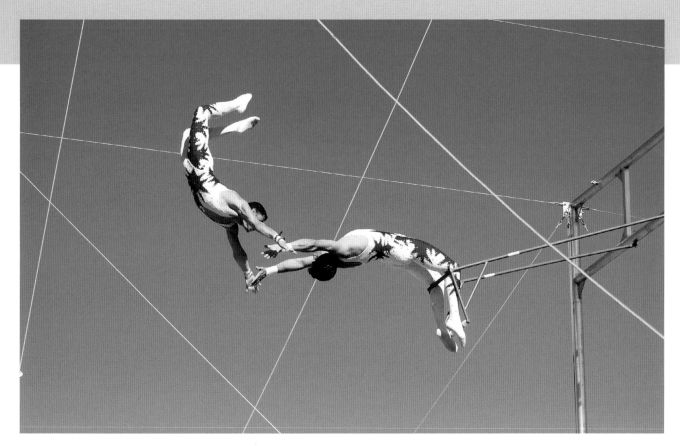

about the rigging, the more I would understand how the performers related to it. The rigging is everything to trapeze and high-wire performers—it's their lifeline in every sense of the word—and so I walked the circumference of the rigging and traced each and every cable. I started at one corner of the performance area (which is probably a few hundred feet long) and followed every line, every wire, every joint, and every trapeze bar. I then shot test photos of the empty rigging to see how my angles and compositions looked on the LCD. And in my mind I tried to remember the performance from the day before so that I could anticipate (at least roughly) where the action would occur. I even tried to remember the performers' faces. Did they smile during their jumps? Where were their eyes focused? Far more than just preparing technically for the shot, I tried to get into the mindset of the performers as if I would be a part of the action. And in a way, as photographers, aren't we intimately involved with recording the scenes around us?

I'm convinced that the photos I took that second day are better because of the time I spent meditating on the empty rigging and, if nothing more, I felt wholly connected to

TECH SPECS: LENS: 70-300mm
FOCAL LENGTH: 105mm
EXPOSURE SETTING: 1/800 @ f/7.1
EXPOSURE MODE: Shutter Priority
WHITE BALANCE: Cloudy
FILE FORMAT: RAW / ISO: 200

performers as I was shooting and that made the day even more enjoyable. More importantly, perhaps, my percentage of "keepers" was extremely high—far higher than I normally get.

I think you can apply this philosophy to photographing almost anything, from insects in your garden to your kids' soccer matches. If you have a son or daughter that plays soccer, for example, you've watched them enough times to know what they're thinking on the field. Try to place yourself in their mind (ignore the teenage angst while you're in there) as you shoot and you will find yourself anticipating shots far faster than you might have thought possible. And good anticipation is the secret of great photography, Grasshopper.

Give Yourself a Technical & Creative Challenge

To grow in photography, to enhance your skills and your vision, requires that you continually push yourself beyond your comfort zone and work with subjects that are challenging. If all you ever photograph are the things that you're already good at shooting, you'll be living in a kind of technical and creative limbo—sitting legs crossed on an artistic plateau. This happens to every artist in every medium, but it's important that you push through this invisible wall and experience the fun (and danger) of more demanding subjects. You need to stand up and stretch your photo legs.

It takes a lot of work to get good at something new. While out doing errands last summer I stopped by a small pond near my home to take a few practice panoramic shots and, after I finished, I took a walk to the edge of the pond just to see what was living there. I spent most of my childhood hanging out at this small park and it hasn't changed much since I was a kid. There is still a lot of pickerelweed growing along the edges and, as I discovered (and remembered from my childhood), dragonflies love pickerelweed.

There were dozens, if not hundreds, of beautiful dragonflies buzzing in and out of the weeds and among the wildflowers that grew at the edge of the pond. And as I was watching them, I had a bit of a photographic epiphany—I had never taken a really nice photograph of a dragonfly and I've always wanted to do that. So I went back to the car, got out my close-up gear, and decided to spend a few minutes to see if I could get any good shots. Well, of course, a few minutes turned into a few hours and by the end of the session I was getting incredibly excited about the subject and, to be honest, somewhat frustrated. I began to see my patience fraying a bit as my ability to resolve issues like depth of field and distracting backgrounds got severely tested.

Getting photos of these quick little beauties, I discovered, is not easy. To call it a challenge is a huge understatement--it was like learning a whole new language. But I decided right then and there that I was going to make this my summer goal: I was going to challenge myself to get some world-class dragonfly photos by the end of the month (or until they disappeared, anyway).

The shot here is probably the best of the lot from that first day and it is nice, but still has some technical flaws (to my eyes, at least). I learned a lot about photographing insects in those few hours though, and since the pond is only a short walk from my house, I will spend as much free time as I can working on my game.

If you find yourself lacking a goal or become bored with your pictures, think about a subject you've always wanted to master and see if you can't create a challenge for yourself. Once you start to go after the subject seriously, I'm sure you'll find your skills will grow much faster than you thought they would. And remember, growth and learning are always exponential things; once you get to the next level, you climb ever faster and ever higher to the next peak (not plateau!) and pretty soon you'll be soaring around your new subjects like a dragonfly skimming along the surface of a pond.

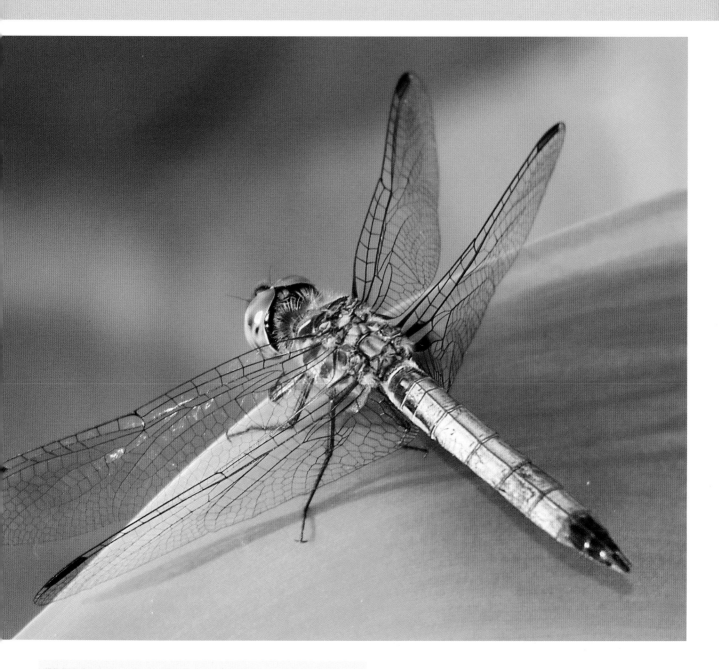

TECH SPECS: LENS: 70-300mm f/5.6
FOCAL LENGTH: 450mm
EXPOSURE SETTING: 1/60 @ f/16, with accessory flash
EXPOSURE MODE: Aperture Priority
WHITE BALANCE: Auto
FILE FORMAT: RAW / ISO: 640

INDEX